Image and Inscription

Image and Inscription

An Anthology of Contemporary Canadian Photography

Edited by Robert Bean

Gallery 44 | YYZ Books | Toronto

Co-published by YYZ Books and Gallery 44 Centre for Contemporary Photography

LIBRARY AND ARCHIVES CANADA CATALOGUING IN PUBLICATION

Image and inscription : an anthology of contemporary Canadian photography / edited by Robert Bean.

Co-published by: Gallery 44 Centre for Contemporary Photography.

Includes bibliographical references.

ISBN 0-920397-41-7

1. Photography, Artistic.
2. Photography--Canada.
3. Photographic criticism--Canada. I. Bean, Robert, 1954- II. Gallery 44

TR646.C3143 2006 779'.0971
 C2005-906445-5

Printed in Canada

REPRESENTED BY
The Literary Press Group of Canada
www.lpg.ca

DISTRIBUTED BY ListDistCo
orders@litdistco.ca

EDITOR
Robert Bean

ARTIST PROJECTS SELECTED BY
Sara Angelucci
Robert Bean
Katy McCormick

MANAGING EDITOR, GALLERY 44
Katy McCormick

MANAGING EDITOR, YYZ BOOKS
Robert Labossière

COPY EDITORS
Bridget Indelicato, Katy McCormick

DESIGN
Zab Design &Typography

COLOUR CORRECTION
Jim Panou

COVER
Arnaud Maggs, *Cercles Chromatiques de M.E. Chevreul, 1861* (detail), 2005.

BACK COVER
Cheryl Sourkes, *Cam Cities: Virtual London* (detail), 2001.

GALLERY 44 INTERN
Stuart Sakai

YYZ BOOKS INTERNS
Miyo Takeda, Charles Prinsep

GALLERY 44 EDITORIAL COMMITTEE
Sara Angelucci, David Donald, Lee Ka-sing, Guntar Kravis, Katherine Knight, Ken Montague, Katy McCormick, Louise Noguchi, Brian Piitz, Arthur Renwick, Amy Satterthwaite, Elaine Whittaker

YYZ BOOKS PUBLISHING COMMITTEE
Andrew Johnson, Ella Joseph, Michael Klein, Kym Preusse, Scott Sörli (chair)

Gallery 44 CENTRE FOR CONTEMPORARY PHOTOGRAPHY is a non-profit artist-run centre committed to the advancement of photographic art. Founded in 1979 to establish a creative, supportive environment in which photography could flourish, today our centre consists of an art gallery, resource centre, and darkroom and production facilities. We offer education programs, weekend workshops and gallery tours, and serve a rapidly growing membership of artists and photo enthusiasts. The centre is supported by its members and patrons, The Canada Council for the Arts, the Ontario Arts Council, and the City of Toronto through the Toronto Arts Council.

GALLERY 44 Centre for Contemporary Photography
401 Richmond Street West
Suite 120
Toronto, Ontario
Canada M5V 3A8
www.gallery44.org

YYZ Books is an alternative press dedicated to publishing critical writings on Canadian art and culture. YYZ Books is associated with YYZ Artists' Outlet, an artist-run centre that presents challenging programs of visual art, film, video, performance, lectures, and publications.

YYZ Artists' Outlet is supported by its members, The Canada Council for the Arts, the Ontario Arts Council, and the City of Toronto through the Toronto Arts Council.

YYZ BOOKS
401 Richmond Street West
Suite 140
Toronto, Ontario
Canada M5V 3A8
www.yyzartistsoutlet.org

YYZ Artists' Outlet and YYZ Books gratefully acknowledge the support of The Canada Council for the Arts and the Government of Canada through the Book Publishing Industry Development Program (BPDIP).

We also thank the following individuals and organizations without whose support this publication would not have been possible:
The Ontario Trillium Foundation
Toronto Friends of the Visual Arts
The Phyllis Lambert Foundation
Edward Burtynsky and Jeannie Baxter
Morden Yolles
Toronto Image Works

Someone has said: The illiteracy of the future will be ignorance not of reading or writing, but of photography.

Contents

Acknowledgements

In autumn 2003, Gallery 44 began a discussion on what sort of book this would be. Founded in 1979 by a group of young photo-based artists, Gallery 44 was nearing its quarter-century mark. The gallery's board was in deep discussion about how best to commemorate its twenty-five year history as a production, exhibition, and education centre geared to the "support and understanding of photography as an artistic medium." The exhibition selection committee would continue this discussion over the next year in consultation with gallery founders and long-time members. We concluded early on that the book would be an anthology that would not be limited to Gallery 44's history; rather, it would elaborate on various currents in contemporary Canadian photographic culture — both products of and an outgrowth from the work done by artist-run centres across Canada. Given the gallery's history of exhibitions and publications — five catalogues since 1999 and eight brochures annually to accompany each exhibition — a call for new work made sense. What better way to celebrate the gallery's silver anniversary than to publish *Image and Inscription: An Anthology of Contemporary Canadian Photography*, thereby giving voice to some of Canada's brightest photo-based authors and artists?

Many people have contributed to this publication. First thanks go to editor Robert Bean, whose affable spirit and keen intelligence made this collaboration so fruitful. Myriad ideas and goals were shared between Gallery 44 and Robert; he generously accommodated the gallery's input while pursuing his own vision of what this anthology could be. Robert's insightful and prodding comments have succeeded in bringing out the best in our contributors. We extend praise and thanks to the artists and authors for their finely crafted works; they form a critical mass from which many future discussions will arise. For the initial idea, Gallery 44 gives credit to Sara Angelucci, whose insights, impeccable grant writing, and unflagging leadership got the project off the ground. For the seed money, we thank the Ontario Trillium Foundation, whose generous support made this book possible. Grateful thanks go to our co-publisher, YYZ Books, whose generous collaboration made this book all that it could be. We are thrilled to be working with one of Canada's finest artist-run presses, whose growing list of publications form a substantial collection of critical writing on contemporary Canadian art.

Without the support of special individuals, projects like *Image and Inscription* wouldn't get very far. For their generous financial assistance we thank the following: Toronto Friends of the Visual Arts, who underwrote the artists' projects through their Visual Arts Project Award, The Phyllis Lambert Foundation, Morden Yolles, and Edward Burtynsky and Jeannie Baxter.

I am indebted to my colleague Robert Labossière, managing editor at YYZ Books, for his council on this project. Thanks as well to the YYZ Artists' Outlet board, publishing committee, and membership, and the Gallery 44 board, membership, and all its patrons. We thank The Canada Council for the Arts, the Ontario Arts Council, and The City of Toronto through the Toronto Arts Council for supporting the work we do. I wish to thank the exhibition selection committee who participated in the conception of this publication: Sara Angelucci, David Donald, Lee Ka-sing, Guntar Kravis, Katherine Knight, Arthur Renwick, Amy Satterthwaite, and Elaine Whittaker. Thank you, as well, to the Gallery 44 founders and long-time members who contributed ideas: Peter Sramek, Simon Glass, April Hickox, Terry Constantino, Brian Piitz, Leslie Thompson, Sally Ayre, and others. We thank Edward Burtynsky, Lou O'Reilly, and Ann Malcolmson for championing this project, Zab Design & Typography for giving it shape, and Bridget Indelicato for her attentive copy editing. Finally, I gratefully thank my colleagues, Gaye Jackson, Danielle Bleakley, and Jennifer Long, for their support.

KATY McCORMICK
Managing Editor, Gallery 44

Foreword

Robert Bean

From a contemporary perspective, *Image and Inscription* is a pivotal title for this anthology. Seventy-five years ago, Walter Benjamin assessed the future of photography in this way: **Isn't it the task of the photographer — descendant of the augurs and haruspices — to reveal guilt and to point out the guilty in his pictures? "The illiteracy of the future," someone has said, "will be ignorance not of reading or writing, but of photography." But shouldn't a photographer who cannot read his own pictures be no less accounted an illiterate? Won't inscription become the most important part of the photograph? Such are the questions in which the interval of ninety years that separate us from the age of the daguerreotype discharges its historical tension.**[1]

In an allegorical reference to divination, Benjamin describes the photographer as a descendent of the augurs and haruspices. By interpreting events such as the flight of birds, cloud formations, and other natural phenomena, the ancient augurs of Rome attempted to decipher the future will of the gods. The haruspices undertook a similar practice by decoding the entrails of sacrificial animals. What is significant to Benjamin's amusing astrological analogy is the fact that these traces could be apprehended in the present and committed to memory — a memory of what was yet-to-come. In this respect, history, memory, and photography all have an appointment with the future.

Still caught in the wonder and presence of the photographic image, Walter Benjamin witnessed and chronicled the moment that photography was integrated into mass media. This shift in the contextualization and distribution of images was as startling as the appearance of photography ninety years prior to the "Little History of Photography." The "someone" that Benjamin quotes above was László Moholy-Nagy, also an exponent of the decisive role that photography would have in the modern era. Acknowledging the culture of light that photography and film were initiating, Moholy-Nagy wrote, "[t]his century belongs to light." Both authors understood photography as a new literacy, a new technology, and a new criticality. For Benjamin, however, the future of photography and literacy would be dependent on the photographer's ability to "name" their images through the use of inscription. This was an aspect of photography that would be consequential to the political authenticity of art and culture. From a contemporary perspective, we may infer that the future of photography is *what we do* in the name of photography. Seventy-five years after Benjamin's declaration, we are also experiencing a new literacy, a new technology, and a new criticality.

Image and Inscription: An Anthology of Contemporary Canadian Photography features

the work of many of Canada's distinguished authors, critics, curators, and artists who are recognized for their contribution to the discourse and practice of photography. As a compilation of photographs, captions, narratives, and explanations, this book has an affinity with the photo album.

Image and Inscription presents the diversity and the changeable milieu of photographic practice and evokes an unanticipated moment in Canadian photography. It also represents an important step in expanding the contemporary authorship on photography in Canada. The practice of photography and photo-based art has established a unique presence in art since 1945. It has surpassed Walter Benjamin's predictions on image literacy and critical inscription. Explorations of temporality, history, narrative, memory and forgetting, situated identity, contemporary technology, and art are infused throughout the images and texts assembled in this volume. In this respect, the book asks, what is photography becoming? This question accentuates the temporal experience of the photographic object in relation to contemporary photo-based art in Canada.

The publication of *Image and Inscription* celebrates the twenty-fifth anniversary of Gallery 44 as an artist-run centre. Gallery 44 has a prominent history in promoting photography and photo-based art through the exhibition and dissemination of work by emerging, mid-career, and established artists. In addition to programming exhibitions, an important aspect of Gallery 44's mandate has been education and public outreach. In many cases, this outreach has extended to communities beyond those normally served by artist-run centres. Although the essays and artworks in this book do not recapitulate an historical overview of the gallery's activities, this publication actively embraces the spirit and objectives that Gallery 44 has sustained for a quarter of a century.

Preparing this book has been a challenging and inspiring endeavour. I would like to thank Gallery 44 for the opportunity to participate in their passage toward the next twenty-five years of productive engagement with photography and art. I would also like to convey my deep and sincere gratitude to all of the authors and artists that have generously contributed their creative talents to this book. Without their dedicated interest in contemporary art and photography, this book would not exist. Finally, I wish to express my great appreciation to Katy McCormick for the unwavering support, insight, and meticulous effort that she gave to the publication of this book.

1. Walter Benjamin, "Little History of Photography," in *Walter Benjamin: Selected Writings Volume 2, 1927-1934*, eds. Michael W. Jennings, Howard Eiland, and Gary Smith (Cambridge and London: The Belknap Press, 1999), 527.

2. László Moholy-Nagy, "Photography in Advertising (1927)," in *Photography in the Modern Era: European Documents and Critical Writings, 1913-1940*, ed. Christopher Phillips (New York: The Metropolitan Museum of Art and Aperture Press, 1989), 90.

3. Ibid., 85.

List of Artist Pages

CATHY BUSBY

WE HAVE A SITUATION: SORRY, 2005

ROSALIE FAVELL

Spiritual Suite, 2004/2005

Giclée prints, 118.3 x 86.8 cm.

Hollywoodland Shaman (Plain(s) Warrior Artist)
Searching for My Mother (Plain(s) Warrior Artist)
My Turtle Island (Plain(s) Warrior Artist)
My Father's Hands (Plain(s) Warrior Artist)
Passages (Plain(s) Warrior Artist)

JEANNE JU

Art Stars, 2004

Framed chromogenic prints, dimensions variable.

ME AND CINDY SHERMAN
ME AND GREGORY CREWDSON
ME AND ANDREAS GURSKY
ME AND SUSAN SONTAG
ME AND JOEL MEYEROWITZ
ME AND CHRISTO

KATHERINE KNIGHT

Mabou/Caribou, 2005

Excerpts from *Navigate* (in progress), colour and gelatin silver prints. Typography by Matthew MacKay.

ARNAUD MAGGS

Cercles Chromatiques de M.E. Chevreul, 1861, (details), 2005

Ultrachrome digital prints, 111.7 x 83.8 cm. each. The artist wishes to thank the Robertson Davies Library, Massey College, Toronto for allowing him to photograph the original book.

MICHAEL MARANDA

Archival Treatment, 1995/2005

Copper envelopes containing unfixed gelatin silver prints, each 20 x 25 cm.

SCOTT McFARLAND

Empire, 2003/2005

Ink-jet prints, dimensions variable.

ALAIN PAIEMENT

Local Rock, 2002

Eight panels, ultrachrome prints, overall 383.5 x 496.6 cm.

ARTHUR RENWICK

First Nation's BC, 2005

Four chromogenic prints, 50.8 x 50.8 cm. each.

Git'ksan BC
Secwepemc BC
Wet'suwet'en BC
Nlaka'pamux BC

ÈVE K. TREMBLAY

Tales Without Grounds, 2004/2005

Chromogenic prints, dimensions variable.

Mémoire anticipée d'une jeune fille dérangée
Perdre de vue
Différence
Tear Catcher
Chaîne de montagne
Voir au loin
Growing Medium
Suspended
Walking on Water

Arnaud Maggs
Cercles Chromatiques de M.E. Chevreul, 1861

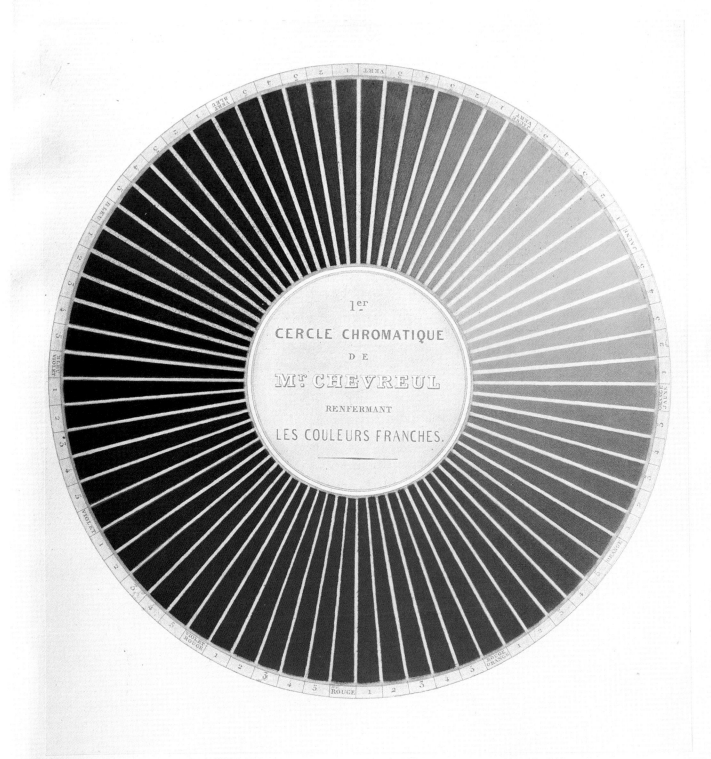

1er

CERCLE CHROMATIQUE

DE

Mr CHEVREUL

RENFERMANT

LES COULEURS FRANCHES.

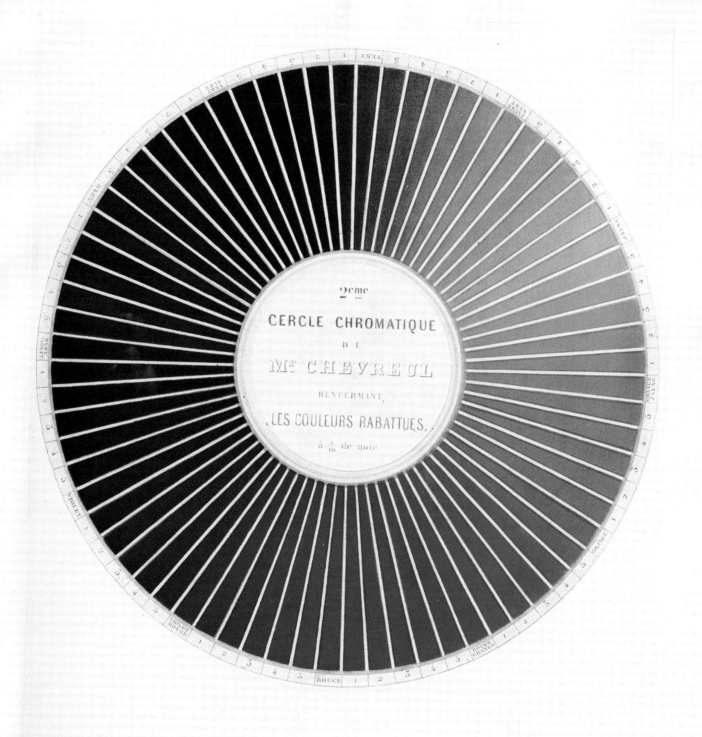

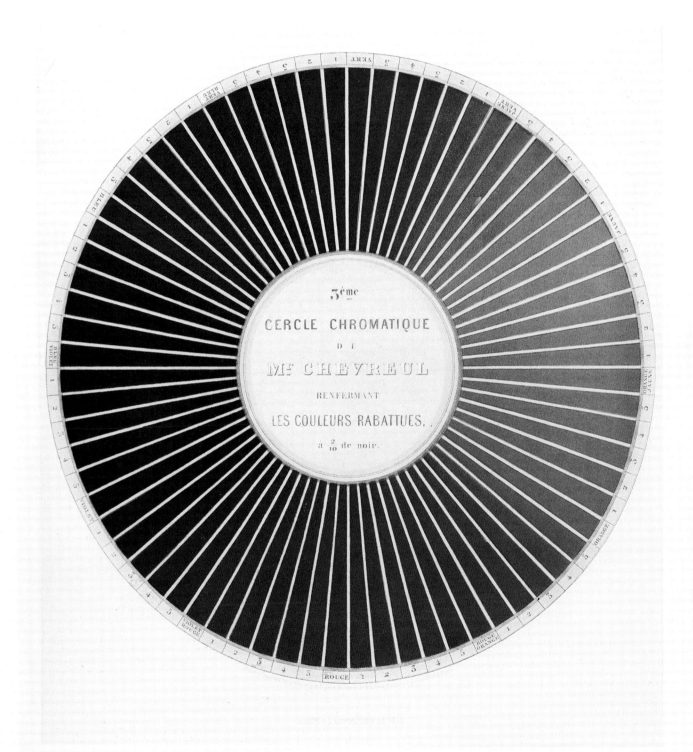

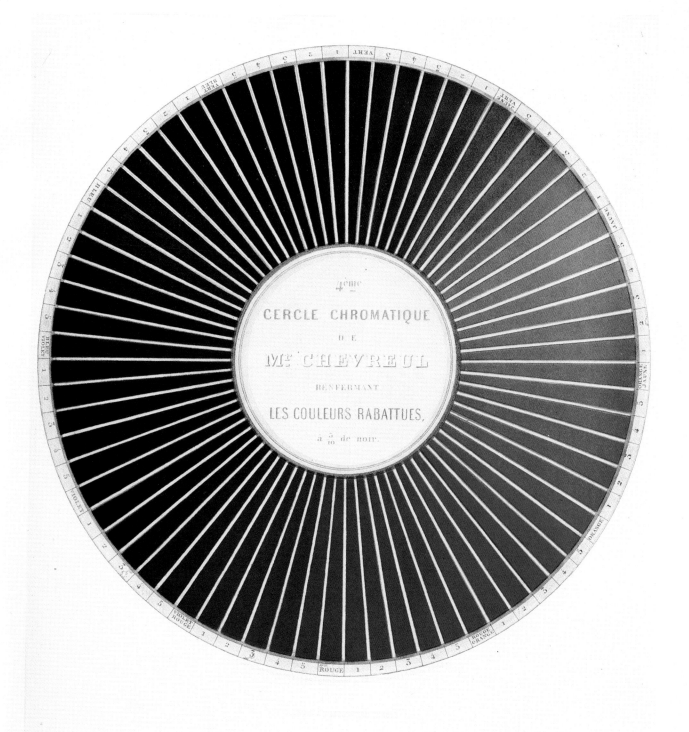

4ème

CERCLE CHROMATIQUE

DE

Mr CHEVREUL

RENFERMANT

LES COULEURS RABATTUES,

a 5/10 de noir.

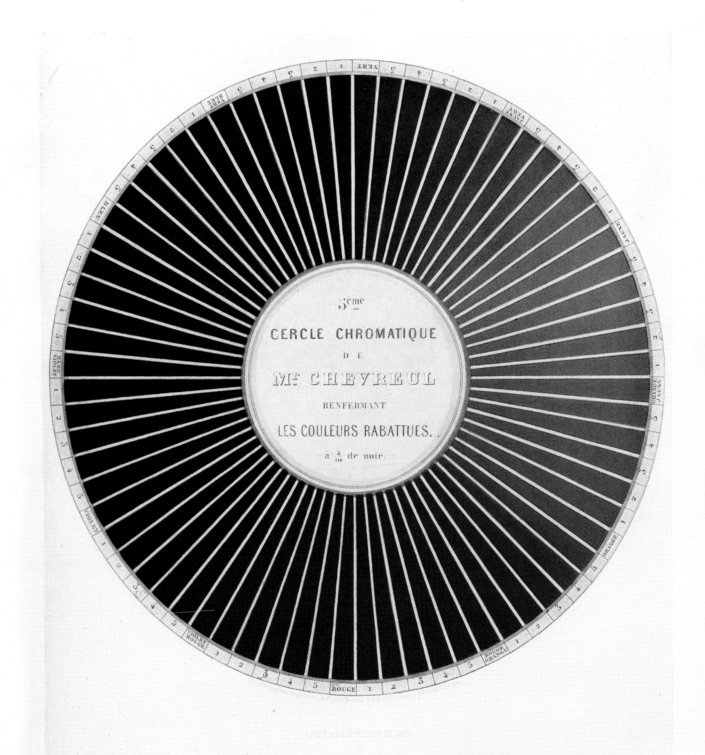

3ème

CERCLE CHROMATIQUE

DE

M^r CHEVREUL

RENFERMANT

LES COULEURS RABATTUES,

à $\frac{4}{10}$ de noir.

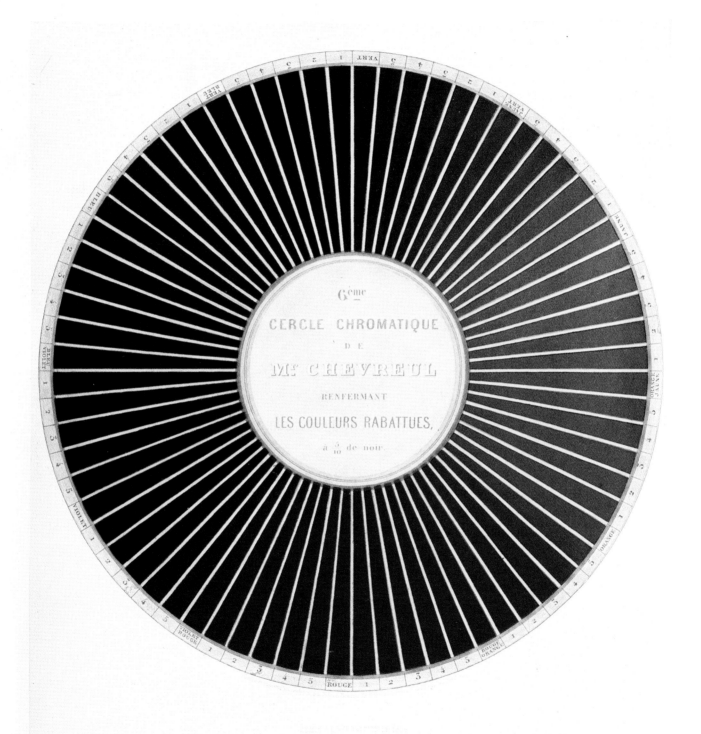

Alain Paiement Local Rock

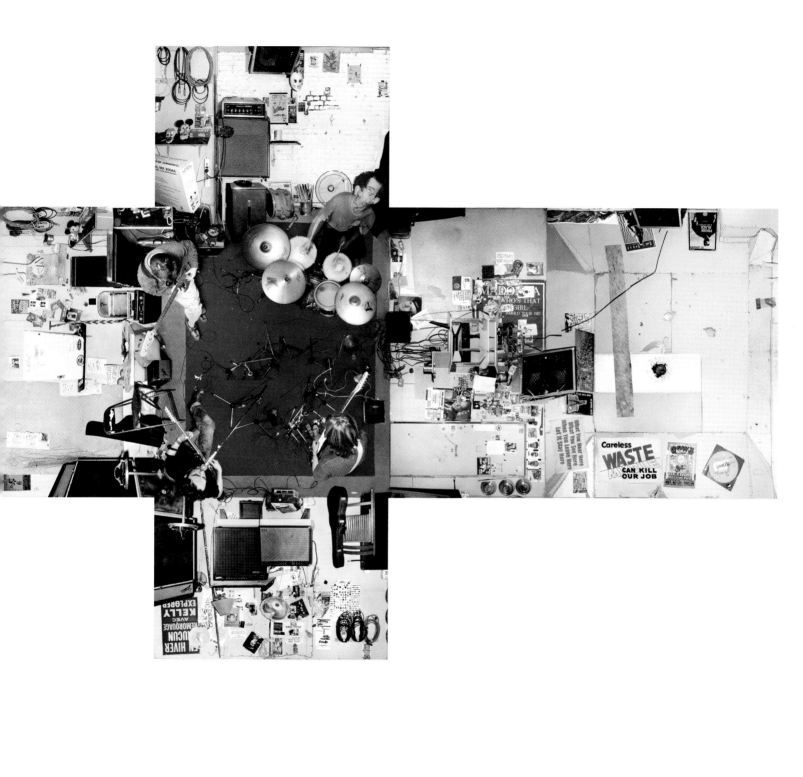

Ève K. Tremblay Tales Without Grounds

The System of Allusions
Marie-Josée Jean

Chaque chose était allusion; rien ne se bornait à être; tout pensait, dans ces royaumes ornés de miroirs; ou, du moins, tout semblait penser.
— PAUL VALÉRY[1]

THERE ARE NUMEROUS ARTISTIC PRACTICES that appropriate or mimic pre-existing images, drawn from visual culture. A considerable number of artists are abandoning the work of representing reality, in its immediate, direct form, now preferring to reference this inexhaustible reserve of images. Those attempting to trace the origins of this aesthetic often point to the rhetoric of the ready-made — to the famous appropriation by Marcel Duchamp of a mechanical reproduction of the Mona Lisa — and to the allegorical nature of collage and photomontage as practiced by the artists of the avant-garde. And yet, this "new" imaginative space had already been observed in the nineteenth century by Gustave Flaubert, for whom, as Michel Foucault writes, "... a true image is now a product of learning. It derives from words spoken in the past, exact recensions, the amassing of minute facts, monuments reduced to infinitesimal fragments, and the reproductions of reproductions. In the modern experience, these elements contain the power of the impossible."[2] This relationship to the world of *Bouvard et Pécuchet*, essentially a relationship to the authority of books — educational works, encyclopedias, literary works, philosophical essays, scientific texts, holy scripture — speaks eloquently to that shift, from the reference drawn from reality to that drawn from books. Nor was this an isolated enterprise, for in 1845 Edgar Allan Poe published "The Thousand-And-Second Tale of Scheherazade," whose plot sprang from information supposedly gleaned by the narrator in an old journal: that the *Arabian Nights* contained errors and that the story in fact did not end where we thought. This thousand-and-second of Queen Scheherazade's tales tells of a new adventure of Sinbad, who, travelling at phenomenal speed on the back of a fabulous beast, encounters several

STAN DOUGLAS, *Journey into Fear: Pilot's Quarters 1*, 2001, diptych, 2 chromogenic prints, 71 x 89 cm. each. Courtesy of the artist.

1 Paul Valéry, *Variété* (1924; repr. Paris: Gallimard, 1948), 107.

2 Michel Foucault, "Fantasia of the Library," translation by Donald F. Bouchard and Sherry Simon, in *Michel Foucault: Language, Counter-Memory, Practice: Selected Essays and Interviews*, ed. Donald F. Bouchard (Ithaca, New York: Cornell University Press, 1977), 90.

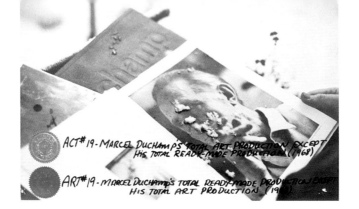

3 Edgar Allan Poe, "The Thousand-And-Second Tale of Scheherazade," in *Complete Stories and Poems by Edgar Allan Poe* (New York: Doubleday, 1966), 383-396.

4 In her essay "Photography After Art Photography," Solomon-Godeau notes that many postmodern artists, taking up the legacy of Duchamp, increasingly use pre-existing, highly conventional imagery drawn from the media. Essay published in *Art After Modernism: Rethinking Representation* (New York: The New Museum of Contemporary Art, 1984), 75-85.

5 The company had also considered developing an ANT (Aesthetically Neutral Things) department to state its indifference to certain things. The department never took shape, however, and no certificates were issued.

6 Description of Ian Wallace's artistic process from an unpublished catalogue, *Work: 1967-1983*. Quoted by Scott Watson in *Ian Wallace: The Idea of the University* (Vancouver: UBC Fine Arts Gallery, 1990), 9.

far-fetched natural phenomena — all of which were described in encyclopedias and journals of the time, as the reader learns from Poe's numerous footnotes. "Truth is stranger than fiction," if we are to believe the old adage that appears as an introduction to the tale.[3] However, that imaginative space is not erected against reality; on the contrary, it takes shape in the space of existing books and is superimposed on the real world transforming it into a domain of added experiences. Like the library, the image society is a monument to knowledge and an incubator of experience. Can we not today consider that the so-called real world has also become the sum of its images, be they fictional or not?

The many references to pictures in artistic practices since the 1960s would seem to suggest so. Several artists — all of them contemporaneous with a society in which reality is increasingly duplicated by signs — appropriate existing images or reproduce their codes and conventions, often with the goal of challenging the models to which they are submitted by advertising, reproductions of works in print, and the cinema. This aesthetic attitude was observed during the 1970s — as far as the practice of American artists (among others, John Baldessari, Barbara Kruger, Sherrie Levine, Richard Prince, Cindy Sherman) was concerned — by a group of theorists closely associated with the journals *October* and *Art in America* as well as with the Metro Pictures Gallery. And yet this same aesthetic is also seen in Canadian artists who very early on made use of "already-made" images, as Abigail Solomon-Godeau has so accurately called them.[4] An examination of this aesthetic phenomenon in the practices of the N.E. Thing Co. and Ian Wallace enables us to trace its emergence on the Canadian artistic scene to the late 1960s, and to get an idea of its most recent manifestations in the practice of contemporary artists, who employ many referential devices in their photo and video work.

Between 1967 and 1970, the N.E. Thing Co. developed the ACT and ART (Aesthetically Claimed and Rejected Things) departments, whose project was to conduct photographic documentation of situations, things, and works and pass judgment on them. Did they meet the requirements for meaningful information as defined by the company, or not?[5] The N.E. Thing Co. was a conceptual enterprise founded by Iain Baxter in 1966, officially incorporated

in 1969, with Ingrid Baxter as its co-president from 1972 to 1978. The photographs they produced for the ACT and ART departments were systematically reproduced on information sheets, which were then stamped with an official seal certifying or disapproving of the quality of their content. The ready-mades by Duchamp, the non-sites of Robert Smithson, Andy Warhol's *Elvis*, Mike Heizer's *Circumflex*, an Edward Weston landscape, and even the cover of the January 1969 issue of *Artforum* magazine were all ironically appraised in this manner, according to the opinions and stances of the N.E. Thing Co. directors. The goal of this enterprise, among others, was to make observers conscious of the aesthetic judgment procedures that we all employ in our relationships to works of art. The images were often based on evocative shapes that the artists noticed in their immediate surroundings or encountered in their travels. Otherwise, their image production consisted in re-photographing works or landscapes published in art catalogues and journals — a method that would be systematically taken up again at the end of the 1970s by Sherry Levine and Richard Prince. As artists of the information age, strongly influenced by the theories of Marshall McLuhan, the Baxters paid constant attention to the image and to technological transformations likely to generate new perceptual habits. As such, many of their images speak judiciously of a relationship to the world and an experience of art conditioned by the reproductions published in magazines and books.

In 1970, Ian Wallace first produced the project *Magazine Piece*, which was to take multiple forms depending on the spaces in which it was presented. For each of his installations, the Vancouver artist's instructions to the curator involved taking "any magazine or published media and taping it page by page to the wall in regular formation cover side facing out with any kind of adhesive tape."[6] Thus he left it up to the curator to choose the magazine — which most often was mainstream in content — and install it according to a systematic scheme that referred to the modernist project. Thus *Magazine Piece* used "already-made" images borrowed from the mass media and arranged as part of a vast installation whose final dimensions were determined by the format of the magazine and the number of pages. Yet the final objective of this self-referential approach was not to restrict the experience

N.E. THING CO., ACT, n° 19: *Marcel Duchamp's Total Art Production Except his Total Ready-Made Production. ART, n° 19: Marcel Duchamp's Total Ready-Made Production Except his Total Art Production*, 1968, felt pen and paper seal on silver print, 33 x 40.5 cm. Collection: the National Gallery of Canada. Courtesy of the artist.

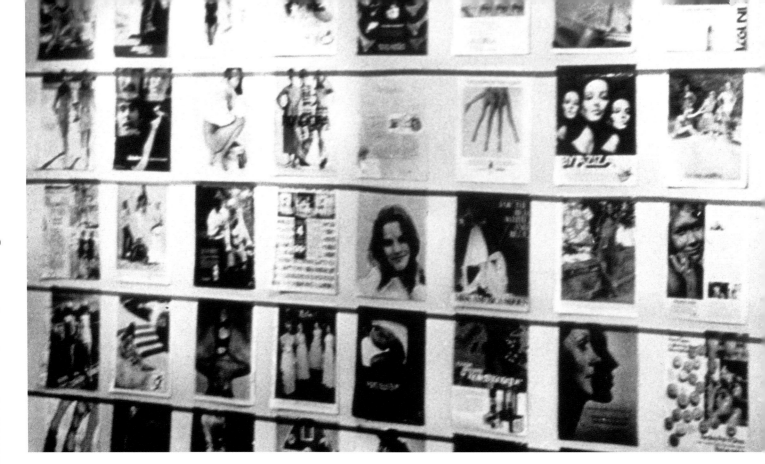

7 I refer here to Jacques Derrida, *Dissemination*. trans., annotation, and introduction Barbara Johnson (Chicago and London: Athlone Press, University of Chicago Press, 1981); Roland Barthes, "The Death of the Author," in *Image, Music, Text*, ed. and trans. Stephen Heath (New York: Hill, 1977); and Gilles Deleuze, *Difference and Repetition* (New York: Columbia University Press, 1995).

8 This, at least, is the position defended by Jeff Wall in a group work published on the occasion of the exhibition *Reconsidering the Object of Art*, that conceptual artists' use of photography had enabled the establishment of the medium as a modernist form. See Ann Goldstein and Anne Rorimer, *Reconsidering the Object of Art* (Los Angeles: The Museum of Contemporary Art / Cambridge: The MIT Press, 1995), 242-267.

of the work exclusively to the parameters of the famous modernist tenet "what you see is what you see," but to view with a critical, ironic gaze that aesthetic ideology whereby one can supposedly withdraw from any reference to the outside world or to a representation thereof. Wallace was one of the rare conceptual artists to embrace modernist aesthetic principles while simultaneously trying to anchor his work in a tangible, social reality. For a 1971 version of *Magazine Piece* exhibited at the UBC Fine Arts Gallery, the curator chose an issue of *Seventeen*, a magazine for young women, whose contents, exhibited in this way, laid bare the normative codes of female representation employed by it and similar mainstream magazines in stimulating the consumerist desires of adolescent girls. Through the use of such "already-made" images and the systematic linking of their content to representations of current events (or, simply, of the period), the public could grasp how each of us is liable to be shaped by visual molds, which condition social structure below the surface. The process by which *Magazine Piece* was created and exhibited also had the effect of questioning the originality and purpose of art as well as the artist's intentionality — all of which were issues eventually debated by poststructuralist art theorists concerned with the themes of dissemination, the death of the author, difference, and repetition.[7]

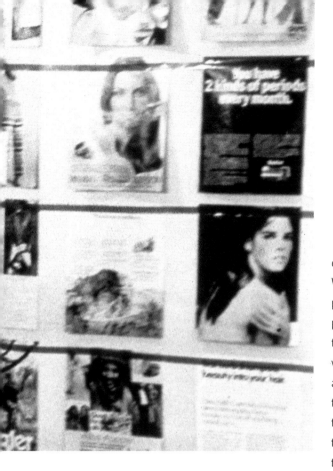

IAN WALLACE, *Magazine Piece* (detail), 1971. Installation view, UBC Fine Arts Gallery, 1971. Courtesy of the artist.

What stands out most in these series of works by the N.E. Thing Co. and Ian Wallace is without doubt the artists' preferred material, printed matter and pictures reproduced in print publications — and the unexpected uses to which they were putting it as early as the late 1960s and early 1970s: the Baxters chose to re-photograph the images, while Wallace used them without intervention other than having them presented on the gallery walls. The references thus borrowed from the print medium represented, for these conceptual artists, a way of re-inscribing reality — phenomenological or social — into the field of art. This desire for realism doubtless came in response to the reductivist regime still posited at the time by modernism. The return to realism and appropriation of press imagery had occurred first in Pop Art, especially in the practice of Andy Warhol, who, since the early 1960s, had been borrowing modes of production from advertising communications strategies. These borrowings, however, relied essentially on their iconographic content; i.e., the use of collectively recognizable images reproduced in series, and in turn of the visibility strategies they were based on, aimed to inscribe art in the public domain and the domain of spectacle. The conceptual artists were also interested in the descriptive and figurative functions of the image, but preferred to radicalize it, the better to fashion it into a true self-critical tool. It is worth recalling that such image practices evolved on the fringe of the modernist avant-garde's development, and that it was not until the 1960s that a generation of artists developed alternative propositions by which they were able to reframe the image as part of a self-referential project.[8] As such, the desire for realism driving many artists of the period rested on an autonomous descriptive system in which

reality is represented as something real and an already given form. The use of imagery drawn from newspapers and magazines represented a self-critical tool where the image functioned as both the medium and the subject of their works.

The works of these two conceptual artists lead us to question mediated experience, the function of art, the ideology of the art object, and the notion of originality, as well as force us to reinterpret works drawn from art history. In this sense, their practice of appropriation appears to rest on a *symbolic system of incorporation* of visual culture. On the one hand, they represented the possibility of appropriating the concerns and aesthetic filiations claimed by the artists, or at least of differentiating oneself from them. On the other, they were symptomatic of a type of subjectivity, marked by an experience conditioned by imagery. The vast bank of images produced by these printed materials thus developed into a referential system, which from that point on would be integrated into our experience of the world. That bank of images was to grow even larger in the 1980s, however, with the increasingly widespread use of live television as well as the advent of the personal computer, which is leading us unwaveringly to the age of globalization. Images now proliferate in all strata of society. The bulk of them, however, are produced and disseminated by cultural and media industries whose agendas are set by economic and political interests. The messages, values, and lifestyles advocated by the film, media, and advertising industries are all alike insofar as they rest upon a similar structure and similar codifications, which in turn are rooted essentially in the comfort of repetition, in immediate communication, and in very rapid assimilation of meaning. This elevated rate of visual consumption can only be attained if the communication channel relies on normative content and simple messages, which tend more often than not to reproduce social stereotypes. Artists of the late 1970s attempted to reveal these stereotypes and normative codification by deconstructing the structures of their images and revealing the overdetermination of their contents. This opened up a space for resistance, in which a process of social criticism of power structures could be initiated. The appropriationist postures of American artists of the late 1970s — those of Barbara Kruger, Cindy Sherman, and Dara Birnbaum, for instance — were much

more militant, for these artists appropriated not only advertising and television imagery but also borrowed modes of expression from political propaganda and mainstream movies in denouncing the phallocratic, discriminatory discourses perpetuated and disseminated by these same industries for maximum profit. Their appropriationist attitude spoke to an awareness of the role played by structures of visuality and mediation in the creation of individualities. It was symptomatic of a world being increasingly viewed through a cultural and historical screen, consisting of a repertory of images and meanings that now condition the individual's ways of seeing and thinking.

During the 1990s, artists using referential mechanisms pursued their code-decon-struction enterprise, more systematically targeting television and movies — except, in contrast to the denunciatory attitude of their predecessors, they focused attention on the behaviours and imagination of users of these media. Artists also began to employ the specific production methods of these industries — e.g., a film crew, larger budget, professional equipment — since they had access to production support and financial resources that were far greater. Many Canadian artists also engaged in reproduction of cinematic codes and conventions, or remakes of films, sometimes with the aim of examining the social and economic changes that occurred during the intervening years since the production of the earlier version(s). When Stan Douglas remade *Journey into Fear* in 2001 (the spy drama was originally directed by Norman Foster in 1942 and had already been remade by Daniel Mann in 1975), he was attempting to retrace the determining economic and political factors underlying the contexts in which each film had been articulated. In the statement accompanying the screening of his film at the São Paulo Biennial, Douglas explained how, in the time separating the production of the two earlier versions, the world had changed substantially:

The 1942 version was set during World War II while the context of the 1975 remake was the 1973 oil crisis — two events significant for the purposes of this project because the former initiates, and the latter roughly marks a halfway point in the transition from internationalism to globalism: the passage from a world in which

STAN DOUGLAS, *Journey into Fear: Pilot's Quarters 2* (diptych), 2001, 2 chromogenic prints, 71 x 89 cm. each. Courtesy of the artist.

IMAGE AND INSCRIPTION

THE SYSTEM OF ALLUSIONS | MARIE-JOSÉE JEAN

power is brokered by politics to one in which finance is the preferred medium of influence.[9]

The action in Douglas's version takes place on a freighter, and the dialogue between the custodian of the cargo and the captain offers clues to the historical passage from the pre-eminence of politics to that of a globalized economy. The ship, like the film's dubbing into several languages, acts as a metaphor for present-day socio-economic realities. In producing this remake, Douglas employed a less explicit or literal referential process — allusion. For a space of criticism to emerge, we must distance ourselves from the reference.

In his photographic work *Every Building on 100 West Hastings* (2001), Douglas employed referential devices, this time for the purpose of studying a section of Vancouver's Hastings Street that has been radically transformed in recent years by crime and poverty. It is now populated by homeless people as well as sex-trade workers, drug dealers, and their clients. The work's title and its panoramic form make explicit reference to Ed Ruscha's *Every Building on the Sunset Strip* (1966), while the frontal view of the buildings and the way the sections of the work are imperceptibly joined more directly recall Melvin Charney's *The Main ... Montréal* (1965). In the work of these two Canadian artists, Hastings Street and Saint-Laurent Boulevard are the borders of areas in Vancouver and Montréal that are marked by the same social problems. Although made in different eras, they cast the same critical gaze — more suggestive than directive — on urban scenes in which numerous social conflicts are played out. But while Charney's boulevard is animated by urban activity, Douglas's street is deserted. This "theatrical" emptiness gives the images a troubling quality and makes us doubt that they are real. Shot at night using a professional lighting system, Douglas borrowed techniques from filmmaking to produce this photographic sequence of the façades along the west side of Hastings Street. Illuminated in this way, the

9 Stan Douglas, *Journey into Fear* (Vancouver Art Gallery: Vancouver, 2002), 5.

STAN DOUGLAS, *Every Building on 100 West Hastings*, 2001, chromogenic print, 66 x 426.9 cm. Courtesy of the artist.

façades give the impression of a standing set on a studio backlot, as if the set were waiting for characters to come and act out their roles on it. This strategy eschews any portrayal of the misery of the people who normally populate the street, all the while using the clue-generating and allusive power of the image to speak to the root causes of Hastings's tragic decline.

Construction, deconstruction, and reconstruction of visual or literary systems is the essential project of Rodney Graham's artistic practice, which reveals a fascination for forgotten stories and mechanisms of reactivation. That fascination is expressed in, among other things, appropriation of narratives and their re-inscription into new contexts. The narrative in *City Self/Country Self* (2000) developed out of fairy-tale imagery found by the artist in a nineteenth-century *Épinal* — a broadsheet (more specifically from the period 1865–1870, according to the artist) that in all likelihood was designed to amuse children. It relates the comic misadventures of a country bumpkin visiting Paris for the first time, and Graham reproduces it in cinematic form, using angles and settings that painstakingly reproduce those in the vintage illustrations. The mild-mannered peasant (Country Self) ambulates naively through the streets, unwittingly shadowed by a bourgeois dandy (City Self) who stops at one point to have his shoe shined — whereupon we notice the extravagant shape of said footwear, obviously designed for kicking the hayseed's posterior, which, being padded, is obviously designed to be a target. Both characters are played by the artist. In addition to all this signifying detail, multiple aspects of the film — its looped structure, the tick-tock of the clock tower and pocket watch, the church bells, the use of slow-motion — contribute to the observer's consciously measuring the real time of the actions depicted and to enhancing the paroxysmal effect of their dénouement. Yet ironically, the sequence never truly ends, because it is repeated in an infinite loop. Graham has also used loops in two other film projects, *Vexation Island* (1997) and *How I Became a Ramblin' Man* (1999), which

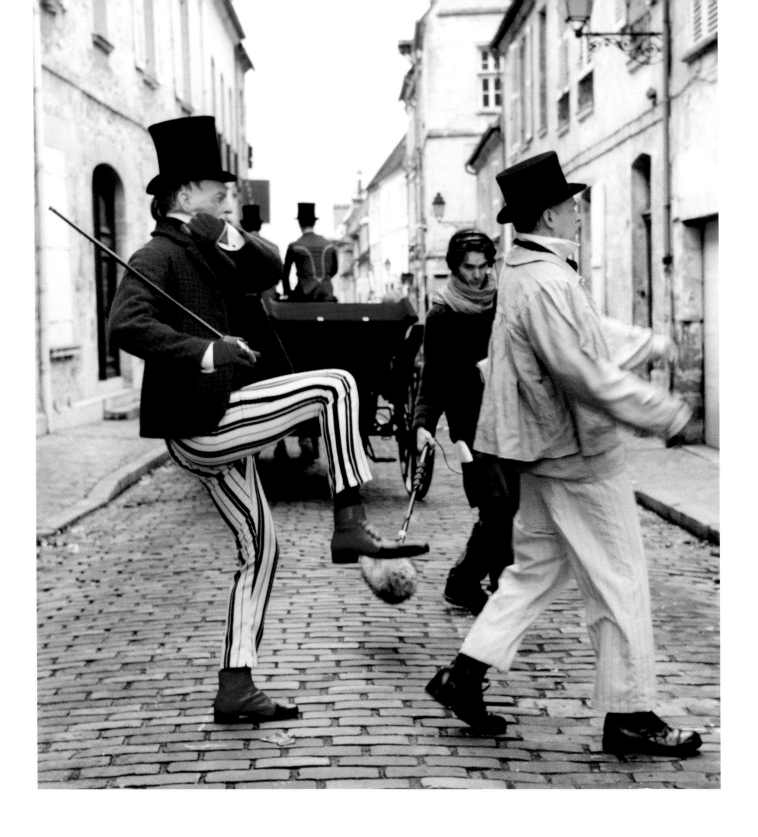

RODNEY GRAHAM, stills from *City Self/Country Self*, 2000, 35-mm film transferred to DVD, 9 min., projected on continuous loop. Courtesy of the artist and the Donald Young Gallery.

with *City Self/Country Self* form a trilogy. In this trilogy, Graham introduces a psychological dimension that is found metaphorically in Hollywood cinema: a compulsion to repetition. In the field of psychopathology this process refers to the unconscious repetition of past experiences without recollection of their prototype, accompanied by the distinct impression that the situation is current and new. By appropriating various cinematic genres — in this case historical melodrama — Graham demonstrates the strategy of Hollywood cinema, which consists in the repetition of existing conventions and a concomitant attempt to make viewers forget the prototype and feel like they are having a new experience each time they go to the movies.

The appropriationist attitudes of Stan Douglas and Rodney Graham consist of reconsidering the models that have conditioned the production of images, rather than the images themselves. This schematization leads us to make a distinction between practices that appropriate and whose recognizable images allow us to identify their origins, and those that produce images based on the persistence of conventional regularity. A similar type of schematization of advertising imagery conventions is taken up by Kevin Schmidt. In a series of photographs entitled *1984 Chevrolet Caprice Classic Wagon, 94000 kms, Good Condition, Engine Needs Minor Work, $1200 OBO 604 888 3243* (2000), he uses advertising stratagems to uncover the stereotypes undergirding our visual culture. The car for sale is set against a natural vista that recalls the romantic landscapes so often reproduced on postcards or tourism advertisements for British Columbia. The location also mimics the picturesque backdrops typically employed by automotive advertisers, who sing the praises of their cars by reproducing the durable poetic expressions characteristic of the Romantic aesthetic... except that the car Schmidt depicts reveals judicious marks of the passage of time. Where advertisers seek a surreal effect in their imagery to enhance its persuasive function, Schmidt here uses the methods of adspeak to lay bare its contrivances.

Like that of Kevin Schmidt, the recent work of Louise Noguchi seeks to distill the general schema of existing imagery. Noguchi focuses her attention on the cowboy myth and its endurance in popular culture with a photographic series that documents the living

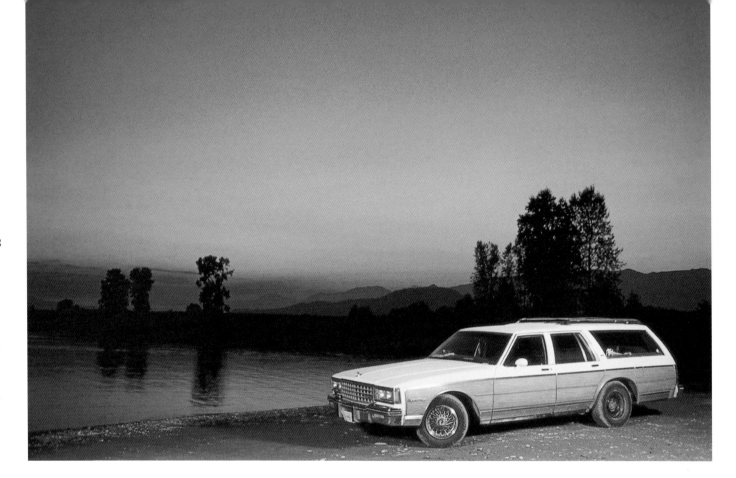

10 In an article on the use of allusion in cinema, Noel Carroll links the growing importance of this rhetorical figure beginning in the late 1970s to a generation of filmmakers then studying cinema in university, which contributed to an intellectualizing of the practice. "The Future of Allusion: Hollywood in the Seventies (and Beyond)," in *October*, no. 20 (Spring 1982): 50-81.

11 Antoine Compagnon references English- and German-speaking theorists, among others, such as Udo J. Hebel, author of "Towards a Descriptive Poetics of Allusion." Antoine Compagnon, "L'allusion et le fait littéraire," in *L'allusion dans la littérature* (Paris: Presses de l'Université de Paris-Sorbonne, 2000). The author had previously conducted an exhaustive study of citation; see *La seconde main, ou, Le travail de la citation* (Paris: Seuil, 1979).

12 Compagnon, 246 [freely translated].

history of this archetype that is still to be found in theme parks such as Six Gun City in Jefferson, New Jersey, and Donley's Wild West Town in Union, Illinois. The origins of this prolific entertainment industry lie in the theatrical shows organized by William Frederick (Buffalo Bill) Cody, which from 1883 to 1913 toured the United States and Europe, its colourful troupe, sets, and musicians helping to glorify the Wild West legend. Today, this history is continually retold in these theme-park settings; the scenes of frontier conquest are acted out, over and over, by actors dressed in period costumes and equipped with the necessary props, who are all skilled, professional gunmen, lasso artists, knife throwers, and, of course, horseback riders. What is fascinating about the performances that Noguchi documents is the way in which cowboy history is recreated so that it corresponds exactly to the audience's expectations. Wild West theme parks can thus be seen as sites of symbolic action, in the way they stage the collective imagination, referring to and adopting the appearance of the widely familiar Western movie genre. The artist, mindful of these effects of mediated reality, creates photographs that resemble nothing so much as stills from a Western movie. At times the action seems suspended, partial; at others it is shown at its apex. The shots, often close-ups, might reveal signifying details or capture the expressions

of characters after a duel. Thus Noguchi not only documents these re-enactments of Wild West scenes, but also offers us a synthesis of the way they are re-presented.

As we have seen, artists deploy many means to signal the presence of a reference in their works. Explicit reference markers are often visible in titles, either through literal citation, indication of origin, or the use of italics or quotation marks. Most often, though, the reference must be divined based on a network of more or less precise clues. We have just noted this in the works of Stan Douglas, Rodney Graham, Kevin Schmidt, and Louise Noguchi, and it can be further appreciated in certain projects by Michel de Broin, Emmanuelle Léonard, Mathieu Beauséjour, Nathalie Melikian, and Tim Lee. Their works employ the allusive power of the image to subtly reveal the social structures, systems of production, and aesthetic conventions engendering them. In this sense, allusion may be considered as the referential mechanism characterizing their practices and those of many contemporary artists. Allusion has traditionally been defined as a combinatorial way of thinking that deploys the resources of implicit discourse to name something that is related to something else without stating it explicitly. In that sense it is a risky statement because its referential content is likely to be lost on anyone who lacks the necessary knowledge or mental acuity to decode it.[10] Further, it is intrinsically linked to the fact that culture is a social institution, custodian of collective memory and shared knowledge. As defined by Antoine Compagnon, however, allusion has taken on a new meaning since its description by contemporary theorists, according to the logic of "intertextuality" as referring to any device that places two or more texts in relation to one another.[11] There is a subtle shift in focus from the source of the allusion to the relationship that it produces. Before, allusion was a justification of erudite knowledge of sources; now it encourages intertextual and semiotic analysis of the relationships between "statements that allude to" and "statements alluded to." The consequence, Compagnon continues, is that "explicit references are now treated as *allusional* signals to the same degree as implicit references."[12] This leads to the assertion that allusion has become a global system of meaning-production, which contemporary artists make abundant use of, employing a variety of means including

KEVIN SCHMIDT, *1984 Chevrolet Caprice Classic Wagon, 94000 kms, Good Condition. Engine Needs Minor Work, $1200 OBO 604 888 3243, 2000,* **series of 5 chromogenic prints, each 41 x 51 cm. Courtesy of the artist.**

LOUISE NOGUCHI, *Virgil,* **2004, transmounted digital print, 76 x 102 cm. Courtesy of the artist.**

LOUISE NOGUCHI, BOOM, 2004, transmounted digital print, 114 x 152 cm. Courtesy of the artist.

13 As Compagnon has aptly noted: "Specifically, and unlike Genette's system, allusion encompasses citation. Thus it does not merely refer to the allusioned text, in the manner of a denotation, but enriches the allusioning text via unlimited and unforeseeable associations and connotations — like thick alluvia." Compagnon, 247 [freely translated].

* * * * *

This essay incorporates and extends ideas previously developed for the exhibitions *The System of Allusions* (2005) and *The Space of Making* (2005), which the author organized for Vox, centre de l'image contemporaine, Montréal, and the Neuer Berliner Kunstverein, Berlin, respectively.

appropriation, citation, reconstitution, transposition, and re-making to set up diverse relationships among the statements.[13]

The question that remains to be elucidated is, what relationship to reality do these allusive practices now suggest? We tend to believe that the use of referential devices by contemporary artists aims essentially at "re-presenting" an image or its codes so as to add meaning to reality but reshaping it or suggesting a new way of experiencing it. But in fact, the resulting narrative acquires the same value as the original, given that (like the latter) it depends on facts established via the experience of an individual observer. Like the original, it is also the shaping of a certain reality, transformed into representation through its construction as narrative. Finally, it is a re-appropriation of an image with critical or ideological intent. As such, the new narrative produced from pre-existing imagery is anything but a simple paraphrasing enriched by an old story. It may be much more about the expressing of several different superimposed systems of reality. Thus, in contrast to the poststructuralists, who predicted the advent of a society leaning monolithically toward a generalized, simulated hyperreality (Baudrillard), the loss of belief in reality having become the simple expression of a bad film (Deleuze) or the impossibility of apprehending the world other than through the mediated spectacle of it (Debord), I believe that the image society is much more about the expression of interpenetrating, complementary realities. From earliest childhood, we learn life through novels and textbooks, movies and television shows, magazines and newspapers, videogames and the Internet — as well as through direct experiences, discussions, and encounters. All of these forms of experience and knowledge contribute to the complexities that mediate our relationship to the world. This does not mean that we are losing contact with reality; rather, it means that by penetrating these other worlds we gain access to a plurality of realities and to enhanced experiences.

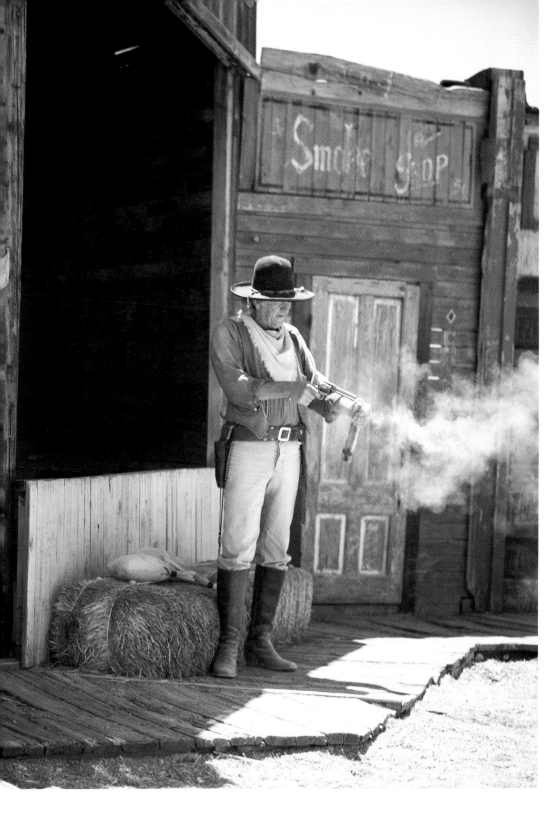

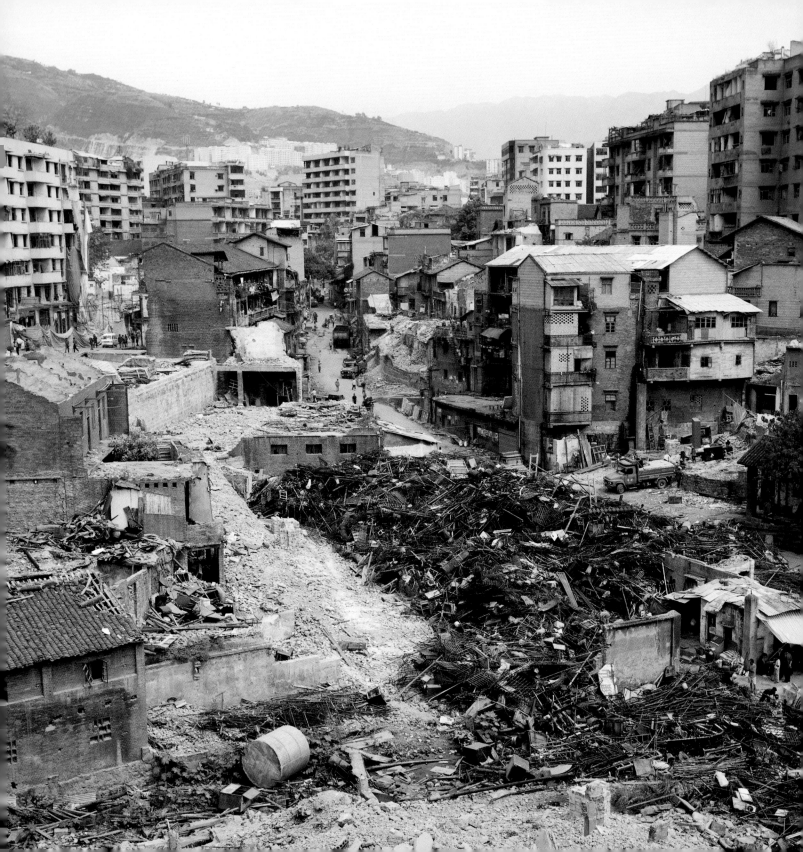

Disaster Topographics

Blake Fitzpatrick

IN THE AFTERMATH OF September 11th (2001), photographs of individuals escaping the collapse of the World Trade Center began to resurface in the press and on the Internet. Pictures taken immediately after the planes rammed into the towers were updated with survivor portraits and testimonial accounts recorded months after the ordeal. For example, a photograph of financial executive Ed Fines, carrying his briefcase and struggling to breathe in the dust of the South Tower explosion was juxtaposed with a post-9/11 portrait of the same man, same suit and briefcase, back on the job and wearing an American flag tie. Such before-and-after juxtapositions look back and forth between disaster and its aftermath and tame the terror opened by the September 11th attack by picturing the symbolic transformation of the survivor. If according to Kafka, "we photograph things in order to drive them out of our minds,"[1] then the before-and-after photographs of 9/11 survivors became one of the ways in which the wounds opened in attack could be symbolically healed and remembered — if only to be forgotten.

Canadian photographers Edward Burtynsky, David McMillan, and Japanese photographer Hiromi Tsuchida offer no such resolution and depict sites in which the disaster is either unstoppable, growing, or where the evidence of social recovery marks its own disaster of forgetting. A common element in each photographer's work is the use of the before-and-after photograph to represent technological catastrophe resulting from human decision as opposed to a natural occurrence. The before-and-after photograph is a trope that marks, by way of the photographer's return to the site of disaster, an unresolved site with wounds and fissures still unfinished for contemporary generations.

Post Documentary

As a strategic response to disaster, each photographer employs the before-and-after photograph to visualize a historical gap between what has been and what is now. Their shared task is to disrupt the complacency of the present with traces of ruin and victimization as dislodged from the continuum of history.

Before-and-after photographs of disaster sites produce responses for viewers that

EDWARD BURTYNSKY, *Feng Jie 1* (detail), September 2002, chromogenic print, 68.6 x 86.3 cm.

IMAGE AND INSCRIPTION

1 Franz Kafka cited in Roland Barthes, *Camera Lucida: Reflections on Photography* (New York: Hill and Wang, 1981), 53.

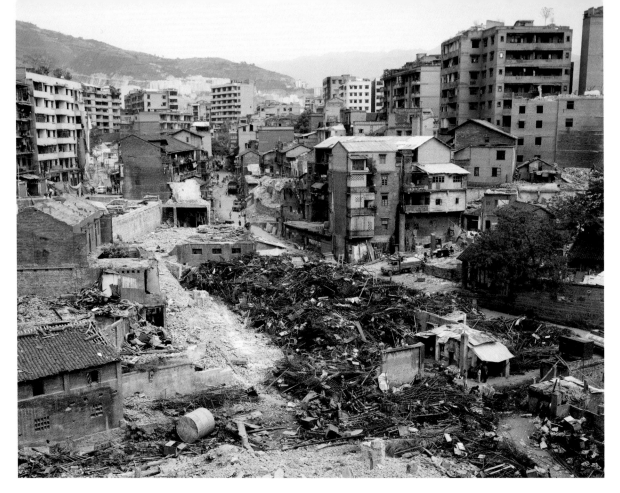

combine elements of surprise with shame. The sense of surprise has to do with the revelation of sudden change and by extension, an awareness of an absence — the absent time that is missing between two photographs. Put differently, we might say that surprise results from an experience of an experience gone missing, time out of joint, and traces coming and going. But the playful juxtaposition of recurring and absent traces is simultaneously overtaken by a sense of failure and shame evoked by the name of the disaster itself; for example, Hiroshima. Hiroshima is of course, that primal scene of atomic warfare in which on August 6th, 1945, approximately 72,000 people were quickly killed in the first atomic attack on a civilian population. How might images of present day Hiroshima interrupt the well-adjusted forgetfulness of the rebuilt city to reach across the intervening generations and remember the dead? In the "Postscript" to the volume *Hiroshima Monument II*, Hiromi Tsuchida alerts us to the potential failure of the image in meeting this task:

At the comparison of two photographs, there I was, indulging solely in the pleasure of looking [. . .] Although my intention was to ascertain the nature of Hiroshima's transformation, I am afraid now that I might have ended up demonstrating how

2 Hiromi Tsuchida, "Postscript," in *Hiroshima Monument II* (Tokyo: Kose Publishing, 1995).

3 Susan Sontag, "The Imagination of Disaster," in *Against Interpretation and Other Essays* (New York: Picador USA, 2001), 224.

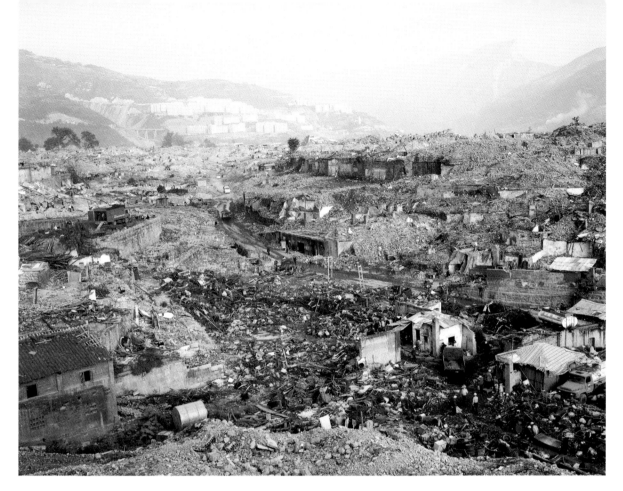

EDWARD BURTYNSKY, *Feng Jie 1,* **September 2002, chromogenic print, 68.6 x 86.3 cm.**

EDWARD BURTYNSKY, *Feng Jie 2,* **November 2002, chromogenic print, 68.6 x 86.3 cm.**

difficult it is to develop a consciousness for what Hiroshima stands for.[2]

Every image is an invitation to look, but Tsuchida's comment refers to the difficulty of comprehending the meaning of history through before-and-after photographs. Such images invent the means by which time can be pictured but turn against themselves to question the adequacy of an always belated response. The representation of disaster is thus, as Susan Sontag once observed in relation to science fiction film, "the emblem of an inadequate response."[3] The response to disaster is inadequate because the disaster has already happened or it is unstoppable. It is also because for photographers, the controlling political and social mechanisms of history are not in themselves visible and can't really be photographed.

Do realist artists visualizing any number of brutal histories owe those victimized something that goes beyond a sense of our present inadequacy or as Tsuchida put it in an almost confessional mode — the pleasure of looking — after the fact? Is *the pleasure of looking* through before-and-after photographs, inadequate precisely to the extent that it masks the profundity of historical loss and its slow unravelling in time behind a binary of

then and now, here today and gone tomorrow? Such questions speak to a trend in recent art making that graphs the return of the artist to sites of past catastrophe in order to interrogate the signs, languages, and representations through which historical knowledge is produced and legitimated.

One of the emblematic figures in an era of historical upheaval is the belated witness or the "latecomer" left to inherit the detritus of the twentieth century.[4] Burtynsky, McMillan, and Tsuchida are members of this group and use the rhetorical effect of re-photography, to comment obliquely on the subject in question as well as what comes "after" the disaster has occurred. Such work may be considered an art of post-documentation that incorporates the self-interrogation of other Postmodern art practices in responding to that which can not be seen or photographed and that which has been left out of the official narratives of history. Ian Walker coined a similar term — post-reportage — to describe a shift in the efficacy of photojournalism with so many of its beliefs in photographic authenticity thrown into doubt by new forms of digital technology. In questioning photographic practices dedicated to catching "the decisive moment" he looks to artists such as Sophie Ristelhueber and Richard Misrach to discern a new role for the photograph: "to record, document what comes after" and to "speak in considered retrospect."[5] This is particularly true for artists who recover the clues left after an event has occurred and whose work explores the discrepancy between what was experienced then and what can be discerned now by way of photographic evidence. One might wonder if the self-interrogation of photographic evidence unmoored from its historical context patronizes reality or negates the suffering of victims. James Young suggests that it cannot in truthfulness be otherwise, as these latecomers are part of a generation of artists working with a historical paradigm that joins a conception of past historical events to the distances and present conditions under which they are remembered.[6] In this context, repeat photography speaks to a crisis in the present and a need to continually supplement the original image in a repetition response to unrelenting historical change. In sites where the change has been substantial, change itself may become the subject matter. The impossibility of any final photograph is not,

4 See Michael Rothburg, *Traumatic Realism: The Demands of Holocaust Representation* (Minneapolis: University of Minnesota Press, 2000), 13.

5 Ian Walker, "Desert Stories or Faith in Facts," in *The Photographic Image in Digital Culture*, ed. Martin Lister (London: Routledge, 1995), 240.

6 James E. Young, *At Memory's Edge: After-Images of the Holocaust in Contemporary Art and Architecture* (New Haven: Yale University Press, 2000), 24.

7 Edward Burtynsky cited in Gary Michael Dault, "The Eleventh Hour in Photography," in *Canadian Art* (Spring 2003): 61.

however, a reflection on the photographer's abilities so much as it is a visual strategy that comments upon a history that is itself unfinished, demanding of critical engagement and inherently insufficient — insufficient in sustaining life and community and in preventing future disaster.

Palimpsests of Oblivion

Edward Burtynsky's photographs depict the forced destruction and abandonment of communities lying on the flood plain of the Yangtze River in China. These sacrificial communities are being moved to make way for the Three Gorges Dam Project, which upon completion in 2009 will result in the complete submerging of 21 cities over a 600-square kilometre area. Burtynsky's photographs document the epic levelling of cities, brick by brick, and provide viewers with a last look at communities on the precipice of a final slide into the impending waters of the Yangtze River.

Documentary photography has always been haunted by the fear of a lost trace, or the final hour of a subject running out before an exposure is made. In a race against time, the testimonial power of the photograph becomes most compelling. For example, slated for complete disappearance, the city of Feng Jie was first photographed by Burtynsky in 2002 (p.54). Returning two months later in November, Feng Jie's uncanny disappearance is now complete (p. 55). Burtynsky reports: "I expected to come back and find the city half gone [...] I had no idea a whole city could be done in so quickly. I got there at the eleventh hour."[7]

The frantic assault on the city is graphically animated in the compressed time of Burtynsky's before-and-after photographs. Look to the image on the left and Feng Jie is there, look to the right and now it is gone. Looking back and forth between the two images, a palimpsest of oblivion is revealed with one moment superimposed upon another. The intelligibility of the palimpsest depends on a repeated and consistent subject, holding its position within the frame. This is a rhetorical device that anchors the frame and provides a marker by which change can be measured. An oil drum in the foreground of the Feng Jie photograph anchors the scene as does a tree or a shed in a set of images taken in the city

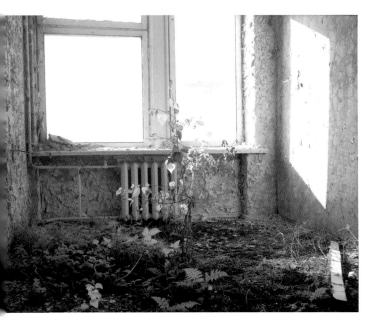

of Wusham between September and November, 2002. Even still, the effect is one of bewilderment as Burtynsky's before-and-after images of Feng Jie and Washam strip history out of time to displace not only the city, but as well, the social, political, and environmental contexts of its labourious destruction.[8]

While Burtynsky's before-and-after photographs of China seem uncharacteristically tied to their informational and evidential base, his highly attuned formal skills and the high production values characteristic of his work have been criticized for aestheticizing ecological peril.[9] This criticism is particularly charged because the content of Burtynsky's work are the landscapes of depleted environmental possibility we have learned to tolerate as the price of progress. Does the beauty of Burtynsky's large colour photographs tame the disaster, or disavow its social context by turning the viewers attention to the medium itself? Is it advisable to employ an anti-aesthetic in photographing social disorder in order to appear less manipulative and to guard the photographs authenticity against *the pleasure of looking*? Such questions point to a nagging doubt in the adequacy of the image to respond to disaster. Ultimately, the unanswered question of whether one should be seduced or repelled by disaster is what Burtynsky's photographs ask the viewer to live with.

Starting in 1994, David McMillan has now made nine trips to the site of the 1986 Chernobyl nuclear disaster. His before-and-after photographs of Pripyat, the city where the employees of the nuclear plant once lived with their families, record subtle shifts in the quality of light, changes in seasons, and the decaying traces of a modern technological ruin. As a record of change, the images remind us of how conditional the photograph is and how provisional is the world that it describes. McMillan's photographs are primarily concerned with the social settings where people once lived, learned, and made things. These environments are even more poignant because of the posthumous rendering of a

8 Lucas Lackner has nicely summarized the economic and cultural context of the project. He notes that on an economic level, the project employs 60,000 workers and on completion it will replace the burning of 50-million tons of coal a year with hydro-electric power that is equivalent to the production of 18 nuclear power plants. On an ecological, social, and cultural level, the project will result in hundreds of flooded coal mines releasing tons of sulphur into the newly forming lake, rare species of river dolphin and Chinese sturgeon may come closer to extinction. The climate throughout the region is expected to rise by two degrees centigrade, with approximately 1.8 million people being displaced and some 8,000 archeological sites becoming completely submerged. See Lucas Lackner, *Before the Flood: Photographs by Edward Burtynsky* (Toronto: self published by Edward Burtynsky, 2003), 27.

social space devoid of humans.

We tend to think of ruins as keeping places, time capsules where time is held still against ongoing history.[10] This is not so in McMillan's photographs of an atomic ruin, where the built environment continues in a slow decline while the natural world, paradoxically stimulated as much by the absence of human agents as by the radioactivity of the surrounding environment, is alive and growing. Even indoors, in photographs such as the Pripyat *Hotel Room*, trees have remarkably taken root and flourish. Dual signifiers, such as nature and technology, growth and toxicity join as an increasingly complex if not contradictory picture of the disaster. The paradox of lush plant growth in the con taminated zones of atomic destruction is not unique to Chernobyl and was cited in John Hersey's documentary-novel, *Hiroshima* (1946). The city of Hiroshima was turned into an inadvertent greenhouse when the atomic explosion resulted in a rapid escalation of heat and fire:

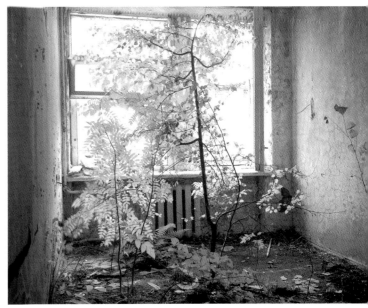

Over everything — up through the wreckage of the city, in gutters, along the riverbanks, tangled among tiles and tin roofing, climbing on charred tree trunks — was a blanket of fresh, vivid, lush, optimistic green: the verdancy rose even from the foundations of ruined houses [...] the wild flowers were in bloom among the city's bones.[11]

In the 1997 photograph of what appears to be a classroom, a bas-relief of Lenin — the leader of the Russian Communist Party in the early part of the twentieth century — has fallen to the floor (p.60). A red banner hanging on the wall includes an outline of the relief, demarcating the spot where it was once located, indexing, like a photograph, an earlier time. In the most recent photograph dated 2004, the red banner is tattered and bleached, the silhouette is now gone, and Lenin's cast, physically if not ideologically, is completely flattened on the floor (p. 61). In this juxtaposition, history is made intelligible by the play of time acting on object survivors. David MacDougall suggests that such objects may be

9 I am grateful to Jonathan Bordo for sharing with me a draft of his insightful essay, which draws out the relational tensions between the evidential and aesthetic in Edward Burtynsky's work. See Jonathan Bordo, "The Wasteland: an essay on *Manufactured Landscapes: The Photographs of Edward Burtynsky*," in *Material History Review* (*Journal of the Canadian Museum of Science & Technology*, Fall 2005).

10 For a conceptual account of keeping places, see Jonathan Bordo, "The Keeping Place (Arising from an Incident on the Land)," in *Monuments and Memory, Made and Unmade,* eds. R. Nelson and M. Olin (Chicago: The University of Chicago Press, 2003). For a fascinating collection of essays on ways of responding to ruins, see Michael Roth, Claire Lyons, and Charles Merewether, *Irresistible Decay: Ruins Reclaimed* (Los Angeles: The Getty

considered "signs of survival," because of the way that they stand for a larger event, while declaring their connection to the past by virtue of the damage that they have sustained.[12]

In another juxtaposition, the damage and neglect sustained by an object has become terminal as a radar tower once used defensively by the former Soviet military has toppled over and has nearly become invisible. In this example, the object is not a survivor and is pictured on the cusp of an impending topographic amnesia. Because the before-and-after photograph gives the rhetorical last word to the after-image, the form is retrospective. Potentially never closed, the before-and-after photograph endlessly sets the stage for more repeat photographs — documents of increasingly invisible objects caught in an incremental slide toward oblivion.

Empty Frames

Hiroshima Monument II (1995) is Hiromi Tsuchida's second iteration in an ongoing project to re-photograph Hiroshima on a ten-year cycle over the next 100 years.[13] In this work, the trees, buildings, and bridges that survived the 1945 atomic bombing of Hiroshima are systematically photographed as anonymous atomic remnants. Significantly, Tsuchida calls these remnant structures "witnesses" and thus imbues their presence with an obligation for testimony. As it is impossible for the latecomer to witness the disaster directly, Tsuchida's work provides a witness to these witnesses. Paradoxically, what makes his post-documentary images most powerful, is the dramatization of the impossibility of

Research Institute for the History of Art and the Humanities, 1997).

11 John Hersey, *Hiroshima* (New York: Random House, 1989), 69.

12 David MacDougall, "Films of Memory," in *Visualizing Theory: Selected Essays from V.A.R.,* 1990-1994, ed. Lucien Taylor (New York and London: Routledge, 1994), 262.

13 See Hiromi Tsuchida, *Hiroshima* (Tokyo: Kosei Publishing, 1985) and *Hiroshima Monument II* (Tokyo: Kosei Publishing, 1995).

14 For a thoughtful discussion of the photograph as a historical form that can replace the traditional documents and artifacts of history, see Bordo, "The Wasteland" (2005).

witnessing through images that keep the invisibility of the dead invisible.

So as to orient the photographs in relation to the atomic bombing, the proximity of the objects photographed to the 1945 hypocentre are plotted on a topographic map that eerily connotes a bull's eye. Topographic maps and aerial photographs are often aligned with acts of surveillance, war, and militarism. In Tsuchida's mapping of atomic remnants, an image of a target seems to emerge, littered with hits.

In one notable image set, a cherry tree has been photographed as it appeared in 1979, 800 metres from the hypocentre (p. 62). The next photograph reproduces the same site as it appeared in 1993 (p. 63). Belatedly, we look in vain for the signifier in the sign, the cherry tree is now gone. What happens when war's witnesses are all gone, what happens to the before-and-after trope when it looses its final anchor? Is this what forgetting looks like?

For Hiromi Tsuchida and the other photographers of a belated disaster documentary, object witnesses authenticate past presences, inscribed by what Roland Barthes discerned in all photographs, a stenciled trace — "that has been." The photograph of the missing cherry tree enables viewers to examine not only traces *that have been* but also traces that have in fact been seen disappearing. In this topography of disappearing traces, the vanishing witness has become, for lack of anything else, its photograph.[14] The living city of Hiroshima is thus rendered a ghost town where every corner, every building stands over a disappearance as witnessed by the photograph. In Walter Benjamin's famous "Artwork" essay, he makes the case that Eugene Atget (1857-1927) photographed the deserted

15 Walter Benjamin, "The Work of Art in the Age of Mechanical Reproduction," in *Illuminations* (New York: Schocken Books, 1969), 226. This point is reiterated in Benjamin's essay, "A Small History of Photography" where he suggests that "every square inch of our cities is the scene of a crime" and that the task of the photographer is to "reveal guilt and point out the guilty in his pictures." See Walter Benjamin, "A Small History of Photography," in *One-Way Street and Other Writings* (London: Verso, 1992), 256.

16 I am grateful to Jonathan Bordo for drawing my attention to these issues and for related discussion at a talk that Edward Burtynsky and I gave during the exhibition *Disaster Topographics* (Gallery TPW, May 2005).

Parisian streets like the scenes of a crime.[15] Hiroshima is also the scene of a crime and it is photographed for the purpose of establishing evidence.

I have paid particular attention to Tsuchida's photograph of the missing cherry tree because its disappearance foreshadows the ultimate fate of all survival objects. Doomed to disappearance, such objects call upon the photograph to halt time and to carry the past into the present, even as our own present falls away from it. But if the atomic witness as personified in the cherry tree has already disappeared, why go back every ten years to photograph more invisibility?

One way to answer this is to recognize that historical memory is not contained in the objectified remnant but is activated in an act of returned attention to a site of loss. The before-and-after photograph demonstrates this act of returned attention, even if it is limited to the binary logic of "then and now." Limitations in the before-and-after photograph are, however, acknowledged and to some extent overcome by the number of times the site is revisited. Tsuchida's 100-year plan to return to Hiroshima on a ten-year

cycle, McMillan's nine trips to Chernobyl, and Burtynsky's return to Feng Jie at the eleventh hour all speak to differing ethical investments in the photographic document as a mode of historical representation. It is here that Tsuchida's proposal calls for the most critical form of documentary, one that can transform the photographic moment into a performative act conceptualized to exceed the lifespan of the photographer. A perpetual document arises as his loyal return to the cherry tree signals an act of sustained responsibility to a history that is itself unfolding in time.[16] The necessity of more and more photographs acknowledges a history that is beyond representation, unfinished, and thus open to the critical engagement of the present and the future. In the example of the cherry tree juxtaposition, an open space seems to have been left behind. Perhaps, this is a space for a viewer's response to the address of an incomplete photograph.

HIROMI TSUCHIDA, *Cherry Tree, Chuo Park, 800 meters, Hiroshima*, **1979, gelatin silver print, 50.8 x 40.6 cm.**

HIROMI TSUCHIDA, *Chuo Park, 800 meters, Hiroshima*, **1993, gelatin silver print, 50.8 x 40.6 cm.**

* * * * *

I would like to thank Edward Burtynsky, David McMillan, Hiromi Tsuchida, Deborah Sharp, and Jonathan Bordo for information, discussion, and support for this essay.

I would also like to thank Gallery TPW for supporting the production of the exhibition and the original essay.

An earlier version of the essay "Disaster Topographics" accompanied an exhibition of the same name curated by the author for Gallery TPW, Toronto (May, 2005).

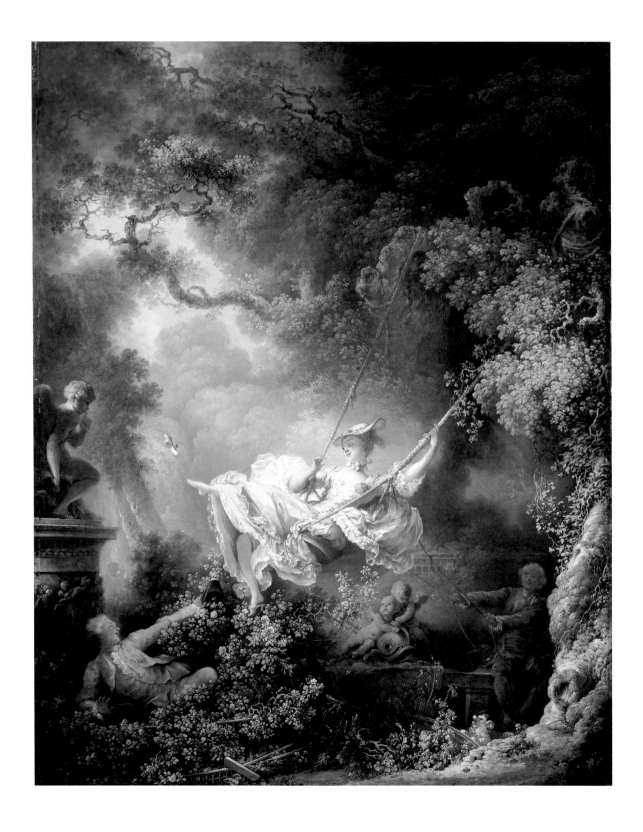

Light in the Loafers:
The Gaynor Photographs of Gaëtan Dugas and the Invention of Patient Zero

Robin Metcalfe

ONE SUMMER DAY AT THE START OF THE 1980S, two Halifax acquaintances met by a lakeshore in Toronto. One had a camera, the other wanted to have his picture taken, so he posed for his friend on a swing. Five black-and-white photographs survived as documents of the moment.

Half a decade later, one of the images that Rand Gaynor recorded with his camera entered the popular imagination around the world as an icon of the AIDS crisis, the very face of contagion. The figure of Gaëtan Dugas in a swing on Centre Island has been used to tell a widely disseminated story. This essay is an attempt to pry that figure loose, a bit, from the narrative in which he has been embedded; to consider some of the cultural mechanisms that construct that story and its meanings.

A bit of the pink

The most famous image of a swing in Western art is a 1767 painting by French Rococo artist Jean-Honoré Fragonard. *Les hasards heureux de l'escarpolette*, better known simply as *The Swing*, shows an expensively dressed young woman in mid flight in a wooded clearing, observed by a male companion. As she surges forward, a dainty shoe flies off her extended right foot. One could take this gay mischance for the "happy hazard" of the title, or one could, more substantively, take it as referring to the privileged gaze of the principal male figure in the composition, whose position offers him a view up the skirts of the young woman, to glimpse what a British friend of mine calls "a bit of the pink." The image is naughty, rather than pornographic, because the viewer is not offered that view directly: he (the presumptively male viewer) is left to imagine it by putting himself in the place of the man in the lower left.

Two diagonals hold the figure of the woman suspended in the centre of Fragonard's composition. A golden chiaroscuro light breaks into the woodland glade from deep in the upper right, through an opening in the forest canopy, illuminating her surging skirts and coming to rest in the lower right foreground at the base of a tree trunk. From the upper left background, the ropes that support the woman curve forward and down to intersect at

JEAN-HONORÉ FRAGONARD, *The Swing (Les hazards heureux de l'escarpolette)*, 1767, oil on canvas, 81 x 64.2 cm. Reproduced by kind permission of the Trustees of The Wallace Collection, London.

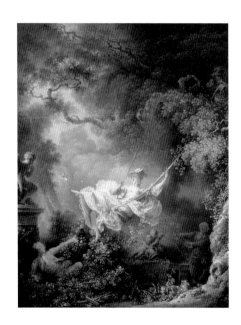

her seat, like a slender arrowhead pointing towards her admirer, who reclines on his elbow downstage in the lower left. This diagonal, in the form of a bar sinister, is a two-way street, for the man's gaze returns along the same arc, following the line of his upraised arm.

The crossed diagonals of light and of vision construct a sinuous armature of sexualized visual pleasure. The phallic references in the image — the upraised arm, for instance, and the tree trunk — align themselves with these lineaments of erotic revelation. On either side, the structure is horizontally tethered — literally, on the deep right, by the shadowy figure of a second man pulling the rope that moves the woman backwards, and figuratively, on the left, by the Cupid who stands on a plinth just behind the gentleman at leisure, his gaze level with that of the woman, his fingers raised to his lips in a gesture that could suggest either the hush of awe or a lascivious orality.

In the Gaynor photograph, as in Fragonard's *The Swing*, crossed diagonals hold the figure in place, with his groin at the centre of the converging lines. Thick branches of the background trees rise from either side, bracing Gaëtan Dugas at his hips while his legs are splayed in a second inverted V. While the linked chains that hold the swing are faintly visible, carrying the legs' diagonal force upward and outward again, most of it dissipates in a dark blur that serves to accentuate the whiteness of Gaëtan's T-shirt and to set off dramatically his halo of unearthly blond hair.

In contrast with the Baroque three-dimensionality of Fragonard's deep space, the photograph's composition is rigidly frontal, as symmetrical as a Byzantine icon. Foreground lies over an indistinct background as against a stage flat. The relation between figure and ground is that of separation and contrast: a silhouette that reverses its values from the upper half to the lower; light against dark and dark against light, respectively. The illumination on the upper figure comes from in front, from directly above the viewer, while a wedge of background luminosity rises between the trees to sodomize the man on the swing through the provocative gap in his shorts.

Where the flying shoe of Fragonard's lady suggests orgasmic sexual abandon in an ephemeral, dynamic movement, the structure of the Gaynor photograph creates

1 Arthur King Peters, *Jean Cocteau and his World* (London: Thames and Hudson, 1987), 203.

2 All quotations by Rand Gaynor from conversations with the author, August 6, 1997 and August 16, 2005.

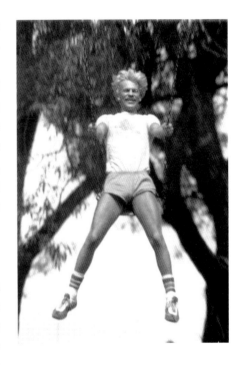

a moment of stasis, freezing the man in space. That his sneakers stay firmly tied on his feet only emphasizes his weightless suspension. The feet they clad, with rather the same pornographic intensity as spike heels on a nude, will only ever stand on air.

If the woman in Fragonard's swing is an intake of breath, a movement towards and through sexual satisfaction, Gaynor's man, levitating with his eyes closed and mouth open, hair blown back, is an orgasmic climax embodied, the moment when breath and time stop altogether. He appears before the viewer like a religious image, a being not of this world. He manifests, like the poet Cégeste, rising from the sea in Jean Cocteau's 1959 film, *Le Testament d'Orphée,* an effect that Cocteau produced by reversing the direction of the film stock. A still from the film shows actor Édouard Dermit — beloved of the filmmaker — miraculously suspended in space.[1]

The Murder Weapon

"We were trying to get a picture of his dick," Rand Gaynor told me in 1997. Gaynor is a graphic designer and visual artist from New Brunswick who moved to Halifax in the 1970s to attend the Nova Scotia College of Art and Design and lived in the city throughout the 1980s and 1990s. According to Gaynor, the photograph resulted from a chance encounter. He was walking on Centre Island in Toronto Harbour during a summer visit sometime around 1980 when he came upon Gaëtan Dugas, whose social circles overlapped with his own back in Halifax. Although Dugas was to him "just a casual acquaintance," Gaynor's former partner, with whom the photographer remained close, had "had a fling" with Dugas, whom Gaynor described as "very sexual and really sweet." Dugas, he says, "was impish, he was adorable, he was hot, he was horny. He always seemed to be smiling and in good spirits. His stated mission in life was to have sex with a different man every night."[2]

The five surviving photographs include a rather conventional smiling portrait with the strap of a shoulder bag visible on one shoulder — the only one in which the swing does not feature — and two close-ups of Dugas sitting still in the swing, in one of which his face gives a pouty hint of his devastating seductiveness (p. 73).

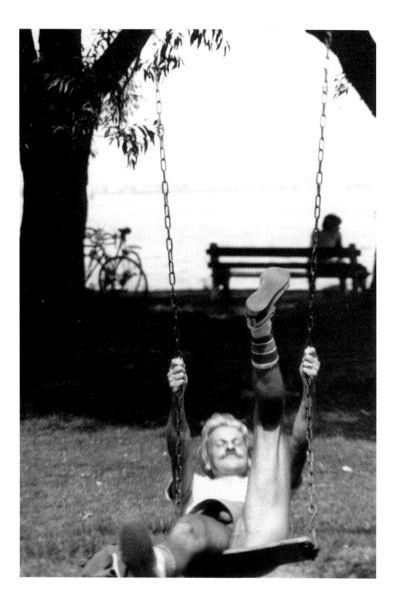

RAND GAYNOR, *Gaëtan Dugas, Centre Island, Toronto*, circa 1980, gelatin silver prints, dimensions variable. Courtesy of the artist.

Dugas's T-shirt is legible in these other images — it bears a cartoon drawing of a fish blowing bubbles and the words "St. Thomas." (I presume this refers to the largest of the Virgin Islands rather than to the town in Southwestern Ontario where Jumbo the elephant died.) The legend on the T-shirt is barely visible in the most famous photograph of the set, in which it is bleached out by overexposure in the dazzling sunlight.

In a more recent interview, Gaynor said that Dugas "was trying to show me his balls." The second statement matches the one image in which Dugas's genitalia can be glimpsed, an awkwardly foreshortened view of Dugas leaning far back in the swing with his right leg nearly horizontal and his left raised high above his head. When LIFE asked Gaynor for one of the photographs, he says, his ex joked, "Don't send them that one: they probably don't want to see the murder weapon."

The Fragonard image conjures a world into which the intended viewer, an aristocratic male, imagines himself in the place of the reclining gentleman, enjoying his privileged glimpse up the skirts of the woman. The man in the Gaynor image, on the other hand, addresses himself directly to the camera and, through it, the photographer and the viewer. That viewer expands into a multitude of voyeurs, encompassing the readers of LIFE magazine and of this anthology. In the kind of visual play that took place between two gay men on a Toronto beach, voyeurism is implicated with exhibitionism in a reciprocal exchange that destabilizes the conventional (heterosexual) eroticized visual relations between viewer and viewed. The stories of the making of each of these images illustrates their distinct means of engaging the voyeuristic impulse, a distinction that reflects the political differences between the conditions of heterosexual and homosexual representation under patriarchy.

3 Randy Shilts, *And the Band Played On: Politics, People and the AIDS Epidemic* (New York: Penguin, 1988). My references are to this first (revised) paperback edition.

Typhoid Mary

In 1987, St. Martin's Press in the United States published a thick journalistic account, by San Fransisco writer Randy Shilts, of the early course of AIDS in American society. *And the Band Played On: Politics, People and the AIDS Epidemic* borrowed the narrative conventions of fiction to tell a melodramatic tale that sold well and lent itself to the made-for-TV movie it quickly spawned. Shilts's account interweaves a medical whodunit — the epidemiological search for pattern that would establish an aetiology for the syndrome and, eventually, it was hoped, a cure — with an indictment of the failures of public health policy during the homophobic, know-nothing administration of Ronald Reagan.[3]

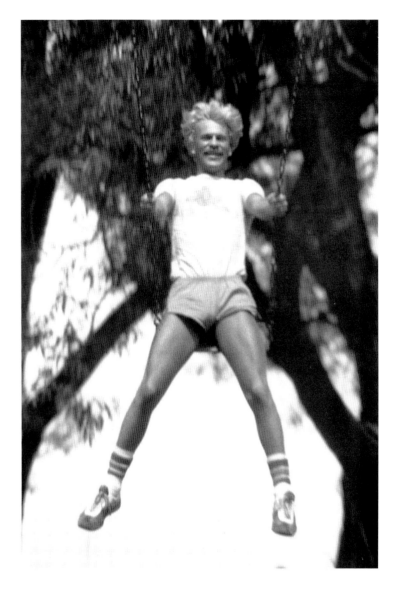

Truman Capote's *In Cold Blood* (1965) provided Shilts a literary precedent for investigative journalism in fictive drag. Capote's example licenced Shilts to speak as an omniscient narrator privy to the inner thoughts and feelings of real people and to reconstruct their experiences in an imaginative storyline. Shilts's subjects appear in the familiar guises of hero and villain, Everyman and monster. The good guys include medical researchers, public health activists, and "responsible" members of the gay community; the bad guys include conservative politicians and sexual bad actors who spread the plague with impunity.

The most consequential narrative invention in the book is a character called Patient Zero. For the researchers who coined the term, "Patient Zero" was a statistical label — the individual first identified as the common element in several overlapping populations of infected gay men. Shilts builds on this slender artifact of epidemiology an entire narrative structure, inhabited at its centre by a sinister and compelling villain.

Any one of a hundred sexually active men might have come to be known as Patient Zero.

That Gaëtan Dugas, a Québécois flight attendant, attained a posthumous career as the Typhoid Mary of AIDS owes something to chance, something to his widely acknowledged sexual magnetism and something to his willingness to cooperate with researchers, discussing his sexual behaviour openly and without shame.[4] One need not defend Dugas's later conduct — Shilts suggests he knowingly passed the disease on to other men — to object to the reductive label with which Shilts has stuck him, and by which an international public came to see him as the man who infected North America with AIDS.[5]

The concept of Patient Zero dovetailed with a popular desire to displace the source of contagion as far as possible from white, heterosexual America to other cultures, other races, other continents, other sexualities. Gay, francophone, an international traveller, Dugas fit the bill in several respects. (A francophone sexual villain, acting as a foil for the virtuous American researchers who uncover his identity, was a highly suggestive conceit in the context of the fierce competition then underway between American and French researchers to name, and to claim credit for discovering HIV.) Consequently, it was the notion of Patient Zero that the corporate media picked up from Shilts's book.

After the book's publication, several mass-circulation magazines reproduced Gaynor's photograph to accompany stories about Patient Zero. Gaynor says that he provided access to the image, for a modest fee, not only to LIFE in the United States, but also to *Burda* in Germany, *Europea* in Italy, and a magazine in South Africa.[6]

Lions and Mice

Like the Gaynor photograph, Fragonard's *The Swing* also came into being to satisfy a voyeuristic erotic craving. According to Hugh Honour and John Fleming, a writer named Charles Collé learned from the painter Gabriel-François Doyen, on October 2nd, 1767, that "a gentleman of the court" had approached Doyen to commission a painting on a theme of the gentleman's devising: a portrait of his mistress in a swing, with the gentleman placed "in such a way that I would be able to see the legs of the lovely girl, and better still, if you want to enliven your picture a little more…." Doyen claimed credit for the idea

4 Ibid., 141. Dugas, for example, gave researcher Bill Darrow, of the Centers for Disease Control, access to his address book in order to track other infected men.

5 Ibid., 439. Late in the the book, after describing Dugas's death, Shilts inserts the following, single disclaimer: "Whether Gaëtan Dugas was the person who brought AIDS to North America remains a question of debate and is ultimately unanswerable."

6 The LIFE use of the image (in its annual compilation, *The Year in Pictures*), is the subject of Tom Kalin's comments on the photograph – see note 32. A letter to Gaynor from *Burda*'s New York office, dated March 19, 1991, acknowledges receipt of four black-and-white photographs of Gaëtan Dugas. Gaynor says he has forgotten the South African magazine's name and never received a copy of it.

7 Hugh Honour and John Fleming, *The Visual Arts: A History*, 6th edition, 62. In my Web-based research for this essay, I discovered that www.fragonard.com is the website for a fragrance called "Swing."

8 John Canaday, *Mainstreams of Modern Art* (New York: Holt, Rinehart, and Winston, 1959), 225.

9 H W Janson, *History of Art: A Survey of the Major Visual Arts from the Dawn of History to the Present Day* (Englewood Cliffs, New Jersey/New York: Prentice-Hall/Harry N Abrams, 1977), colourplate 86.

10 Ibid., 540.

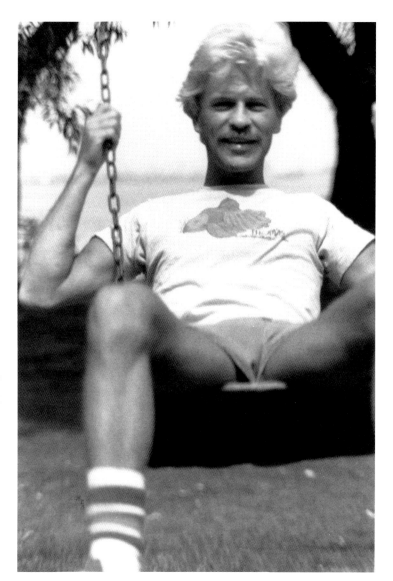

of the woman's shoes flying off "and having some cupids catch them," but he did not accept the commission and passed it on to Fragonard.[7]

Jean-Honoré Fragonard was a link in a distinguished line of French painters that stretched through him from Watteau, Chardin, and Boucher to Jacques Louis David. John Canaday, a former art news editor for *The New York Times*, dismisses Fragonard in a footnote to his *Mainstreams of Modern Art*, as "the last of the three-generation trio of eighteenth-century painters — Watteau, Boucher, Fragonard — and the most facile. In line with the taste of the day, his style was feminine, coquetish, fanciful." Canaday goes on to suggest that Jacques Louis David later "protected" Fragonard during the Revolution, "in lion-and-mouse fashion," in return for a commission the older painter had thrown his way in his youth.[8]

One can sense Canaday's unease with having to link the masculine, republican virtues of the "lion" David with the aristocratic baubles of the "mouse" Fragonard. Janson, by contrast, honours Fragonard with a colour plate of *The Bathers* (circa 1765), a group of gambolling female nudes who are so unconcerned with the effects of gravity that they might be filled with helium, like Macy's balloons.[9]

Janson describes Fragonard as a Rubéniste whose "fluid breadth and spontaneity" stood in contrast with the dominant French tradition of solidity in form and sobriety in colour associated with Poussin and, later, David.[10] Easily dismissed as a convectioner of idle pleasures, Fragonard might invite more serious consideration as a precursor of the Impressionists.

The Phaidon entry on the painter locates him as a major player in the art of his youth, having studied as a 15-year-old with Chardin (to whom he was referred by Boucher) and

won, at the age of 20, the Prix de Rome in 1752. This account of his relationship with David appears more respectful than Canaday's towards the older *maître*, who was named president of the Conservatoire du Musée des Arts in 1796 through the younger man's influence.[11]

The anonymous author of the Fragonard entry in Phaidon — although clearly more charmed than Canaday (describing as "adorable" the painter's *Boy as Pierrot*) — speaks of the painter in similar terms of "lightness." "Fragonard's reputation as a painter was made," the text notes, by *The Swing*, which was a commission for the Marquis de Saint-Julien. Other works from the late 1760s and early 1770s include *Cupid Undressing a Girl Lying on a Bed*, *Girl Making Her Dog Dance on Her Bed* and *Longed-for Moment*. These "might be considered risqué," the writer says, "were they not redeemed by the artist's lightness of touch and innocent grace."[12]

Tropes of lightness (of brushwork, of subject matter) versus gravity crop up repeatedly in the canonical texts about Fragonard, distinguishing him from that painter of heroic butch statuary, Jacques Louis David. It is a neat conjunction that the best known work of Fragonard the Light shows a young woman escaping from the bonds of gravity in the giddy euphoria of a swing.

The prevailing condescension towards the pleasurable and "merely" erotic reflects the hierarchies of things understood as feminine or masculine in gender and the bourgeois distaste for aspects of aristocratic culture that have since been appropriated into the emergent constructions of homosexuality.[13] The characterization of Gaëtan Dugas in Shilts's book recapitulates a bourgeois suspicion that links seduction and corruption, locating it in the dangerous person of Patient Zero.

The Ugly Duckling

When we first meet Gaëtan, on the opening page of *And the Band Played On*, he is examining himself in a mirror.[14] His second appearance begins with the words, "I am the prettiest one."[15] Anxieties about appearances, the visible, and the hidden signs of contagion, form a

11 *Phaidon Encyclopedia of Art and Artists* (Oxford: Phaidon, 1978), 210.

12 Loc. cit.

13 For the translation of aristocratic visual modes from Rococo through "dandy" culture into the modern figure of the homosexual, as embodied by Oscar Wilde, see Robin Metcalfe, *Dressing Down* (Oakville: Oakville Galleries, 1998), 26-30.

14 Ibid., 11. He regards himself again in a mirror, in a bathhouse, on page 196.

15 Ibid., 21. The remark is repeated a couple of lines later and again on the following page.

16 For a critical re-examinition of the myth of Narcissus and its uses in relation to male homosexuality, see Steven Bruhm, *Reflecting Narcissus: A Queer Aesthetic* (Minneapolis: University of Minnesota Press, 2001).

17 Shilts, *And the Band Played On*, 22.

18 Ibid., 147.

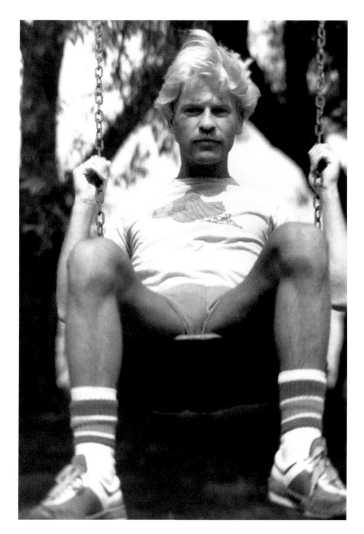
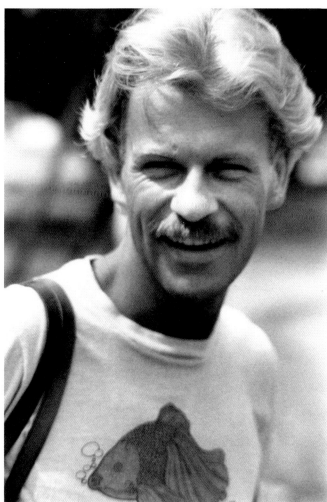

recurrent theme in Shilts's historical novel.

Literature and visual culture have played homoerotic games with reflections since the myth of Narcissus.[16] There is no subtlety, however, in Shilts's deployment of the standard confabulation of male homosexuality with "feminine" vanity and self-absorption through the trope of the mirror. Two of its most famous instances in nineteenth-century literature find their way into the text. The "major sissy of his working class neighbourhood in Québec City," Dugas is "the ugly duckling who had become the swan."[17] More ominously, "the prettiest one" is an almost unblemished Dorian Gray whose true portrait, Shilts implies, is to be seen in the sores and cancers that mark the men with whom he has had sex.

Not that Dugas simply has sex. He "cavorts," he has "trysts."[18] The twisting, slippery, untrustworthy fairy is never fair from Shilts's depiction of Dugas. His "unusual name,"

19 Ibid., 38 and 124, "an unusual appelation."

20 Ibid., 137.

21 Ibid., 157.

22 Ibid., 139.

23 Ibid., 157.

24 Ibid., 196.

25 Ibid., 47.

26 Ibid., 439.

27 Ibid., 155.

28 Ibid., 412.

29 Ibid., 196.

30 For a consideration of the flying boy and "why men run from relationships," in the mode of Robert Bly, see John H. Lee, *The Flying Boy: Healing the Wounded Man* (Deerfield Beach, Florida: Health Communications, Inc., 1989).

31 Robin Metcalfe, *Queer Looking, Queer Acting: Lesbian and Gay Vernacular* (Halifax: Mount Saint Vincent University Art Gallery, 1997), 55-57.

32 Tom Kalin, "Flesh Histories," in *A Leap in the Dark: AIDS, Art and Contemporary Cultures*, eds. Alan Klusecek and Ken Morrison (Montréal: Véhicule Press, 1992), 125.

33 Of these fictive constructions of Gaëtan Dugas, that in John Greyson's 1993 film, *Zero Patience* is surely the most artificial — and arguably redeemed by that very artificiality, since it is difficult to mistake the militant AIDS activist "Gaëtan Dugas" for the actual flight attendant of the same name.

to which Shilts refers repeatedly,[19] reminds the reader that he is other, not American, the possessor of a seductive but inscrutable tongue, "speaking smoothly in his charming French accent."[20] Shilts even trots out that old homophobic euphemism, "flamboyant."[21] By contrast, one of the upright, responsible homosexuals with whose point of view Shilts aligns himself — Paul Popham of Gay Men's Health Crisis — speaks with a "broad plainspoken Oregon accent."[22] Shilts explicitly names Dugas a "Québeçois [sic] version of Typhoid Mary."[23] The book perversely insists on misspelling the word "Québécois," as if to emphasize the otherness of a language whose strange rules of orthography normal people really cannot be expected to master.

One reads more than enough here of the "bitter Canadian winters"[24] that Dugas found "so tedious"[25] and how Gaëtan "hated cold and dreary Québec City."[26] The harsh climate of the land where Dugas's life begins and ends becomes a metaphoric counterpart of Dorian Gray's portrait, a painful essential reality that "the suave Québeçois [sic] airline steward"[27] ultimately cannot escape. When he lies dying "in a Catholic hospital, Gaëtan Dugas had never looked so scared."[28]

That Gaëtan Dugas was one of Air Canada's "fly boys," part of "the royalty of gay beauty, a star of the homosexual jet set,"[29] links him to the archetypal figure of the *puer aeternus* or eternal boy, who is also frequently represented as a flying boy, like Peter Pan, unbound by mundane responsibilities.[30] Like Fragonard's angels, Shilts's Dugas is a little too "light in the loafers" to be trusted. The airborne sexual angel in Rand Gaynor's photograph of Gaëtan Dugas, as reproduced in the global media after 1987, is the perfect embodiment of this semimythical personage.

Postscript

The last time I saw Gaëtan Dugas, as I recall, was at Rumours, a community-controlled lesbian and gay dance club in Halifax. It would have to have been 1982 at the earliest, since that was when the club moved to the location on Granville Street that subsequently housed Critic's Choice video rental, Café Mokka and now the restaurant, Tribeca. Four

pillars define the corners of the long vanished dance floor at the edge of which I caught a glimpse of that lovely face.

When the AIDS epidemic entered my consciousness, through the pages of *The Body Politic*, the pioneering radical journal of gay liberation in which I did my first serious writing, the disease seemed a long way from Halifax. That illusion collapsed in an instant when Gaëtan, through Rand's photograph of him, had his brief moment as the world poster boy of AIDS.

When I was researching the 1997 exhibition, *Queer Looking, Queer Acting: Lesbian and Gay Vernacular* for the Mount Saint Vincent University Art Gallery in Halifax, in whose catalogue the Gaynor photograph is reproduced,[31] my attention was drawn to Tom Kalin's essay, "Flesh Histories." Kalin places the Gaynor image in a thoughtful meditation on AIDS in visual culture, and my own critique of Shilts owes something to Kalin's. In his examinition of this "snapshot of Gaëtan (taken by a friend? a sister? a lover?)," however, he creates a second bogeyman: the photographer. "(I wonder: who sold this photograph? And for how much?)."[32]

"To answer Tom's question," says Rand Gaynor, "they pay by the size of the picture: three by five gets you 120 bucks." My own motive in writing this, my addition to the literature of Gaëtan Dugas, is to rescue my experience of two men who have been (to different degrees) known to me — the man in the swing and the man behind the camera — from discursive constructions that tend to eclipse a lived reality.[33]

Nation, Identity, Periphery, and Modernity: Synthesizing Canada's Photographic History

Carol Williams

HISTORIANS CHART TRANSFORMATION over time determining where, why, and how human agency interferes with the inanimate and "natural" world. Art historians, conversely, rely on the paradigms of aesthetic trends, on the concept of the artist as the embodiment of genius or innovative insight, and on consumer tendencies generated by the marketplace. Art history's search for common, stylistically shared, eruptions in visual culture seems, on one hand reliant on a cult of individuality, and on the other hand, complicit with conformity, leading me to ponder whether the disciplinary methodologies of history and art history are irreconcilable. The question asked by this essay is where, between these discourses, shall we situate a history of photography, the conditions of which diverge from, and overlap with, those of art? In my view, the methodologies of art history uncomfortably collide with, and at times inhibit, an effective narration of photography's history given that social and political events within national boundaries so obviously influence the trajectory of the photographic gaze.

By staying within conventions established by the discipline, art history seems destined to isolate itself and to reproduce gender-and-race-segregated narratives although in recent decades social art historians have substantively refuted these conventions. Individual artists and artists' collectives who similarly challenge art history's conventions have thrust the discipline and its practitioners towards reconstruction, to confront issues and ideas formerly perceived as beyond disciplinary purview. This transformation is not smooth. The marketplace — defined by a multiple-limbed web of public and private galleries, prizes, collectors, curators, art magazines, press reviews, auction houses, and so forth — depends on values acquired over time woven across these numerous spheres of discursive authority. Objects and makers are promoted and reinforced by this echo chamber of institutional and critical authority. The market may adapt and flex in response to be more inclusive of the renovations of disciplinary scholarship yet the market persistently lapses back towards more conservative, safer evocations — recycling over and over that which is tried and tested. The fluctuation between the new and sensational, as well as resuscitation of the canon, are complementary bookends of a market-driven cycle.

MARIAN PENNER BANCROFT, *The first group of Mennonites of the 1923 migration, bound for Canada and boarding the S.S. Bruton at Libau, near Riga, Latvia* from the exhibition *By Land and Sea (Prospect and Refuge).* Original photograph 1923, re-photographed by Marian Penner Bancroft 1999, gelatin silver print, 28 x 35.5 cm.

Across the generations, Canadian artists have exploited ideas situated outside of national or local discourses on art, productively drawing on debates elsewhere, not only for economic and psychic nurture but for systems of meaning and aesthetic templates. This essay reviews the vexing attempt to critically narrate photography's history, looking to sources written about Canada's northwest coast in particular. Although two contemporary Vancouver-based photographic artists, Jin-me Yoon and Marian Penner Bancroft, are discussed as exemplars of transformative, oppositional voices and cultural activity, the essay purposefully chose not to conduct close expositions of any individual works. The intention of this approach is to avoid elevating or isolating their work and the artists themselves from a wide community of artists and curators who are similarly engaged and politicized. Yoon and Penner Bancroft are a reciprocal part of, rather than distinguished from, this community and participate in the conversations that arise from this social environment.

Both Yoon and Penner Bancroft have rejected art history's limits by presenting complex perceptions of sociality, community, family, and nation. The contest around identity, expansively and tangentialy explored by various exhibited components, guides both Yoon and Penner Bancroft: Self is understood not as authentic or singular but as an intersection of projected meanings, impositions of location or place, of time and history. In age and exhibition experience, Yoon and Penner Bancroft span two generations of artistic practice in Vancouver but neither, in my view, has received the international attention their work rightly deserves. Why? By revisiting two Vancouver exhibits, *Unfinished Business* and *In Transition*, the essay investigates how localized narratives of photography's history impede the appraisal of politically conscious work.

Yoon and Penner Bancroft respectively summon nineteenth-century social history and imagery and by so doing illuminate a critical pathway, they intervene with their bodies and lived, or situated, circumstances of identity to reconfigure the "values" attributed to art and photography. Socially, women, like others disenfranchised, have consistently embodied the notion of "lack." Disadvantaged by an inability to distance themselves from

1 A critical perspective is exemplified by the work of Geoffrey Batchen, Abigail Solomon-Godeau, Allan Sekula, Deborah Brith, Marta Braun, Keith Bell, Peter While, Elspeth Brown, Louis Kaplan, Martha Sandweiss, Andrea Kunard, Carol Payne, and Joan Swartz among others who contextualize photography's production.

2 Mary Warner Marien, "What Shall We Tell the Children? Photography and Its Text (Books)," republished in *Illuminations: Women Writing On Photography from the 1850s to the Present*, eds. Liz Heron and Val Williams (Durham: Duke University Press, 1996), 207-222.

3 Ibid., 209.

the messy aspects of quotidian life and the signifiers and responsibility of flesh and skin, this situated knowledge is embedded in the content of their cultural production. Propelled by political and economic necessity, artists who have been marginal to art history's conventional narratives — whether those narratives are locally or nationally circulated — are well placed to interrogate market-driven classifications, or discourses of authority established by a dependency on linearity (as established by hierarchies of value such as high art trumps craft, etc.), exceptionalism, and celebrity. By casting their gaze elsewhere, Yoon and Penner Bancroft visually dissect the manner in which immigration history, policy, and law as well as social status determined by race, gender, and class have constrained or configured national and personal identity and privilege. Their work consolidates undeniably political aspects of existence — the nation, gender, domesticity, race — thus refuting any attempt to separate lived experience from aesthetic output. Hence, in order to adequately address the context of their work, art history must shift its discursive frame.

Photography, in many respects, shares this conundrum of dependency on, and necessary independence from, the limiting restraints of art history. Photography's historians have long sought the most theoretically appropriate narrative forms to configure photography's social, political, and industrial place in history in order to comprehend the agency and activism of its producers.[1] Critical thinkers rapidly realized that art historical conventions were inadequate to evaluate the unique discursive and technological environment of photography; thus other narrative methods were tested. In a 1984 essay published in *Afterimage* and reissued in a 1996 anthology of women's writing on photography, Mary Warner Marien criticized two celebrated monoliths of American photographic history: Beaumont Newhall's *The History of Photography* (first published in 1949) and Naomi Rosenblum's *A World History of Photography*.[2] She was troubled by various issues but primarily by how the two volumes misrepresented photography's historical diversity. *History of Photography* introduced Newhall's modernist inclinations to "construct a foundation by which the significance of photography as an esthetic medium can be fully grasped."[3] By citing influential contemporary criticism, analyzing production beyond Europe and the

MARIAN PENNER BANCROFT,
On the road near Auchingills, Sordale, Caithness, (Scotland), from the exhibition By Land and Sea (Prospect and Refuge), 1999, colour photograph, 86.5 x 104.5 cm.

4 Ibid., 217-218.

5 Mary Warner Marien, *Photography: A Cultural History* (Upper Saddle River, New Jersey: Prentice Hall, 2002), xiv.

6 Ibid.

7 Ibid., xv.

8 Rosalind Krauss, *Bachelors* (Cambridge: MIT Press, 1999).

9 Ralph Greenhill, *Early Photography in Canada* (Toronto: Oxford University Press, 1965); Edward Cavel, *Sometimes A Great Nation: A Photo Album of Canada: 1850-1925* (Banff: Altitude Publishing, 1984).

United States, and partitioning technology from theoretical musings, Rosenblum's survey deviated somewhat from Newhall. Still, *World History*'s loyalties to the masterworker or masterwork lineage common to art history were undeniable and while "heterogeneous" the impact of "collectivities...popular photography, collections, and propaganda efforts" were underestimated.[4]

In *Photography: A Cultural History*, Warner Marien undertook increased gender, social, national, and cultural diversity alongside an overview of genre from pictorialism to the vernacular; from imperialist-rooted travel photographs to industrial imagery; as well as a glimpse into the practices and habits arising from the Kodak "revolution."[5] For Warner Marien, human responses to the idea of photography, as first asserted by Elizabeth Eastlake in 1857, were more intellectually engaging than the clustering of contraptions, single iconic images, or genius.[6] Warner Marien further appealed for an analysis of the convergences between "art, photojournalism, social documentary, and scientific imaging," that are "blurring traditional boundaries and energizing photographic practice."[7]

The debate over how to formulate an inclusive, yet complex and intellectually broad assessment of photography's history, remains animated. Too often, aesthetics and biography trumped intellectual concerns escalating into a full blown cult of the celebrity artist, a status and privilege historically assigned largely to men until the late 1970s when feminism eroded these claims. Women's production attains equal acclaim in short and temporary spurts most commonly mobilized by a prurient fascination with personal reclusive tendencies, tragic circumstances, or sexuality as in the instances of Cindy Sherman, Claude Cahun, Diane Arbus, Francesa Woodman, and Nan Goldin.[8] The female "stars" who conform to the male model of singular ambition and who are unhampered by the perils of family, career disruptions, and contrary physicality, grip consumer attention as museums appease feminist critics, and the cult of difference, with large-scale retrospectives trimmed with corresponding fridge magnets and posters (Frida Kahlo is of course the cultish example of a marketable female artist). But women's place in art history, and its marketing infrastructure, is never secure. Her authority is unstable, susceptible

to displacement simply because masculine genius, while at times similarly dependent on classic themes of tragedy but never hysteria, remains the consistent hallmark of longevity and success. As three decades of feminist criticism has argued, revisionism is an insufficient strategy for change; all parts of the fundament must be systematically refuted and rebuilt.

Canadian authors, wisely or unintentionally, have dodged the quandary of how to synthesize the nation's photographic history and can learn from international debates. There exists no grand monograph on Canadian photography's history equal to Orvell, Warner Marien, Newhall, Rosenblum, Freund, or Alison and Helmut Gernsheim. Nor is there a comprehensive "early" history to interleave photography's reception, production, and distribution save Greenhill's *Early Photography in Canada* originally issued in 1965, and other contemporary anthologies.[9] Penny Cousineau-Levine's *Faking Death: Canadian Art Photography and the Canadian Imagination* attempted to probe this silence by considering photography in the arena of art since 1955. *Faking Death* was written in response to students

JIN-ME YOON, from the *Touring Home From Away* series, 1998-99, 18 Ilfochrome translucent prints with polyester overlaminate and 9 double-sided lightboxes, each 81.3 x 66.1 x 12.7 cm.

10 Penny Cousineau-Levine, *Faking Death: Canadian Art Photography and the Canadian Imagination* (Montréal: McGill-Queens Press, 2004), 4; Daina Augaitis, ed., *Frame of Mind: Viewpoints on Photography in Contemporary Canadian Art* (Banff: Walter Phillips Gallery, 1993); Geoffrey James, ed., *Thirteen Essays on Photography* (Ottawa: CMCP, 1991).

11 Cyril Leonoff, *An Enterprising Life: Leonard Frank Photographs 1895-1944* (Vancouver: Talonbooks, 1990), 5.

12 For example, see: BC Studies, *The Past in Focus: Photography & British Columbia, 1858-1914*, no. 52 (Winter 1981-82); Faith Moosang, *First Son: Portraits by C.D. Hoy* (Vancouver: Presentation House Gallery and Arsenal Pulp Press, 1999); Jo Ann Roe, *The Real Old West: Images of a Frontier Photographs by Frank Matsura* (Vancouver: Douglas & McIntyre, 1981); *Gum San Gold Mountain: Images of Gold Mountain, 1886-1947* (Vancouver: Vancouver Art Gallery, 1985); Charles Hill, *John Vanderpant, Photographs* (Ottawa: National Gallery of Canada, 1976); Sheryl Salloum, *Underlying Vibrations: The Photography and Life of John Vanderpant* (Victoria: Horsdal & Schubart Publishers Ltd., 1995); Henri Robideau, *Flapjacks and Photographs: A History of Mattie Günterman, Camp Cook and Photographer* (Vancouver: Polestar Book Publishers, 1995); David Mattison, *The BC Photographers Directory 1858-1900* (Camera Workers Press, nd); Peter White, *It Pays to Play: British Columbia in Postcards, 1950s-1980s* (Vancouver: Presentation House Gallery and Arsenal Pulp Press, 1996). Also see: *Facing History: Portraits from Vancouver* (Vancouver: Presentation House Gallery and Arsenal Pulp Press, 2002); *The BC Photographer*, a pictorial magazine produced in the 1970s and published by Gary Wilcox with editorial contributions from Peter Wollheim, Vicki Jensen, Randy Thomas, Denes Devenyi, and Trevor Martin; Fred Douglas, *Eleven Early British Columbia Photographers, 1890 to 1940* (Vancouver: Presentation House Gallery, 1976);

who lacked a "sense of the significance of the products of their own people, and hence by extrapolation of their own artistic work, that they could look forward only to making images they themselves view as valueless, and that would fall invisible into a critical void."[10] In a historical biography of British Columbian photographer Leonard Frank, Cyril Leonoff similarly bemoaned the national tendency towards cultural amnesia proposing that the failure of audiences and public officials to reap the potential of documentary photographs was detrimental to the national imagination. He observed an elevated recognition of the value of photographic records in the preservation of historical memory and the protection of "heritage values" but a frustrating disinterest in history prevailed.[11]

Any effective synthesis of Canada's photographic history necessarily would stride forward, as well as arching back into the nineteenth century across discipline and genre to conceptually trace the monumental leap of ideas about photography from (pseudo) scientific-bound instrumentality, questions of documentary, and realism to the visual embodiment of postmodernist issues and aesthetics. To clarify how industrial, commercial, popular, vernacular, scientific, and artistic practices overlap or mutually inform discursive or technical fluctuations across two centuries, as Marien Warner advocates, would be formidable. Canada's photographic history, as it stands, seems rather arbitrarily cleaved across two distinct centuries lacking adequate explanatory transitions; this is another demonstration of loyalty to modernism. One historical effect of that breach is the continued assumption that turn-of-the-century modernity, or "progress," was imported, or learned, from Europe or the United States thus Euro and Anglo American artistic production is firmly entrenched. What narrative and theoretical strands might comprise Canada's history of photography's objects and epistemology? What images, artifacts, and producers would be included or, alternatively, rendered invisible by oversight?

British Columbia's rich and expansive photographic history is fragmented across an assortment of periodicals, monographs on individual practitioners, specialty magazines, and anthologies.[12] Contemporary photographic activity is retrieved from an extraordinary plethora of limited edition catalogues and pamphlets independently published by artist-run

initiatives and photographic-specific galleries such as Vancouver's Presentation House. Sadly, no synthesizing initiatives have surfaced to imbricate the development of British Columbia's photographic history across the centuries, individual studios, or exhibition venues as manifest in the available primary and secondary sources.

Is Canada's history of photography worthy of a synthesis? Why not tease the rent between present and past by re-attaching context with creative agency? What is the long route travelled by contemporary photographers to find contemporary idiom and exhibition opportunities? In a nation largely devoid of commercial galleries, with reduced or diminished public or private philanthropy, how did, or does, historical and market value accrue in Canada? Why have certain careers been legitimated as deserving while

Peter Wollheim, *New West Coast Photographers from 1981*; and *1982: Twelve Photographers* (Victoria: Art Gallery of Greater Victoria) which illuminate popular sensibilities of the 1960s to mid-1980s. A retrospective analysis of this era of photographic activity remains neglected.

others fall into obscurity? What factors or circumstances favour some work and neglect others? Why not situate individual producers in their historically contingent circumstances to acknowledge that lives have divergent paths, influences, and ambitions arising from region, identity, and opportunity?

Evidence determines, for instance, that much of western Canada's early production was the handmaiden to colonial expansion and emblematic of the asymmetry of Euro American privileges.[13] A standard companion to colonial expansion worldwide, the camera was widely held by earlier users and audiences as an indexical tool of social control and realism. Embraced by an emergent class of late-nineteenth-century social science bureaucrats on behalf of public discourses of colonial settlement and population, in Canada, as elsewhere, photography was put to official purpose as well as private: for expeditionary and survey photography, to scrutinize immigrants and their status, to document industrial transformation of the land, and urban development. And, in Canada's northwest in particular, the camera was used to police the cultural and political activism of First Nations populations. For Aboriginal subjects, the camera's gaze extended the political agenda of the newcomers: the theft of territory, resources, and livelihoods.

Discussion of photographic instrumentality within a social context conventionally has been segregated from the histories of modernist-related "art" photography. The latter was conceived and framed as aesthetically pure and detached from the baser, public politics of nation, nationalism, and commercialism. Assigned to the disciplinary confines of anthropology, ethnohistory, technological, or business history, pseudo-scientific, scientific, and industrial uses of photography were isolated from that driven by creative intent.[14] Symptoms of these divisions still reign. Very little critical art historical response followed the publication of David Neel's volume of portraits, *Our Chiefs and Elders*, for example. Surely one must question this cruel silence reflecting on how disciplinary barriers and conventions recollect, and reproduce, the racial segregation between Euro/Anglo Americans and First Nations established by oppressive state policies of the nineteenth century. Highlighting the cultural activity and activism of four artists, Doreen Jensen,

13 Dan Ring, Keith Bell, and Sheila Petty, *Plain Truth* (Saskatoon: Mendel Art Gallery, 1998); Carol Williams, *Framing the West: Race, Gender, and the Photographic Frontier in the Pacific Northwest* (New York: Oxford University Books, 2003); Martha A. Sandweiss, *Print the Legend: Photography and the American West* (New Haven: Yale University Press, 2002).

14 Carolyn Marr, "Photographers and Their Subjects on the Southern Northwest Coast: Motivation and Response," in *Arctic Anthropology*, vol. 27, no. 2 (1990): 13-26; Leslie Tepper, *The Bella Coola Valley: Harlan I. Smith's Fieldwork Photographs, 1920-1924* (Ottawa: Canadian Museum of Civilization, 1991); Linda Riley, *Marius Barbeau's Photographic Collection: The Nass River* (Ottawa: Canadian Ethnology Service Mercury Series Paper no. 189, 1988); Victoria Wyatt, *Images from the Inside Passage: A Northern Portrait by Winter & Pond* (Vancouver: Douglas & McIntyre, 1992); Joanna Scherer, "Pictures as Documents: Resources for the Study of North American Ethnohistory" and "You Can't Believe Your Eyes: Inaccuracies in Photographs of North American Indians," in *Studies in the Anthropology of Visual Communications*, vol. 2, no. 2 (1975): 65-79.

15 Lee-Ann Martin, ed., *Making a Noise!: Aboriginal Perspectives on Art, Art History, Critical Writing and Community* (Banff: The Banff Centre, 2004); also see, Carol Payne and Jeffrey Thomas, "Aboriginal Interventions into the Photographic Archives," in *Visual Resources: An International Journal of Documentation*, vol. XVII, no. 2 (June 2002): 109-125.

16 Williams, *Framing the West*, 20.

Rena Point Bolton, Joanne Cardinal Schubert, and Jane Ash Poitras, filmmaker Loretta Todd, in *Hands of History*, similarly exposed the arbitrary, yet race-bound, classifications differentiating between craft, ethnography, and "fine art" that, as the film's featured artists argue, have prevented a holistic, inclusive, consideration of First Nations cultural production. Curators and writers such as Lee Ann Martin, Catherine Mattes, Richard Hill, Gerald McMaster, Doreen Jensen, Jeffrey Thomas, and others, have been dogged in their disruption of the apparent disconnect between past and present, community and audience, gallery and longhouse, craft and fine art, preserved by modernism.[15]

Contemporary photographers such as Arthur Renwick, Jolene Rickard, Jin-me Yoon, and Laiwan who revisit the historical asymmetry of the photographic gaze, recognize that use fluctuated according to motive and location. In the nineteenth-century pacific northwest, studio and itinerant freelancers put their photographs to as many uses as possible. Cameras were commissioned for the mapping of new Anglo-defined territorial boundaries, private and public. As independent entrepreneurs, photographers sought any and all opportunities for profit; studio and in-situ photographs were marketed not only to individual clientele but for the promotion of European immigration and local tourism. Photographs, clearly, had use-value and practitioners accommodated available and developing markets. Is contemporary practice so distinct?

The rise in the market for artistic imagery — detached from documentary realism — emerged with widening claims that photography could also be art as proposed by the work of British amateur Peter Henry Emerson. Experimental works produced by British Columbia nineteenth-century photographers, Hannah Maynard and Benjamin Leeson were characterized as "art" and indeed, Maynard self-identified as an "artist" to elevate her studio's prestige above those of her competitors.[16] But creative art photography, at least by those two northwest coast photographers, subsisted alongside more recognizably commercial output. The role of rural, urban, and civic landscape photography served official ends rather than for private consumption and photographs mailed home by immigrants to announce new world affluence might deliver both personal and bureaucratic interests.

JIN-ME YOON, from the *Touring Home From Away* series, 1998-99, 18 Ilfochrome translucent prints with polyester overlaminate and 9 double-sided lightboxes, each 81.3 x 66.1 x 12.7 cm.

Clearly contemporary feminist and postcolonial theory and history has seriously corrupted the weathered myths of lineage, aesthetics, and iconography advocated by Newhall, Rosenblum, and others. From the late 1960s onward, fierce debates around identity and its privileges collapsed the assumption that photography of either century was driven by pure aestheticism as claimed by modernism. An unflinching semiotic interrogation of the fluctuating, site-specific, itinerant status of photography's meanings proved critical and much needed to shift the conventions of looking. The recognition that asymmetry existed between the photographer and the photographed, between the users and those "captured" by the camera's gaze, revealed that social factors of class, gender, and race influenced photography's production and history resulting in the revision of modernist assertions of detached aestheticism.

In the North American West, access to the camera was limited to Euro American men. Women, such as Hannah Maynard and Mattie Gunterman, as well as non–Euro American practitioners, such as C.D. Hoy and Frank Matsura and others less familiar, were active but perceived as extraordinary or exceptional.[17] One cannot assume, however, that these photographers possessed radical views. Being female was certainly no guarantee of enlightenment or freedom from Eurocentric bias. The choice of subject matter was dictated by the photographer's cultural, economic, and political status, and mobility. Others with reduced access to the means of self-representation, or social mobility, eventually conscripted the camera to their own interests but the fragmentary remains of peripheral, contrary, or outsider views were generally overlooked in the histories written before the 1970s.

Contemporary regional narratives: Unfinished Business or In Transition?

Historical claims rooted in the weary assumption of male genius are aggravatingly susceptible to resuscitation. *Unfinished Business: Vancouver Street Photographs 1955 to 1985* proposed the role of the photographer in those decades as primarily social; a roaming lens documented gentrification and captured everyday incidents in the urban landscape.[18] One

17 For example: Myrna Cobb, *Eight Women Photographers of British Columbia, 1860-1978* (Victoria: Morgan and Cobb, 1978); Marian Penner Bancroft, "The Photographs of Mattie Gunterman," in *The BC Photographer* (Spring 1975): 24-32; Laura Jones, "Rediscovery: Women in Photography," in *Photocommunique*, vol. 1, no. 4 (September/October 1979): 10-12; David Mattison, "The Multiple Self of Hannah Maynard," in *Vanguard*, vol. 9, no. 8 (October 1980): 15-19; Petra Watson, *The Photographs of Hannah Maynard: Nineteenth Century Portraits* (Vancouver: Charles H. Scott Gallery, 1992); Claire Weissman Wilks, *The Magic Box: Eccentric Genius of Hannah Maynard* (Toronto, Exile Editions, 1980); Claudia Beck, Helga Pakasaar, and Marian Penner Bancroft, eds., "Women Photographers of British Columbia," in *West Coast Review*, vol. 20, no. 1 (Special Issue/Summer 1985).

18 *Unfinished Business: Vancouver Street Photographs, 1955-1985* (Vancouver: Presentation House Gallery, 2003). Artists in the exhibit included Dick Bellamy, Michael de Courcy, Jack Dale, Christos Dikeakos, Fred Douglas, Svend-Erik Eriksen, Robbert Flick, Greg Girard, Fred Herzog, Curt Lang, N.E. Thing Company, Henri Robideau, Brian Stablyk, Bruce Steward, Jeff Wall, Ian Wallace, Tony Westman, and Paul Wong. The booklet, with essays by Bill Jeffries and Stephen Osbourn, was originally published in the January 2003 issue of *Geist* magazine.

19 The influence of Vancouver photography collectors Claudia Beck and Andrew Graft is considerable as noted in *Canadian Art*, vol. 21, no. 1 (Spring 2004): 62-65.

implication of the exhibition's premise was that the public sphere of the street, hence street photography, was basically the domain of the male gaze. The urban landscape, the curator ventured, served as the avant-garde origins of Vancouver's photo-conceptualism of the 1990s. Thus, giving rise to the now collectable and often cited Vancouver school of photography-based artists.[19] But is an artist's entry into historical narratives compelled solely by market viability or by well-oiled critical visibility? How does one explain the exhibit's absence of a senior photographer like Marian Penner Bancroft, visible in all varieties of photographic production from the 1970s forward? Eclipsing a social or political explanation for women's absence, the exhibit, in essence, resurrected the myths of masculine dominance of conceptualism and its evolution. Historical blindness regarding

women's access or exclusion from the photographic profession, or more generally from the public sphere, is not new and women in the field have created parallel environments to nest their production in social context. But what of historical accountability? Did women's absence indicate their lack of expertise or agency from 1960 to 1985, or is it an accurate reflection of women's diminished status within the rising phoenix of photographic modernism/conceptualism? How does women's absence in the archives, or in *Unfinished Business*, reflect on conditions of the industry, access to opportunity or mobility or, more generally, of the gender and race distinctions informing photographic professionalism? Historians must excavate beyond the surface.

The conceptual assertions made by *Unfinished Business* have been quickly upstaged by

20 Gary Michael Dault, "The Eleventh Hour in Photography," in *Canadian Art*, vol. 20, no. 1 (Spring 2003): 57-61.

21 Helga Pakasaar, *In Transition: Postwar Photography in Vancouver* (Vancouver: Presentation House Cultural Society, 1986), np.

a global crisis. Escalating awareness of the impact of corporate-headed globalization and industrialization on our environment and workers has directed audience sympathy towards the photographic realism of Ontario's Edward Burtynsky, to some degree displacing the staged theatricality credited to Vancouver's conceptual photographic artists. If this shift in attention enlarges the credence for the works of artists like Yoon and Penner Bancroft who persistently demonstrate the commitment of public intellectuals, the grandiose scale and sensationalism in the work of Burtynsky and photo conceptualist kingpin Jeff Wall exposes the economics of art-world socialism. The notable shift in scale from street photography detailed by *Unfinished Business*, to this contemporary monumentality reinforces the values of an international and national marketplace.[20] Photography has imposed scale and technological intimidation to negotiate its entry visa into the art gallery.

Another synthesizing exhibit, *In Transition: Postwar Photography in Vancouver*, likewise sought a canonical lineage, but the initial premise was thwarted by the diversity found in the archives. Seeking "image collections that expressed a distinctive personal style," the curatorial mandate necessarily was adapted in accordance with the "range of imagery — pictorialism, abstraction, advertising, photojournalism, and commercial reportage" issuing from commercial studios, amateur salons, and clubs and from fashion, news, and magazine photographers as well as by postwar aesthetic pictorialists.[21] Nevertheless, a faith in the ascendancy, and higher value, of aesthetic-based modernism over documentary and instrumentality inflects the tone of the introductory essay. During the postwar era, the breach between photography as art and photography as industry was consolidated. But what factors compelled this widening divide? If the (now canonized) pictorialists purposefully rejected the documentary realism or studio-based commercialism of their foremothers and forefathers, how did their interest in modern spaces, places, and subjects conceptually intersect, or disassociate, with the earlier, more instrumental concerns of colonial progress: industry, commercialism, ethnicity, and urbanism? But what economic, cultural, or political conditions guided postwar photographers to subscribe, or conform, to the tenants of modernism?

Did contrary ideas bristle against John Vanderpant's heralding of "the beauty of [photography's] inherent qualities — the playing with forms — tones — gradations."[22] The sin of the National Film Board photographers, according to *In Transition*, was didacticism.[23] With the NFB's ideology of the camera as a propagandistic social tool dominating the Canadian scene, receptivity towards art photography was obstructed nudging our nation's photographers towards illustrative, rather than expressive, uses of the medium. This inclination was compounded by an absence of pictorial periodicals equal to America's LIFE or *Picture Post*. Pictorialism flourished in the presumably more sophisticated United States where, "explorations into the self expressive potential of the medium blossomed." Canadian photography was 'in transition' until the 1960s when distinctions between "creative art photography and commercial work" finally materialized as a result of "an education system and market to promote the medium's aesthetic concerns."[25] More "serious amateurs" — Hugh Aikens, Percy Bentley, James Crookall, Ken McAllister — integrated abstraction but were less influential, credible, or ambitious than Vanderpant. These photographers gravitated towards collectives such as the Vancouver Camera Club, Vancouver Photographic Society, and the Camera Arts clubs with results classified as "essentially conservative kind of photographic experimentation." Collective action and amateur status conspired to undermine their secure place in the canon. Rather than gauge their "amateurism" in hierarchical terms with pictorialism as the pinnacle, why not apply the lessons of contemporary cultural activism to determine whether involvement in clubs or the rejection of fine art paradigms and venues was politically or economically strategic?

While another tenant of modernism is the denial of community and reciprocity, since the late 1960s, artist-run initiatives have generated opportunities unavailable from public museums and galleries: a national, and regional, phenomenon now harnessing historical investigation.[26] Canadian artists possess a capricious, and generational-specific, relationship with exhibition "spaces" that varied over time: from publicly funded formal or regional museums, to the artist-run, informal, and entrepreneurial venues inclusive of cyber and commercial space. With growing professionalization, initiated by university

22 Salloum, *Underlying Vibrations*, x.

23 Pakasaar, *In Transition*.

24 Carol Payne reconsiders the photographic output of the NFB against the agenda of nationalism. "Through a Canadian Lens: Discourses of Nationalism in Governmental Photographs of Canada, c 1858 to 2000," in *Canadian Cultural Poesis: an Anthology*, eds. Sheila Petty, Annie Gerin, and Garry Sherbert (Waterloo: Wilfrid Laurier University Press, forthcoming).

25 Pakasaar, *In Transition*.

26 For two significant overviews of west coast artist-run initiatives, see Stan Douglas, ed., *The Vancouver Anthology* (Vancouver: Talon Press, 1990), and Keith Wallace, ed., *Whispered Art History: Twenty Years at the Western Front* (Vancouver: Arsenal Pulp Press, 1993).

Fine Arts programs originating in the late 1960s as implied by *In Transition*, exhibition opportunities correspondingly diminished. Moreover, curatorial biases of the formal exhibition system — individualism, masculinity, whiteness — were increasingly contested. No longer was artistic activity assumed to emerge from isolated, or singular, vision; it was discursively informed by various influences including community, audience, and exhibition destination.

From the mid- to late-1980s, state support for culture and multicultural heritage has been eroded. The transformation from state support of culture to privatized, corporate sponsored philanthropy of neo-liberalism has not benefited artists who now compete in the "free" market. As earlier noted, the marketplace is reluctant to embrace risk and thus returns to well-rehearsed devices such as biography and celebrity. Non-conforming, less linear art struggles against success in this changed landscape failing some clever marketing ploy. Leonoff's appeal for increased public support for culture, expressed in 1990, now seems naïve given a political climate bent on the dismantlement of basic infrastructure for national and provincial archives, museums, and non-profit galleries. Yet, Leonoff's assertion that documentary photographs are intrinsically valuable in the face of rapid and often reckless suburbanization, urban renewal, post-industrialism, and gentrification is worth restating. Ironically, the market attraction for Burtynsky's photographs emerges from these very conditions.

If the conventions of mastery, prominent aesthetic movements, and chronologies of contraptions are no longer feasible for our national circumstances and experiences, how do we renovate? East and west, prairie and coastal, rural and urban, central and maritime, north and south, immigrant and indigenous, francophone and Anglophone, island and mainland — the many binaries and hybrids of identity and region press upon us. Sympathetic to the effects of social categories, and cognizant of the many historical, institutional, cultural, political, and linguistic distinctions splintering the nation, is synthesis possible? Or, how do we dissolve the hardened myth of a homogenous nation built by charismatic and capable pioneering Euro American men? One avenue to avoid heterogeneous chaos

would be to section, or compartmentalize, the nation by region. Individual sections could be assigned to "insiders" acquainted with the concerns of those regions or groups readily divulging regional disputes and distinct historical circumstances.[27] As Hans-Michael Koetzle determined, the manner in which we distinguish any image among the vast daily "deluge" or "torrent of data" is, beyond all else, "a phenomenological problem."[28] By inviting authors to personally select and interpret photographs placed in close proximity but not necessarily linked by theme, origins, iconic significance, or author, the exhibit and catalogue *Facing History* proposed one solution.[29]

Looking elsewhere

Contemporary Canadian photographers, *Faking Death* proposed, confront an exceptional state as "meaning takes place for the Canadian photographer in the space in-between two zones of reality." Artists strategically engage "the visions of both our own photography imagery and that produced outside the country."[30] Mesmerized, or inundated "by the cultural 'noise' of elsewhere" hence "deafened to the content and worth of [one's] own

27 Michel Frizot, ed., *A New History of Photography* (Koln: Konemann, 1998).

28 Hans-Michael Koetzle, *Photo Icons: The Story Behind the Pictures, 1827-1926*, vol. 1 (Koln: Taschen, 2002).

29 Presentation House Gallery, *Facing History: Portraits from Vancouver.*

30 Cousineau-Levine, *Faking Death*, 8.

31 Ibid., 4.

32 Ibid., 6.

voice," Canadians, stated Cousineau-Levine, evoking Atwood, Innis, and Frye, also contribute to the devaluation of their own culture.[31] Marginally placed, outside and inside Canada, contemporary artists in all stages of their careers face hurdles against recognition. Surely artist-run galleries, fêted by many Americans familiar with them, are a positive outcome of the depth of national cultural marginality? While economic solvency largely is unattainable to most, the need to survive dictates, or at least informs, the nature of the objects produced. The World Wide Web and the digital revolution stimulates revolutionary effects as national boundaries no longer constitute a restraint. In practical terms, cyberspace extracts the means of distribution from the fixed domain of galleries, curators, museums, and so forth offering artists active control over their representation. Thus for artists resident on the geographic margins, cyberspace promises liberation. If one is to aspire to international prominence, the conversations we engage must be broad and global in content and significance. How else might a spectator in Indonesia or South Africa engage?

While the "noise of elsewhere" may deafen Canadian artists and audiences to the value of homegrown production, discursive navigation across national boundaries, whether exclusive to Canadian artists or not, is progressive as Yoon and Penner Bancroft show.[32]

Drawing on the history and effects of her family's immigration from South Korea to Canada, Yoon explores hybrid, or hyphenated, identity.[33] Situating herself at the centre of the ever intense discussion over immigrant "departures and arrivals," the silence surrounding national discourses of citizenship are probed (p. 87). A personal point of departure assures that Yoon is not understood as a detached subject buried in dusty records or official documents, nor alienated from contemporary accountability as the "other." Portrayed is Yoon, a working artist/mother, or members of her immediate family inclusive of her children (p. 88). They stand defiantly before the spectator (p. 83). Yoon harnesses the multiplicity and historical conventions of the photographic gaze: the spectator's gaze; the subject's return gaze; and the internal gaze within the frame pondering the landscape. Looking simultaneously past and to the present, Yoon dislodges the well-cultivated myth

MARIAN PENNER BANCROFT, *On the road to Sagradowka, red cows introduced to the region by Mennonites (Ukraine)*, from the exhibition *By Land and Sea (Prospect and Refuge)*,1999, colour photograph, 86.5 x104.5 cm.

33 See the following catalogues or pamphlets on Yoon's work: *(In)authentic (Re)search* (Vancouver: Women in Focus Gallery, 1990); *Souvenirs of the Self (Postcard Project)* (Banff: Walter Phillips Gallery, 1991); *Touring Home: Jin-me Yoon* (Edmonton: Edmonton Art Gallery, 1991); *Jin-me Yoon: between departure and arrival* (Vancouver: Western Front Exhibitions Program, 1997); Shauna McCabe, "Visible Veneers: Jin-me Yoon's Touring Home from Away," in *Lost Homelands* (Kamloops and Charlottetown: Kamloops Art Gallery and Confederation Centre Art Gallery and Museum, 1999), 54-59; *Jin-me Yoon: Welcome Stranger Welcome Home* (Calgary: Glenbow Museum, 2002).

that national development was divorced from violent acts against individual men, women, and children. She evokes the multigenerational effects of regressive immigration laws and policies that have restricted who may, or may not, claim citizenship or fully identify as Canadian. Signaling both subtle and blunt tools of oppression, she wedges her own body between the viewer and national symbols of normativity.

Labouring across, and between, landscape and portraiture, Penner Bancroft's series *By Land and Sea (Prospect and Refuge)* similarly interpolates Canada's complex immigration history. She also questions whether, or how, the landscape of memory and ancestry structures contemporary personal or national disposition (p. 81).[34] A prominently placed official photograph stunningly reinforces photography's capacity to evoke national social history in tandem with family genealogy. The photograph, procured from the archives of the Canadian Pacific Railroad, depicts Mennonites bound for Canada boarding the S.S. Bruton at Libau, near Riga, Latvia, in 1923. Waiting to board are Penner Bancroft's father (a nine-year old child and minder of an uncased violin), her grandmother, then pregnant, her grandfather, aunt, and great grandfather (p. 76). Penner Bancroft's serialized portrait of immigration beckons one of modernism's celebrated photographic icons, Alfred Steiglitz's *The Steerage* of 1907. Lush and moody contemporary landscapes taken in Scotland and Ukraine rest calmly beside stark individual portraits—the family portrayed by frontal brutality; the landscape misty and romantic — to imbricate a Penner Bancroft family genealogy. The non linear *By Land and Sea* is literary and impressionistic as Fred Wah's collaborative response in the catalogue suggests (p. 92). Her mode of presentation vexes the dominance, or seeming immediacy or documentary legibility attributed to the iconic photograph, *The Steerage*. At the same time she generously revives the poignancy of Steiglitz's subject matter (and thus ignoring modernist disclaimers about content). Other contemporary British Columbia photo-based artists including Roy Kiyooka, Sharyn Yuen, Laiwan, Paul Wong, Henry Tsang, and Kiki Yee similarly wrangle with facets of nationalism and the historical traffic of people in the global diaspora citing official sources or family history to reclaim memory, official or personal.[35] Many of these artists, like contemporary

34 Karen Henry, *By Land and Sea (Prospect and Refuge)* (Vancouver: Presentation House Gallery, 1999); Claudia Beck, "Two Places at Once: Marian Penne Bancroft," in *Vanguard*, vol. 17, no. 6 (December/January 1988/89): 24-28; Claudia Beck, Helga Pakasaar, and Marian Penner Bancroft, eds., "Women Photographers of British Columbia," in *West Coast Review*, vol. 20, no. 1 (Special Issue/Summer 1985).

35 Paul Wong, ed., *Yellow Peril Reconsidered* (Vancouver: On Edge, 1990); Tamio Wakayama and Linda Uyehara Hoffman, *Kikyo: Coming Home to Powell Street* (Vancouver: Harbour Publishing and Powell Street Festival Society, 1992); *Gum San Gold Mountain: Image of Gold Mountain* (Vancouver: Vancouver Art Gallery, 1985).

36 David Neel, *Our Chiefs and Elders* (Vancouver: UBC Press, 1992); *Silver Drum: Five Native Photographers* (Hamilton, Ontario: Native Indian/Inuit Photographers Associations, 1986); Special issue: Museums and First Nations, MUSE vol. 6, no. 3 (October 1988); Gerald McMaster and Lee-Ann Martin, *Indigena: Contemporary Native Perspectives* (Hull: Canadian Museum of Contemporary Photography and Vancouver: Douglas & McIntyre, 1992).

indigenous artists who contest the psychic, political, and social segregation created by Canada's Indian Act, unearth latent, often controversial sentiments and beliefs that official histories prefer to bury or forget.[36]

Contemporary "art" photography may be more elusive or ambivalent in its intentions or motives than documentary photography of the nineteenth century; yet contemporary artists, like Yoon and Penner Bancroft, do not willingly divorce from the nation's past, nor photography's, but engage and revive the controversies of it while challenging the assumptions about photographic documentary as truth. Postmodern practices utilize and question the values and conventions of past photography, and antagonize cults of celebrity, individuality, and machismo, blurring the boundaries of what traditionally has constituted photography's history. The question of the artist's identity, how he or she figures as producer within the work and how s/he is erased or visible in the nation or the marketplace, emerge. Individual artists strategically expand discursive horizons, affirming that creative innovation depends on many influences and voices.

Ignorance is perilous

Cyril Leonoff reminds us that ignorance of history is perilous. Asserting respect for the social value of photographs and their capacity to signify, he emphasized the photograph's object, as well as its representational status whereby as artifacts photographs represent subjects — things, persons, or places — that photographers, professional or amateur of each era, believed noteworthy. By embodying the interests and identities of their makers at a unique point in time, and within regions that have particular histories, the photograph reproduces social, cultural, and political agency. The surviving object which outlives its producer simultaneously conveys history and is an expression of imagination. Might we evaluate the impact of regional social, political, and economic history on the vocabulary of contemporary photographers or must we always fully concede to theoretical ideas from elsewhere to validate what happens here? Must art be adverse to history?

Objects of Desire: The Photo Art of William Eakin

Robert Enright

A Desirable Feast

Photography is a way of conducting yourself responsibly.[1]

For William Eakin, photography is a combined act of memory, re-interpretation, and recovery. Throughout various bodies of work spanning more than two decades, he has exercised an undiminished capacity to transform objects of neglect into objects of desire. I can't help but apply Roland Barthes's notion of the pleasure of the text to Eakin's ongoing photographic project, and to reconfigure it as the pleasure of the object, and from that to the pleasure of the image. In taking delight in both the things that make up his pictures and the process of picture making itself, Eakin is doubly pleasured. He experiences the bliss of incorporating both subject and subjectivity. Much of his practice has been in the area of vernacular photography, a type of picture making that relies on a sense of what an object has meant in order to realize what that same object can mean in its re-interpreted form. At the centre of Eakin's transformative aesthetic is the activity of collecting and the actuality of desire.

The Collector

I don't collect things that I don't know anything about personally and directly.

William Eakin is a collector and, like all hunters and gatherers of this sort, he is obsessed. He began collecting hockey, baseball, and special interest cards as a child:

The first ones I was passionate about were called "American Civil War News." They were amazing; very lurid paintings of battles and incidents during the American Civil War, like a rebel soldier falling into a pit of spikes and the spikes going through him. They came with bubble gum and a little piece of Confederate money printed on currency paper. To a kid it was like real money and I would simply tremble. Today they're very expensive and highly collectible because none of that ephemera survived.

Collecting is an activity he continues today and he makes an integral connection between it and his artistic production, a connection that was retrospectively evident in his childhood collecting. "I derived a lot of pleasure from these bits of paper, constantly shuffling through

WILLIAM EAKIN, *Bottle Cap* (Lucky), 2001, pigment ink-jet print, dimensions variable.

97

IMAGE AND INSCRIPTION

[1] All quotations from the artist, both in epigraph form at the beginning of each section and in the body of the essay, are taken from three interviews with the writer. The first two were published in *Border Crossings*: "Collecting Moments of Light," vol. 8, no. 2 (March 1989): 21-8 and "The Pleasure of Looking: The Photography of William Eakin," vol. 24, no. 2 (May 2005): 58-71. The third interview is unpublished and was conducted by the author on August 14, 2005.

2 Jean Baudrillard, *The System of Objects*, trans. James Benedict (London: Verso, 1996), 86.

3 This movement between object and subject is a critical see-saw in photographic criticism. In *Camera Lucida: Reflections on Photography* (New York: Hill and Wang, 1981),14, Roland Barthes writes that "the Photograph represents the very subtle moment when, to tell the truth, I am neither subject nor object but a subject who feels he is becoming an object." In Eakin's case, there is an equally subtle transformation occurring, but it has a trajectory opposite to Barthes's. For Eakin, the object is becoming the subject. His process is a form of aesthetic parthenogenesis: the subject of the photograph and the subjective photographer end up being one and the same.

4 These single bodies of work were written about with grace and insight by Meeka Walsh and Robin Laurence in *Ordinary Art*, the catalogue for the Saint Norbert Arts Centre residency, (St. Norbert, Manitoba: snacpress 2000), unpaginated.

5 Geoffrey Batchen, "Vernacular Photographies," in *Each Wild Idea: Writing, Photography, History* (Cambridge: MIT Press, 2001), 56-80.

them, laying them out, and rearranging and categorizing them. Those kinds of ideas were my first art making and creative impulses." It is important to understand the critical relationship that exists between collecting and art-making in Eakin's practice. Simply put, when he takes photographs he feels he is collecting images; in this sense photography is a manifestation of the same impulse that compels him to collect objects. In determining what to collect and how to photograph them once they are in his collection, he exercises the same discrimination that characterizes his aesthetic choices.

In *The System of Objects*, Jean Baudrillard argues that "what is possessed is always an object *abstracted from its function and thus brought into relationship with the subject*."[2] In this reading, the object becomes the basis for a system in which the collector can articulate his subjectivity. This is the sense in which Baudrillard claims that, ultimately, the collector collects himself. His analysis of the closeness between self and object is useful in comparison with Eakin's implicit understanding of their relationship. Baudrillard goes on:

An object no longer specified by its function is defined by the subject, but in the passionate abstractness of possession all objects are equivalent. And just one object no longer suffices: the fulfilment of the project of possession always means a succession or even a complete series of objects. This is why owning absolutely any object is always so satisfying and so disappointing at the same time: a whole series lies behind any single object, and makes it into a source of anxiety.[3]

Certainly Eakin would agree with the equivalence of the objects in his numerous collections, but he has found a way to minimize the disappointment that Baudrillard argues is the unavoidable fate of the collector. Eakin is assuredly passionate but not about filling in the blanks in his collections; his is not an obsessive search for the complete collection but an intense enthusiasm for each object he collects. His is never the perfect collection, but he is the perfect collector. This is in large part due to the fact that he operates like an artist (he regards taking pictures as another kind of collecting) and not as someone who wants to possess things. His affection for his objects is less about ownership than a kind of objective companionship, and comes from a recognition of how these objects can be

rehabilitated, even how they might be anthropomorphised.

Viewers were able to see the range of Eakin's collections in an Open Studio residency and exhibition programme that took place over four months in the summer of 2000 at the Saint Norbert Arts Centre (SNAC) south of Winnipeg. Eakin moved his collections from his downtown studio to the gallery space at SNAC and became a kind of artist/curator/archivist, actively working with his myriad objects to produce what amounted to a continuous series of overlapping installations and exhibitions focusing on one or more of his collections.[4] He worked on his cookie tins, his paraphernalia from Niagara Falls; his paintings, figures, and objects on the subject of bullfighting. He photographed Tibetan Skeleton Dancers and opera performers who were in residence at SNAC, and even did portraits of the centre's staff dressed up as matadors. The collection is an eclectic mix but characteristically, one kind of image crosses over into the frame of reference of another; Mao buttons sit on images of tauromachy; a toreador fights a plastic bull superimposed on a view of Niagara Falls; a floral cookie tin lid matches intense colour with the radiant costume of a Skeleton Dancer. Because he only keeps things that are personally meaningful, his collection is not systematic. In the true meaning of the term — that it is off-centred — his collecting is eccentric.

What is evident is the personal dimensions of his process and the need for the objects he chooses to be (whether talismanically or psychically) "touching." This drift into the terrain of the talismanic is one that has been well documented by Geoffrey Batchen in his lengthy consideration of the nature of vernacular photography.[5] For Batchen, the photograph is inescapably haptic, an appreciation of the image that shifts its meaning and operation into the domain of the personal.

Docu-memory

In part my work is fiction. It's not documentary. It's a world that I invent.

There are shaping moments in an artist's life and William Eakin is no exception to this kind of epiphanic recognition. His came in 1971 when he was studying at the Vancouver

WILLIAM EAKIN, *Night Garden,* 2000, pigment ink-jet print, dimensions variable.

WILLIAM EAKIN, *Night Garden,* 2000, pigment ink-jet print, dimensions variable.

School of Art (now The Emily Carr College of Art and Design). Eakin admits that while he was committed to making pictures, he was naive about the possibilities the medium offered. He was fortunate in having Jim Dow as a visiting professor in Vancouver that summer. Dow, who taught at the School of the Museum of Fine Arts in Boston, was one of two photographers hired to print the images for the landmark Walker Evans retrospective at the Museum of Modern Art in New York in 1971. Evans was near the end of his life and had become sensitized to the chemicals and so the exhibition curator, John Szarkowski, enlisted the support of Dow and another photographer to produce the images for the MoMA exhibition. Instead of money, Dow was able to keep a single copy of each photograph he printed, and he brought the portfolio with him when he came to Vancouver. The effect on Eakin was revelatory:

They were eight- by ten-inch negatives and contact-printed and I'd never experienced quality like that. I was especially sensitive to the vernacular, which was so central to Evans's art-making. I could understand how one could make photographs using that content as a starting point. Jim Dow also had a deep interest in the vernacular, so I was very lucky to meet someone who was dedicated to that kind of photography.

The other contemporary photographer whose work Eakin became aware of was Robert Frank. (Dow showed slides from *The Americans* during the summer course and it was the first photography book Eakin bought). The publication of *The Americans* in 1959 changed photography forever. In its famous introduction, Jack Kerouac praised Frank as a "great artist in his field"[6] because with his camera "he sucked a sad poem right out of America onto film, taking rank among the tragic poets of the world." Kerouac's rhythmic adulation of Frank's achievement was right for the wrong reasons, and it solidified a way of reading Frank's photographs that was difficult to get around. It is generally understood today that *The Americans* was as much about the photographer as the people photographed; that Frank's own sensibility was shading everything he shot. As a Swiss Jew in a hostile America, he was a stranger in a strange land and the images he gathered on his trip across America have a darkness and sense of unease that was there for the finding but that also

6 Robert Frank, *The Americans*, introduction by Jack Kerouac (New York: Aperture, 1959), 5.

suited Frank's personal disposition. Kerouac described "the HUMOUR, the sadness, the EVERYTHING-ness and American-ness of these pictures!" Had he said "the FRANK-ness of these pictures," he would have been closer to their power.

For Eakin, it was the autobiographical trace running throughout *The Americans* that was so compelling and explains why Frank was his most important influence:

The fact that no-one perceives the same reality clearly emerged in his work and what I came to be interested in exploring was the degree of shared reality. When I was young I thought other people had lives and then I woke up to the fact that I did too. That was the turning point and Robert Frank showed me that.

You can trace the personal influence even in Eakin's more conventional documentary work, like the photographs he took in China in 1986 and over the course of his trips to Baker Lake as the fine arts advisor to the Sanavik Co-op. In Nunavut, he took tributary portraits of the Inuit community with which he was involved and of the landscape in which he was living. These portraits were published under the poetic title, *Where Distance is Measured in Time*. In China, he admitted to being bewildered twenty-four hours a day. "It was like being a tightrope walker with a balancing bar. The camera allowed me to keep my balance. The subject of the Chinese photographs was keeping my balance in an unsettling, unfamiliar, and disturbing situation." Eakin's description of being in China is close to the way Robert Frank interpreted his journey through an America that was no less unfamiliar and disturbing. When Eakin says that Robert Frank showed him how, he means it, and he gives us ocular proof as evidence.

Pairings and Linkages

Photography is all about selection and detail. Telling details are important.

At the centre of Eakin's practice is a reputable tradition of reclamation moving towards transformation. This change occurs not through an individual object being tricked into some other meaning, but by an accumulated significance, as bodies of work alter and shift the meaning of aggregate pieces within them. In this sense, he remains a conceptual

photographer who constantly looks for new ways to connect images and series, one to the other. Occasionally, these combinations result in a minimal narrative, a predisposition that might have been encouraged in his many years working in the film industry, including a stint as a film editor. But the economy of Eakin's expression corresponds to a poetic rationale more than a narrative one, and the way he combines images has more in common with the metaphoric resonances of poetry than the linear echoes of conventional storytelling. In *Strange Attractor* (1989), he combined three disparate images, often mixing flowers, man-made things, and toy guns. They ended up being bizarrely charming tableaux, in which a human hand holds a toy gun made in mainland China, next to a close-up of a vegetable or a flower, which in turn is next to an even more tightly focused scenario of musical monkeys made from pussy willow bodies and insect heads. The series was named after the mathematics of chaos where a strange attractor is a chaotic system that has an actual structure. In naming his body of work, Eakin was claiming for it a readable interpretation.

That said, the photographs in this series have a perplexing legibility. At first glance, the connections among the three disparate series of images are not readily apparent. In this sense, they function differently from constructivist methods of composition, like collage and montage, in which the component parts assume an accumulated meaning. In *Strange Attractor*, Eakin arrives at meaning through association. While these associations never have a literal connection, they add up to a disjunctive poetic, which operates through implication and suggestion rather than declaration. The components he uses, often fragments of other images, accrue meaning in areas between the conditions of their existence and in order to read them, we are obliged to make the overlapping associations from object to object. These are not *made* connections in a constructivist manner; they are affiliations that have to be imagined and, in this regard, they remain resiliently abstract.

In *Home Sweet Home* (1995), Eakin exhibited a dozen chromogenic prints in diptych form that suggested a less chaotic series of associations. The exhibition and catalogue were produced by the Southern Alberta Art Gallery in Lethbridge and it remains one of Eakin's most satisfying shows.[7] Eakin relied on a range of connective tissues to hold together his

7 *Home Sweet Home* was on exhibition at the Southern Alberta Art Gallery from December 9, 1995 to January 21, 1996.

two-part structure. In one pairing, a photograph of the moon with the coordinates for all the American satellites comprises one half of the image, while on the right-hand side, a lawn bowler from his *Monument* series flashes the ball across the bottom of the frame, as if it were a fast-moving planet. What is disconcerting is that the strap on the man's hat makes him appear to be wearing a mask. Suddenly, play is about something else; and moons are about power. The photograph of a decorative plate with a still life design (it looks like a failed attempt to mimic a painting by Georges Braque) is compensated for by a swishy plate on the right showing a woman dancer who could give Michael Snow's *Walking Woman* a run for her iconic money. Or a small button in a wide expanse of black saying "I Love You Mom," is balanced by an adorable painting of a boat (it looks suspiciously like Noah's Ark) that puffs away towards Niagara Falls. These combinations are irresistible and richly suggestive. Because they are invested with so much meaning, when Eakin moves things around, ideas end up being in flux as well. In these simple, resonant couplings, he comes close to the compression Emily Dickinson was able to achieve in her packet poems in which very little counts for an amazing amount. For both Eakin and Dickinson, less is more. In her poetics, the substitution of one word for another dramatically changes the meaning of the poem precisely because so few words are at play in the compositional field. Similarly with Eakin the impoverishment — in number, utility, and aesthetic appeal — of the objects he chooses to include in his images allows them to assume a significance disproportionate to their singular meaning. Eakin's project, then, is one of individual and interstitial reclamation.

Scaling the Depths

I learned fairly early on that scale is one of the rich resources in photographic image making.

Monument is the most popular series of photographs Eakin has ever taken. Comprised of 24 images, they were all produced using a pinhole camera and Polaroid Type 55 positive/ negative material. The subjects are figures from 1940s and 50s sporting trophies and the

WILLIAM EAKIN, *Home Sweet Home* (diptych), 1994, Kodak Duraflex prints, each 76.2 x 106.7 cm.

103

8 After its initial exhibition at the Canadian Embassy Gallery in Tokyo in 1998, *Monument* circulated to public galleries in Winnipeg, North York, and Waterloo.

9 The title of this body of work was a reference to the all-night drive-ins which used to be staple entertainment throughout the prairies.

images are large and dramatic. The series also represents the first time Eakin had used a pinhole camera. "An attribute of the pinhole is that everything is in the same relative focus and the figures are four or five inches tall, so I knew I could get right into their space to try and animate them. With the bowler, the bowling ball is actually touching the front of the box of the camera." Eakin would do two or, at most, three figures a day, taking as many as six photographs before he arrived at one he felt was sufficiently animated. In *Monument*, you can see how much consideration he gives to composition. The way that the figures define the space they occupy is flawless; the weightlifter's barbell moves out on either side of the frame; a basketball player embodies a perfect attenuation; the archer's bow curls back towards his body and situates him statuesquely in the corner of the composition; the thigh and knee of the majorette is pneumatic in the way they pump into the foreshortened

space of the image. Even the objects handled by the figures are brought into aesthetic play: the distorted golf club, the monstrous left leg of the skater and the beautiful, foregrounded weight of the ball which the bowler is about to throw. What Eakin has been able to do in this series is to take emblems of modest achievement and amateur accomplishment, and literally reconfigure them in a monumental space. One of the most charming ironies of this series is that the publication accompanying the exhibition in Japan was a book measuring only nineteen centimetres in height, while the actual images are 101.6 by 127 centimetres. What is remarkable is how well the images hold up to the substantially reduced scale of the book. Even when they're small, the *Monument* photos read big.[8]

They also read in a manner that departs from their origins inside the context of amateur photography. While Eakin has affection for the objects he chooses to photograph, and an abiding appreciation of their aesthetic aspirations, he realizes that they don't always get what they want. He himself is not an amateur photographer, so that while he chooses to work with simple, even primitive, cameras and techniques, the pictures he gets from these processes are rigorously reasoned and produced in a way that is anything but amateur.

The Alienator

We just don't understand why things are mysterious until we set them down and meditate on them.

I mentioned earlier that Eakin has always been sensitive to ways in which he might recombine his photographs, either image to image or body of work to body of work. This is partly a product of being receptive to any visual and thematic resonances that might emerge from the work, and it is also an indication of the operation of a unified sensibility, in which ideas percolate for extensive periods of time. In a body of documentary work from the late nineties called *Dusk To Dawn*, he concentrated on photographing roadside attractions, amusement parks, and sideshows.[9] Among the images included in this series was a photograph of the back seat of a car taken in the Winnipeg Convention Centre in 1979. The photograph is seven-inches-square and it shows the back seat of a vintage car taken

WILLIAM EAKIN, *Monument* **(weightlifter), 1994-95, Fujiflex crystal archive print, 101.6 x 127 cm.**

WILLIAM EAKIN, *Monument* **(bowler), 1994-95, Fujiflex crystal archive print, 101.6 x 127 cm.**

when he stuck a camera in the open back window and "shot from the hip, so to speak." Eakin was using a 126, what he describes as "a very cheap camera, a toy really — it was the snapshot camera of the 60s — and I was working with it because, like my subject, it was out of time." What the picture shows is the ceiling and side of the car interior on the passenger's side; the back seat is covered in a rough blanket and the visible interior sections are stained from water and age. On the left-hand side, you can see only a portion of one of the small, rounded windows that were common in older model cars (Eakin thinks it is a Pontiac). His initial impulse in photographing a back seat was "to conjure up memories of being a child, groggy with the heat of a road trip where you've been reading comic books, or as a teenager when you might find yourself in the back seat with an object of desire."

The image also delivers all that with an added, unintended bonus. What is also visible is three-quarters of the car's rectangular, soft-edged rear window. In contrast to the monochromatic, close-valued light grey of the back seat, the space outside the window is black, and from it emerges eight points of elliptical white light. Three of them on the left hover around what appears to be a distant planet and the points of light, inescapably, look like spaceships that are about to land. They are actually the sodium vapor lights in the building, which Eakin didn't know would be in the composition when he took the picture. But the resulting image is a classic example of a methodology that combines instinct, intention, and accident, an approach Eakin describes as "being willing to accept chance and embrace what happens when you do that."

My point in describing this photograph is to connect it to work that would later occupy Eakin's attention for a period of more than eight years: his spaceship and alien photos. The "inauspicious beginning" of this project occurred when a number of his artist friends hurled day-old donuts into the air in Lethbridge, Alberta, while Eakin tracked and photographed them. The origin of these staged sightings was a tongue-in-cheek declaration that he could come up with alien encounters that would be every bit as convincing as the crude hoaxes in a UFO sightings book he had been shown the day before. From day-old donuts Eakin moved to disc-shaped objects that included a dog dish, a perogy maker, lids, and an

10 *Have a Nice Day* includes a fictional piece by Andrew Hunter, who was then the artistic director of The Saint Norbert Arts and Cultural Centre, and a short but excellent introduction by William Eakin himself where he explains the source of the *Alien* photographs.

assortment of pots, all bought at a Winnipeg Goodwill thrift store. The photographs that resulted are endearingly awkward, as credible as the majority of claimed sightings, which is to say they have no scientific credibility at all. But as images that enter the aerial dance of popular culture and folk belief, they are utterly convincing.

They were also the point of departure for Eakin's inquiry into the labyrinth of newsprint publishing. The UFO magazines he found had low production values, but he interpreted the photographs as having a distinctly artful cast. "They looked like Warhol." When he discovered niche magazines — outlaw biker chicks, true crime, boxing, and hunting — "the collector in me took over" and he began the process of linking these themes to ufology. He made four large collages from this low-tech potpourri; they were deliberately crude because he "wanted to celebrate everything that digital technology isn't: the mark making and the hand-built quality." He rejected the seamless collaging possible with Photoshop for what might be called the seamy collaging that took its tone from his popular magazine sources. The collages were never intended to be the end result, rather they were meant to be "a contact field" from which he could pull images.

A number of these hybrids were included in *Have a Nice Day*, a bookwork published by SNAC in 1999.[10] In one, a hunter crouches in a field behind a huge bale of hay, his binoculars angled in such a way that he misses entirely the flying saucer scurrying overhead in the sky; in another a fifties husband and wife stroll on the grounds of what looks like a palace, unaware that a huge flying saucer is training a beam on the woman who clearly will be "space-napped." On the right hand side, a biker chick lifts her T-shirt to expose a single breast. It is an artful flash, for both the woman and Eakin; the space defined by her arm bending back at the elbow describes the shape of a spaceship, and her hardened nipple stands in, and up, for a miniature flying saucer. Eakin's close looking seduces us into an equivalent act of attentiveness; the harder we look, the more imaginative our gaze becomes, and the more possibilities emerge from that apprehension. These works are about the way a free-wheeling, associative mind sifts through imagery. We see more than we think we see because Eakin's method is essentially poetic.

Have a Nice Day also contains a number of the images from another body of space work Eakin shot in 1999. *Alien Nation* consists of as many as two dozen large pinhole portraits, the subject of which are alien creatures with large, bulbous eyes and ethereal bodies. Most of them are photographs of miniature American plastic toys and of plaster copies of those toys made in China. Sometimes the images are grotesque; at other times they are heartbreaking, occasionally even frightening. When the negative tore on one image with particularly bulbous eyes — it looks like a monstrous fly's head — Eakin took advantage of the accident and produced one of the most powerfully eerie images in the series. In another, the worried introspection of an alien is endearing; one creature wears a space suit with a high collar that could have been designed for an anorexic Elvis Presley. There are even aliens whose forms are so overexposed that they move towards disappearance, seeming to he headed for a "spacey" version of what Emily Dickinson was referring to when she called death "the white exploit."[11] *Alien Nation* is a superb body of work, the emotional impact of which far exceeds our expectations for the source material. Eakin is something of an alchemist in work like this, transforming quotidian, even debased objects into presences of haunting and strange beauty. He wants to capture what he calls the "spark of dignity" in the things he photographs. Eakin's relationship to the look of his

11 Emily Dickinson, "Those who have been in the Grave the longest," in *The Poems of Emily Dickinson*, vol. 2, ed. Thomas H. Johnson (Cambridge: The Belknap Press of Harvard University, 1951), 674.

12 *My Father's Garden* was on exhibition at the Winnipeg Art Gallery from September 15 to November 3, 1985.

WILLIAM EAKIN, *Have a Nice Day*, 1996, Fujiflex crystal archive prints, each 101.6 x 127 cm.

WILLIAM EAKIN, *My Father's Garden*, 1983, gelatin silver print 40.6 x 50.8 cm.

pictures is complicated. His early introduction to the clarity of images by Walker Evans and Robert Frank was subsequently qualified by his awareness that different subjects required different treatments, not just in the kind of camera he would use but in the way the images needed to look. Eakin has a special sensitivity to the relationship between style and content, and to how certain subjects can not only tolerate a less fastidious treatment, but even demand it. His is a form of quotidian connoisseurship.

Death and the Midden

There is an edge to my work and that's the place where I want to be. I think of it as a place of vital health only a step away from darkness or despair.

Between the first frost and the first snowfall in the late fall of 1982, Eakin took a number of photographs in a garden near the Winnipeg International Airport. The photos were taken just at sunset, a time the photographer refers to as the "magic hour." During the period he was photographing, Eakin was also visiting his hospitalized father who was suffering from an untreatable illness. Two months after Eakin finished the series, his father died at home.

The black-and-white images are shot at a very close focal point with the camera aimed towards the earth. The stalks have withered and the vegetables have been largely picked over. There are snapdragons, cabbage, bell peppers, a squash half submerged in the suffocating and collapsed earth. A scatter of onions — bulbs and stalks — could be the site of a spider massacre; cabbage leaves have holes that make them look like slices of Swiss cheese. There is a certain poignant desolation about this body of work, which remained undeveloped for an entire year. It was finally exhibited at the Winnipeg Art Gallery in 1985. In the oversized catalogue for *My Father's Garden*, Terrence Heath, the gallery director, responded in poetic form to Eakin's sequential collection of fifty-five memorial photographs. "This is not the garden I had in mind / I was thinking of perfections and paradigms."[12] Heath's poem is an intelligently fragmented parallel to the decaying garden and its elegiac subject. This body of work may be about death, but it is not macabre. Among the photos

WILLIAM EAKIN, *My Father's Garden,*
1983, gelatin silver print (paper but not
bromide) 40.6 x 50.8 cm.

WILLIAM EAKIN, *Reunion,* 2001,
pigment ink-jet prints, dimensions
variable.

OBJECTS OF DESIRE | ROBERT ENRIGHT

is an image of the outside leaves of a cabbage and the beginning of another interior leaf. The latter curls down as if it were showing us the form of an organic version of the *Winged Victory*, from the back of which lifts a leafy wing. If every blade of grass proves there is no death, then every cabbage leaf has its equivalent transcendence in Eakin's memorial garden. "You have fooled me into a significance / I had not thought of — I wanted a cliché," Heath writes. Earlier the poet had lamented that Eakin's photographs were too prairie, in that they brought him back to "too many inadequacies." They also bring the viewer back to the life-in-death cycle exemplified by the garden.

It would be almost twenty years before Eakin would again confront the image of death, but this time he would reverse the process; in *My Father's Garden*, the decaying vegetables were a symbolic way of representing death. In *Reunion*, a series of photographs he took in a Roman Catholic cemetery in Venice in 2001, he looked directly at death's face but managed to pull out of that eye-to-eye confrontation something paradoxically hopeful. The range of the images in Reunion correspond to the stages of human corporeal existence, from full presence to almost complete obliteration.[13] Eakin was in Venice because his wife, the artist Wanda Koop, was installing a combined painting and video installation in the Arsenale. To escape the intensity of that process he went to the cemetery, probably one of the few quiet places in Venice during the Biennale. "I needed a break from the Giardini and the cemetery is the only other park open to the public. I saw these photographs set into the headstones — I'd seen them before in the Ukraine — but in Venice I understood their potential for the first time. I started collecting them with my camera, just pulling details out of the actual source, which was either enamel or tin." Eakin was attracted here, as he had been elsewhere, to images that reflect a beauty leeched out of the natural process of decay. What became clear is that his specific sense of what constitutes an object of beauty was not shared by many people. "I didn't find it frightening or dark or ugly and was actually surprised when people found them disturbing. I collected the range of images: from those that were just touched to those that were, for all intents and purposes, gone. They're just like us."

13 *Reunion* was published by Gallery 1C03 at the University of Winnipeg in 2003.

14 Meeka Walsh, "A Promise and A Rose Garden: Containing Photographic Truths," in *Ordinary Art*, ed. Amy Karlinsky (Winnipeg: Saint-Norbert Arts Centre, 2000), unpaginated.

There is something unmistakably haunting about these portraits. They are themselves a record of distancing from source, since Eakin had no direct connection with any of them. They are photographs of photographs attached to headstones involved in a process of weathered disintegration. Eakin had used a similar complicated conceptual frame in the images that became *Night Garden* (2000). With his cookie tin lids, he "photographed a photograph that already existed in form on the artifact," a layering that Meeka Walsh neatly summarizes as "a conceptual and referential *mise en abyme*."[14]

The effect of his "abyme" work in *Night Garden* is to raise thirty-five cookie tin lids to the level of the cosmological (p. 98-99). In Venice, his layered distancing created a delicate intimacy, turning the images into emblems of life's fragility and its inexorable immateriality. What *Reunion* draws our attention to is that these figures, even when specific and well defined, are *tabula rasa* on which we press meaning and emotion. Eakin's images encourage our romantic, even gothic, side. If the images weren't so beautiful in their various stages of dissolution, they'd be unsettling; but Eakin refuses to push into those darker corners.

In *Camera Lucida*, Barthes posits that the photograph "always carries its referent with

itself, both affected by the same amorous or funereal immobility, at the very heart of the moving world."[15] Eakin's art has much in common with this assessment of the nature and meaning of photography, especially his self-referentiality and his susceptibility to the seductions of Eros and Thanatos — what Barthes succinctly categorizes as the amorous and the funereal. But I don't want to suggest that there is even a hint of aesthetic necrophilia in Eakin's approach to his photographed "markers" of death, whether they're composed of vegetable or stone. What he achieves in his conjunction of care and termination is something closer to elegy; it is not morbid but celebratory.[16] The object photographed for Eakin partakes of a certain immortality precisely because it is uncompromisingly about its *thingness*. If William Carlos Williams pronounced there are no ideas but in things, Eakin would say there are no images but in objects.

In his most recent body of work, *Ghost Month* (2004), he has again returned to objects that have a direct connection to a ritual surrounding death. The series is comprised of photographs of offerings made by living relatives to their dead ancestors. When the effigy of the object is burned on a recognized ceremonial day, the belief is that the ancestor receives the gift in the afterlife. Eakin bought paper replicas of implements of communication — electronic keyboards, movie cameras, computers, and ghetto blasters. While cheaply produced, these paper objects are relatively expensive to buy; otherwise there would be no sacrifice. Eakin's photos of the *Ghost Month* objects are tidy and bright-looking (they look like unfinished versions of commercially produced Thomas Demand's) and are part of an extended vernacular object language. But in this series, he has given death and the feelings associated with it a decidedly upbeat look; the *Ghost Month* photographs underline that the only sting death has is when the pop star of the same name sings to the ancestors through any one of their new gifts.

15 *Camera Lucida*, 5-6.

16 Ibid., 119. The connection between death and emotion is one that concerns Barthes as well. As he negotiates the terrain of emotion around the photograph of his mother, Barthes searches for a proper description of what he is feeling — pangs of love or pity. Eakin deals with his father's death through the textures of a surrogate garden, but the emotions of loss and recovery are similar. Both deal with what Barthes characterizes in the final line of *Camera Lucida* as the "intractable reality" of being alive to our shared humanity.

Vernacularisme

I have thousands of photographs of vernacular objects, but only a handful make their way into exhibitions and those are the ones that are touching.

In 1980, Eakin shot his tribute to Niagara Falls. *Mighty Niagara* is a high water mark in his work with the vernacular. "Niagara Falls was two things for me: there's this incredible natural phenomenon, and then there's all this commercial kitsch that's grown up around it. It was the kitsch I was after." In the beginning, Eakin was firm in his commitment to get at the place without documenting its natural beauty; as a result he took no pictures of the Falls themselves, insisting on working within his self-imposed "ironic set of brackets." Even though he ultimately determined that landscapes were permissible, he found the Niagara Falls that interested him was something he was more likely to get through details, which he discovered in a corner of a local gift shop. "Everything was scratched, broken, or dented and everything was a buck." Eakin bought a shopping bag full of these shards and they became the objects he photographed close up for the *Mighty Niagara* body of work.

Broken souvenirs, as the embodiment of "mighty Niagara," was one way of walking the delicate line "between bad taste and exquisite sensibility" that was Eakin's operational frame. But in his *Bottle Cap* series, he found objects at their most abject (p. 114). His first bottle caps were rusted and tossed off pieces found in the streets of Winnipeg. "Montréal and Winnipeg are the best bottle cap towns in Canada. Montréal because you can buy beer in any grocery store on any corner and Winnipeg because no one gives a shit, so they drink anywhere — in their cars, in parking lots. It's unbelievable." Eakin's collection of bottle caps developed because he was "involved with entropy and I really liked the rust and how the image dissolved." Then he was sent a large collection of new European bottle caps, and since then he has begun to collect antique caps on his own, paying as much as ten dollars for Celery Cola. "Vegetable cola probably wasn't the greatest idea, but the cap is apparently very rare."

WILLIAM EAKIN, *Ghost Month* (radio), 2003-2004, pigment ink-jet print, dimensions variable.

WILLIAM EAKIN, *Ghost Month* (television), 2003-2004, pigment ink-jet print, dimensions variable.

WILLIAM EAKIN, *Ghost Month* (video camera), 2003-2004, pigment ink-jet print, dimensions variable.

WILLIAM EAKIN, *Ghost Month* (stereo), 2003-2004, pigment ink-jet print, dimensions variable.

WILLIAM EAKIN, *Bottle Cap*
(Love), 2001, pigment ink-jet print,
dimensions variable.

WILLIAM EAKIN, *Bottle Cap*
(Lemon), 2001, pigment ink-jet print,
dimensions variable.

WILLIAM EAKIN, *Bottle Cap*
(Uptown), 2001, pigment ink-jet print,
dimensions variable.

17 Robert Enright, "The Pleasure of Looking: The Photography of William Eakin," in *Border Crossings*, vol. 24, no. 2 (May 2005): 60.

* * * * *

I am indebted to Robert Bean for a number of insightful suggestions that significantly improved this essay and to Katy McCormick at Gallery 44 whose patience and encouragement supplied the time and attitude to allow those suggestions to take form.

We read the photos in the *Bottle Cap* series in various ways, often with a gentle twist of irony. One called "Lucky" has undergone an existence that betrays its name; it is rusted and the Lager part of the cap is obscured and worn away (p. 96). The star is tarnished and, over time, the black and white lettering has lost its punch. Or consider the ornate script for Old Vienna beer spelling out LOVE (the idea of capping a bottle that contains love is, in itself, a delicious notion). These objects embody a pared down, corrupted poetry. They give us just the right amount of information to provoke a reaction to their short-form message. We invariably make more of them than they have made for themselves. This deliberate minimalism is consistent throughout Eakin's work over the last twenty years. His is a reduced phenomenology in which appearance and experience get elevated to a kind of inexplicable poetics.

In *Border Crossings*, I have referred to Eakin's "object anthropomorphism,"[17] and it still seems a useful phrase to describe his uncanny ability to coax out of inanimate objects a telling measure of humanity. Or put more accurately, we display various degrees of humanity in the ways we respond to these objects. They are mute examiners. By their very presence in Eakin's work, they oblige us to respond. For his part, he plays the role of Prospero in a neglected kingdom; he is a thrift store alchemist, an archaeologist of the marginal, not so much unearthing a lost civilization as focusing our attention on one that has been abandoned. But with William Eakin on the prowl, nothing insignificant is left in the dust. "I've always had a full sense," he says with characteristic economy, "of the power of objects."

Arthur Renwick First Nation's BC

Git'ksan BC

Secwepemc BC

Wet'suwet'en BC

Nlaka'pamux BC

Katherine Knight Mabou/Caribou

MABOU

CARIBOU

Rosalie Favell Spiritual Suite

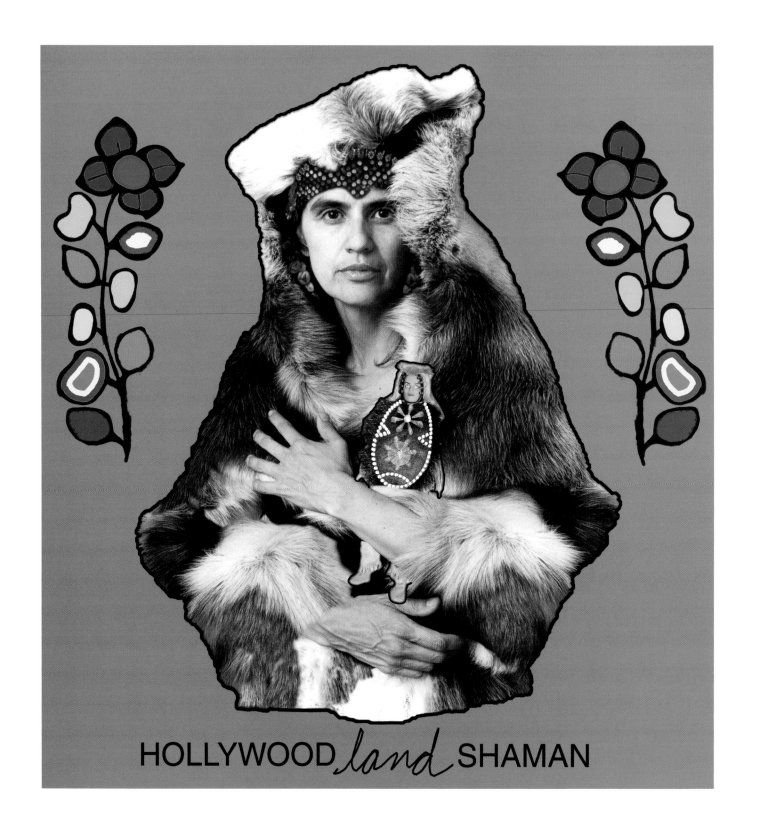

HOLLYWOOD *land* SHAMAN

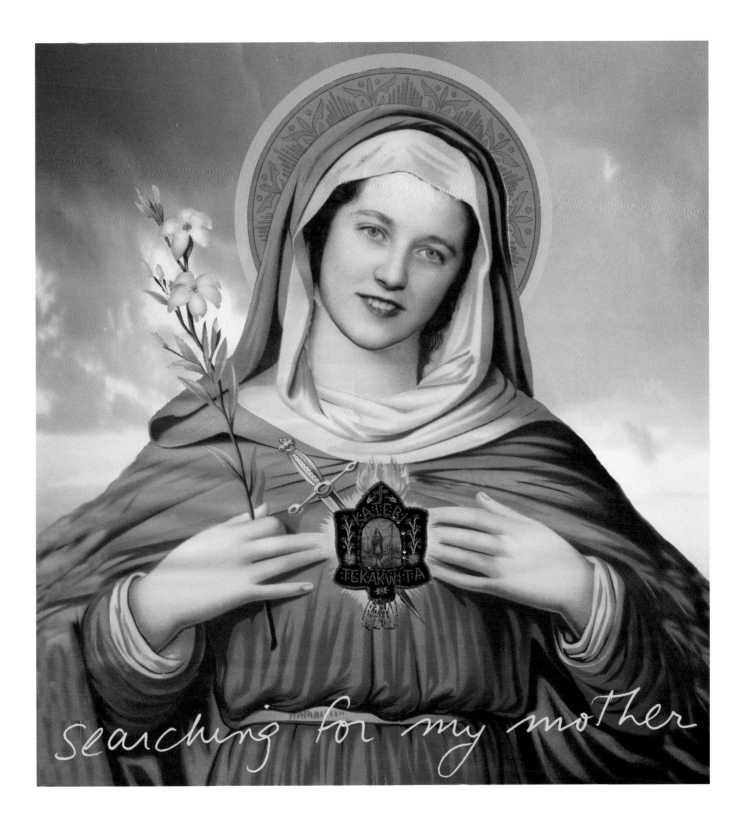

searching for my mother

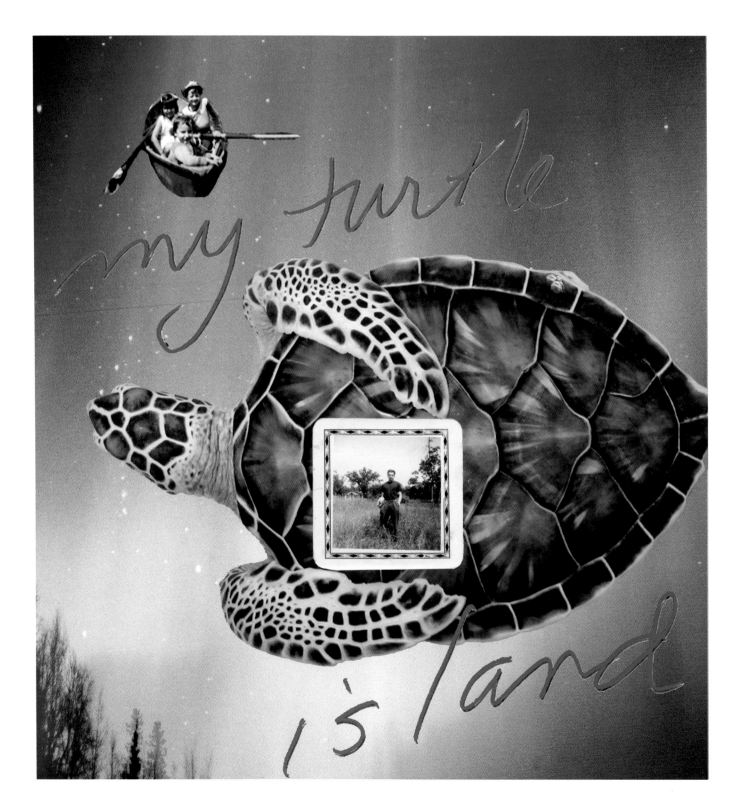

my turtle is land

Scott McFarland Empire

The Metropolitan Museum of Edward Milla

Vid Ingelevics

In the course of the year we presented several special exhibitions of contemporary interest and a number based in large part on the Museum's own collections.
— Special Events and Exhibitions, the Report of the Trustees for the Year 1951, Metropolitan Museum of Art.

SEVERAL "SPECIAL EXHIBITIONS OF A CONTEMPORARY INTEREST" are, in fact, described in the Metropolitan Museum of Art's 1951 annual report and some are additionally judged to have great "memorial" value. However, the exhibition, *Up at the Photographer's: Fifty Years of Museum Photography by Edward Milla*, which had taken place in the Met's Gallery B-13 from May 18 to June 2, 1951, is not one of them. The exhibition by Edward Milla, former chief photographer at the museum, receives no mention anywhere in the museum's surveys of its programming for that year nor has evidence turned up that a catalogue of any kind was produced by the museum. His exhibition spanned a broad range of museum subjects, offering examples of documentation of the collection, renovations, and expansion during the first half of the twentieth century, portraits of employees and, in an interestingly self-reflexive touch, images depicting the space, contents, and day-to-day workings of the Met's photo studio.

This essay considers Edward Milla's career at the Met and the significance of his unique exhibition as a notable historical event at the Metropolitan Museum of Art and as the subject of the photographic documentation that Milla produced of his own exhibition. These two perspectives are linked in many ways but most notably by the fact that the former would today be forgotten were it not for the recent discovery of the latter. The implications of institutional amnesia and the questions concerning how and what we can learn from these photographic documents are key issues to this ambiguity in the archive.

The staging of the exhibition itself marked a unique moment in the Met's social history. Not only was it likely one of the first exhibitions ever held in the museum's public galleries by one of its own employees[1] but the illustrious museum's visual history had been presented

VID INGELEVICS, *Entrance to the Photographic Studio of the Metropolitan Museum of Art, New York, with b+w mural enlargement of a 1924 photograph that shows Edward Milla at work in the studio (detail),* 2000.

IMAGE AND INSCRIPTION

1 In a news article in the May 24, 1951 edition of *The New York Times*, it states that "Probably the greatest mark of recognition, one in which his staff of nine shared, was a public exhibition of his work, a departure from the museum's usual practice of showing its employees' crafts and hobbies to the staff only."

VID INGELEVICS, *Installation of photographs originally in Edward Milla's 1951 exhibition at the Metropolitan Museum, hanging in Milla's grandson's house, Washington, Connecticut, 2000.*

2 The masthead from the Museum's Bulletin (its annual report), vol. XI, no. 1, Summer 1952, spans 1-1/2 pages, from page 4 to page 6, beginning with the museum's director, Francis Henry Taylor, and moves through the various curatorial departments. Edward Milla, as photographer, appears fourth from last, just above assistant photographer, Thomas McAdams, captain of attendants, Thomas J. Hughes, and second lieutenant of attendants, Charles F. Hickley, with the manager of the restaurant — Eloise Hicks — listed last. Of course, there would have been a considerable number of employees working in positions subordinate to many of those listed who would not have been mentioned at all.

3 This term literally means "history of the everyday" and refers to a brand of historiography that explores social history from below, thus refusing the "grand narratives" critiqued by Michel Foucault and Jean-François Lyotard.

4 In Milla's box of museum material was a letter dated Nov. 5, 1891 that referred to "Milano, the janitor" being authorized to receive an advance on his summer pay cheque of $250.00 by A. L. Tuckerman on letterhead of the Office of the Architect at the Met. It is worth noting that the correct family name was "Milanese" not "Milano."

5 Edward Milla himself died on Sept. 25, 1959 "at his home, 455 Eighty-fifth Street, Brooklyn" at the age of 71, as his obituary in *The New York Times* states. The obituary also names him as "Edward Milanese, art photographer," using his given family name.

from the point of view of an employee whose job title, "Photographer," and name were listed 159th out of the 163 employees appearing in the hierarchically structured employees directory found in the institution's annual reports.[2] While certainly not framed this way at the time and now limited by a lack of material evidence, Milla's exhibition could be likened to a kind of museological *alltagsgeschichte*[3] — the 1970s German concept of creating "history from below."

By the time of his exhibition, Edward Milla had worked at the museum for fifty years, the previous thirty-four as the museum's chief photographer. He had come a long way since he started at the museum in 1902 as the thirteen-year old Edward J. Milanese (his given name) in the position of "umbrella boy," as noted in his own words on one of the wall-mounted texts he produced for his exhibition. He was preceded at the museum by his father who was on record as a custodian at the museum in 1891.[4] The young Milla learned his photography on the job at the museum, and by 1920 he was already the senior photographer in the studio. At the time of his exhibition, thirty-one years later, Edward Milla was unquestionably the person at the museum most intimately familiar with the contents of its photographic archive. After all, he and his staff had produced a good percentage of the approximately 400,000 negatives on file by then.

Milla's exhibition would certainly be forgotten today were it not for the 1998 discovery of a box of his personal museum ephemera by his grandchildren. This was found in the Brooklyn apartment of his son, Edward Jr., after Milla's death.[5] Even so, we would not be discussing Milla's exhibition here had his family not gone one step further and reported their find to Barbara File, the Met's associate archivist at the time.[6] Milla had brought the box home at the time of his retirement from the museum in 1952. In it was an eclectic mix of memorabilia including filtration formulas, a few notes related to informal labour negotiations with the museum's administration around the 1920 wage scales in the photo studio,[7] as well as some obviously prized letters from some of New York's wealthiest citizens — the du Ponts and Carnegies — requesting that Milla come to their residences to photograph their art collections. Also included was a note from renowned painter and photographer, Charles

Sheeler, who had worked as a museum photographer as well, congratulating Milla on his 50th anniversary exhibition. The tone of the material turns a little darker in the years just after Milla's retirement as his papers reveal that retired museum employees took up a petition in 1954 asking the museum to augment their pensions. Milla's collection offers a compelling but fragmented glimpse into the everyday working world of the photo studio of one of the world's largest museums.

Also found — and the catalyst for this essay — were the news clippings, letters, and installation photographs undoubtedly taken by Milla himself, that revealed the existence of his exhibition. These installation views, made with a large format camera, carry penciled numbers on their backs that correspond to the negatives in the Met's institutional photo archive. As well, the box contained nine of the more than one hundred photographs that had hung on the walls of Gallery B-13 for sixteen days in 1951 as part of the *Up at the Photographer's* exhibition. The images all appear in Milla's installation views. Their subjects

6 The Met's associate archivist (now archivist), Barbara File, was notified by Peter and Diana Tagely, Milla's grandson and his wife, that the material had been found. I found out about the existence of the Milla files when Barbara File then called me about it. I had done much research at the Met in previous years in the course of producing the exhibition *Camera Obscured: Photographic Documentation and the Public Museum*, in which several of Milla's photographs were included.

7 A copy of a note from Milla dated November 29, 1924 requests of Henry Kent, the Museum Secretary, an upping of the photo studio staff's salaries to a level more comparable to what photographers outside the museum could earn. Milla, whose position was described as "operator," earned $2,640 and requested a raise to $2,840 while noting that outside the museum he would be earning $3,100.

8 In Milla's files is a short note, dated May 6, 1938, from Henry Kent, the Met's secretary, instructing Milla to take two days off for "rest and recreation" as a reward for his work on the Cloisters.

9 Although it is reasonable to assume that Milla would have consulted others during the production of his exhibition, there is no evidence that he was not mainly responsible for the form and content of his exhibition.

were artifacts in the museum's collection and architectural views of the Cloisters.[8] Several of these original exhibition photos were eventually reframed and hung in the Connecticut home of Milla's grandson. The lack of any production notes about the exhibition in Milla's files makes it unclear whether he included the artifact photographs because he loved the objects depicted or because he was proud of his photographic expertise (probably both). Further research on the exhibition's circumstances carried out in the Met's own institutional archives turned up little — a copy of a one-page May 23, 1951 press release, issued about five days into the exhibition (duplicated in Milla's files) and a couple of short news articles on the exhibition from *The New York Times* found in scrapbook-like files in the museum's Thomas J. Watson Library.

The extraordinary opportunity to exhibit his work in a public exhibition at the museum

was generously offered to Milla to honour his fifty years at the museum by the same trustees who then ignored it in 1952 when they sat down to write their summary of significant museum events and exhibitions of the previous year. Why was Milla's show bracketed off from all of the other exhibitions offered to the public by the museum in 1951? Why was an exhibition that concerned itself with the role of photographic documentation at one of the world's most important museums itself so poorly documented?

It should first be noted that leaving Milla's exhibition out of the official records was not necessarily an indication of a lack of respect for Milla personally. From all indications, he was well liked and held in high esteem as photographs of the large crowd at the opening seem to attest. Instead, the almost instant invisibility of his exhibition after it closed seemed to reflect the lack of an existing context within which the museum could situate Milla's exhibition of photographs other than as a personal tribute. The museum's public relations staff described the exhibition, in the words of the press release as "an excellent pictorial review of his career at the Museum." Implied in the release was that the subject should be understood as an exhibition about Edward Milla and his skill as a photographer. However, the photographs were hardly standard hobbyist fare but, rather, were made to record the collections and activities of a major public museum. Milla's photographs (and those taken by his colleagues in the photo studio) were actively used by the museum to define its public image, past and present. Milla's "career" resulted in the creation of a substantial part of the museum's visual history.

As a service department of the museum, most of the photographs taken by the photo studio would have been commissioned by museum staff such as curators and public relations personnel. The exception would be images of the photo studio itself, which serve as evidence of an awareness on the part of the photographers that, in order to be part of the museum's history, they must insert themselves into the institutional archive. The concern here is less the motivation for individual photographs, rather than the fact that Milla had been given the opportunity to re-present some of these photographs in a situation that reflected his choice of subject, his selection, and his sequencing.[9] In contradiction to the

EDWARD MILLA

press release's attempt to limit the subject of the exhibition to his "career," as if it could be somehow separated from the use of the images by the museum, Milla actually goes beyond his own employment at the museum. He acts as a de facto curator and museum historian, by including photographs of the museum from the early twentieth century that obviously precede his time as photographer. He attempts to contextualize his career at the museum within a broader history of the Met's photographic documentation that he is clearly conscious of. By doing this, the exhibition precludes any reduction that it was merely intended to display his skill as a photographer. However, while the museum was willing to acknowledge Milla's competence as a photographer, it was unable to grant him any sense of authorship or authority in relation to his astute perception of the museum's history that included an account of the production and utilization of photographic documentation within the museum.

A key aspect of this unrecognized history that Milla implies can be found in the introductory section of his exhibition where he concentrates on showing examples of the effects of photographic technique on subject matter. Here he demonstrates the subjectivity inherent in what we call "documentation." Even though the concept of documentation entails attaining as close a resemblance as possible to the photographic subject, Milla points out through his own examples, that there are many possible images that can result when an artifact is subjected to the numerous choices that must be made in the process of documentation. These possibilities, as presented, depend on lighting, film, development, and paper choices for their final appearance. While he would have maintained that some of the resulting images were more "correct" than others, the sheer malleability of the photographic image is made evident. The reliance on certain techniques, vantage points, and equipment that affect the appearance of the final photograph is shown with images of the photographers at work, hanging off shaky looking ladders, adapting themselves to the oddities of the physical space where they worked (called the High Attic, located around the false domes high above the Met's central foyer). By highlighting his mastery of technique, Milla demonstrates the transformative nature of photographic documentation,

inadvertently raising the question of subjectivity as an instrumental factor in the relationship between a document and its referent.

The field of museology at the time of Milla's exhibition was concerned mainly with the nuts and bolts aspects of running a museum and not, as it is today, with reflecting critically on museum histories and practices. The concept that a museum was a value-free site that simply re-presented the world's highest cultural achievements was a common sentiment inside and outside of the museum. This assumption was complemented by a similar attitude towards the photographic document. Within the museum world, meaning was seen as inherent in the object and the purpose of the museum display was to exemplify and clarify the indexical function of the exhibit for the viewers. The possibility that an object's meaning could be influenced or even wholly constructed through its institutional viewing context was unimaginable. But context was exactly what Milla's unique perspective on the museum and on photography offered in abundance. From a contemporary critical perspective on museums and photography, Milla could be said to have historicized the museum in ways that clearly fell outside of its official discourse. By highlighting the museum's representational strategies and its socially constructed nature, he couldn't help but provide evidence that was at odds with the assertions of neutrality and objectivity that had provided a rationale for the museum and the photographic document itself, since the mid-nineteenth century. Of course, none of this mattered much to anyone at the time. The result was that the broader implications of Milla's exhibition couldn't (or wouldn't) be recognized. In an institution devoted to the categorizing and display of global culture, it was the display of the culture of the museum itself that was the anomaly. *Up at the Photographer's* quietly slipped through the cracks of that paradox.

The 1998 reappearance of the exhibition's documentation photographs has emerged within a substantially different and far more receptive critical and theoretical climate. Since the 1970s, much thought has been devoted to the representational functions of both the museum and photography and, in fact, they have been linked as conceptual equivalents, sharing a developmental time frame as well as similar representational functions and

strategies.[10] The pretence of objectivity has given way to an understanding of museums and photography as "framing devices," instruments of collecting, and as key sites where historical meaning and value are actively produced within contemporary Western society.

In considering Milla's exhibition and speculating on its relation to the museum, much of the discussion here is based, of course, on the finding of the documentation photographs. These photographs have been the catalyst for investigating the exhibition's reception. What has been surmised through them (and some of the other material in Milla's box of memorabilia) implies that a certain level of productive information is extractable. However, given our knowledge of the contingencies of representation, it would seem important to also ask what the epistemological limits of the photographs might be.

As the issue of photographic verisimilitude is central when considering the subject of documentation, it may be worth recalling André Malraux's astute observation, made several decades ago, that much of art history is actually a history of the art that can be photographed. Malraux did not, however, question the "truth" of photographic representation itself. Its misrepresentational capacities seemed to suit his project, *Le Musée Imaginaire*, very well. The perceptual codes of realism that photography simultaneously affirms and reproduces convince us that what we are seeing in Milla's documentation is a faithful depiction of the space and contents of his exhibition. This is questionable, as the flattening of a three-dimensional space into a black and white, two-dimensional representation cannot avoid various degrees of distortion and reduction. What we see when we look at these exhibition documents has been skewed by optics and the illusory power of a single-point perspective. Scale is difficult to ascertain and the subjects of many of the photos in the documentation are impossible to discern, reduced to less than postage-stamp size. The nuances of colour that offer us further perceptual clues have become grayscale tonality. Important detail that was present in the original exhibition in 1951, such as the handwritten texts that Milla employed throughout his exhibition, is almost entirely illegible. The resolution capabilities of large-format film and view camera lens have been surpassed.[12]

The latter is an especially critical loss as it renders opaque much of the personal

10 "Before becoming itself a collectible, the photograph, like the museum, conserves. In a way, in fact, it provides a foundation for the very idea of conservation — that is, for the idea of the museum." Daniel Soutif, "Pictures and an Exhibition," in *Artforum* (March, 1991).

11 "For the last hundred years (if we except the activities of specialists) art history has been the history of what can be photographed." André Malraux, "Museum Without Walls," in Part One, *Voices of Silence*, 30.

12 This essay concerns itself with the exhibition documentation photographs that Edward Milla chose to take with him when he retired from the museum. While it is always possible that other, more detailed documentation might exist, no evidence of this can be found in the Met's institutional archives, nor in the possession of Milla's family. The only other possible site still left unexplored is the storage facility for the Met's institutional photographic negatives (of which there are likely more than a million today). However, this is not an area currently accessible to researchers.

context Milla had created for his selection of images. A powerful component of the unique perspective Milla was offering in the actual exhibition was the link between the images and his commentary on them. From the installation views one can see that Milla attempted to create some kind of dialectic between "his" photographs (images of the museum mostly taken by him) and his voice. The one site within the exhibition where his voice does survive is in the short autobiographical statements he placed on the walls above his photographs using large prefabricated letters. These statements are presented like quotes, thus leaving an impression that they may have been excerpted from some now missing memoir of his life at the museum. However, with a few exceptions, we cannot read his introductions to the various sections of the exhibition nor the captions he wrote by hand that are adjacent to the individual images. All that remains is the blurred evidence that he did have something to say. Any attempt at reconstructing Milla's exhibition physically would be compromised by that absence and would have to account for the contextualization of the work.

As the original 1951 exhibition is forever inaccessible to us now, the photographic documentation must assume substantial weight in any consideration of its "memorial" value. The lack of a catalogue, pamphlet, or other detailed form of explanatory record of the exhibition creates demands on the visual traces that, on their own, they are unable to meet. The "forgetting" of Milla's exhibition by the museum is compounded by the fact that Milla's own photographs of his exhibition excise key elements that anchored it within his perspective. The close examination of Edward Milla's documentation makes it clear that the archive photographs constitute a new "event" in their own right and they must be engaged with that in mind. This suggests that careful attention must be paid to the nature of the alterations of the subject that are wrought by the documentation of art.

The photographic documentation has, on one hand, accomplished one of its primary purposes — to remind us of the existence of its referent — and, on the other, the documentation has irrevocably transformed the original exhibition. The gap between referent and representation is pushed ever further apart enticing us to work within that space.

FOLLOWING SPREAD **EDWARD MILLA,** *Installation view of the opening section of Edward Milla's exhibition at the Metropolitan Museum of Art, New York, 1951.*

* * * * *

Additional notes and thanks: All scans from Edward Milla's installation views were done at 12,800 dpi on a flatbed scanner. The installation views were kindly provided by the photography studio of the Metropolitan Museum of Art, New York. Edward Milla's grandson, Peter Tagely, and his wife Diana were extremely generous in sharing information. As well, Barbara File, archivist at the Metropolitan Museum of Art, has been more than steadfast in her support for this project.

WE DID OU

THE PHOTOGRAPHER'S

...RS OF MUSEUM PHOTOGRAPHY

BY
EDWARD MILLA

...TING OUT ON THE ROOF ON GOOD DAYS....

The Post/Colonial Photographic Archive and the Work of Memory

Lynne Bell

Perhaps…photographs reveal more than a mere image of the subject, although it is still too early for us to understand and interpret all the information a photograph may contain.
— LESLIE MARMON SILKO, 1996

Can photographs answer the elusive questions of a history that has been repeatedly repressed?
— GERALD M^CMASTER, 1996

ANONYMOUS, *Sir Wilfrid Laurier Lays Cornerstone for College Building, July 29,1910* (detail). **Courtesy of the University of Saskatchewan Archives: A-8.**

151

IMAGE AND INSCRIPTION

Undoing The Colonial Photographic Archive

I am writing this essay at the University of Saskatchewan in 2005. It is the year of Saskatchewan's centenary. As a historian of visual culture, I am keenly interested in how archival photography is being redeployed in Saskatchewan's centennial script to imagine and re-imagine the province's communal life — past, present, and future. This year's "centenary" in Saskatchewan offers my students and I an opportunity to consider what it means for the province to claim it is "just" one hundred years old. In the visual arts, this question enables us to "dialogue with" visual texts — using them as a catalyst, a prompter, and a facilitator — to think critically about the nature of individual and collective memories and their role in the formation of official historical narratives.

What happens when photographs are retrieved from institutional archives? What social and spatial worlds do they map, what chronologies do they construct? What decolonizing testimonies and pedagogies can they now perform? In response to these questions, this essay explores how historical photographs are being used by contemporary artists to interrogate the representation of place and education in Saskatchewan.

In this essay, I focus on two separate projects of visual testimony by the artists Gerald M^cMaster and Dana Claxton. Both artists appropriate and transform late-nineteenth- and

early-twentieth-century photographic imagery taken in Saskatchewan in order to bear witness to a collective memory of colonial violence and to reconnect this photographic material with Indigenous traditions of interpretation, resistance, and emancipation. In this task of "the undoing of the colonial archive," Claxton and M^cMaster use archival photography to disturb and unsettle the cultural and political processes of the past one hundred years in Saskatchewan.[1]

It is a Privilege to be Looked at and Pictured

I am looking at a framed photograph in the hallway of the College of Arts and Science at the University of Saskatchewan. It is one of a series of captioned photographs crowding the walls that tells a history of convocation — one of the key ceremonies of academia. The story begins with a black-and-white photograph entitled *First Graduating Class, May, 1912*. It represents the first class to graduate from the University of Saskatchewan (founded in 1907), seven students (five men and two women — all white) are grouped around Sir Walter Murray, the first president of the university, and one other faculty member. Faculty and

1 This is Isaac Julien's term. Coco Fusco, "Blacks in the Metropolis: Isaac Julien on Frantz Fanon, an interview," in *The Bodies That Were Not Ours and Other Writings* (London and New York: Routledge, 2001), 103.

2 John Tagg, *Grounds of Dispute: Art History, Cultural Politics and the Discursive Field* (Minneapolis: University of Minnesota Press, 1992), 102.

students are dressed alike in black formal academic gowns. While the gender imbalance is immediately visible, they all look confidently at the viewer, clearly at ease in the learning and social ecology of this new University of Saskatchewan.

This photograph is familiar to me. I've seen it recently in a number of places, most notably on bookmarks distributed by the campus bookstore and on the university's Web pages developed to celebrate the institution's upcoming centenary of 2007. Curious about this image, I pay a visit to the University of Saskatchewan Archives, in an attempt to track down the original. I find it in an envelope marked A-3638. Inside, the photograph is brittle and yellowed, releasing a sour smell of old paper into the air. This photograph belongs to a larger photographic narrative depicting the earliest years of the university. Several of the photographs are stained, their corners creased, the writing on the back neat, recording dates, events, and names. As I look at this archive, the same buildings, ceremonies, and people keep popping up: it is like leafing through the photographs of an old family album. The visual data in this photographic archive clearly belongs to what John Tagg calls an "honorific culture" in which it is "a privilege to be looked at and pictured."[2] Here are a few moments in this archive:

The Laying of the Cornerstone of the College Building, July 29, 1910: The prime minister, Sir Wilfrid Laurier, addresses a large crowd from a temporary stage decorated with bunting and flags at the laying of the cornerstone of the College Building in 1910. It is mid afternoon and despite the summer heat, people are formally dressed. In an attempt to get a better view of the ceremony, several men have clambered onto construction scaffolding. Behind the crowded VIP stage, pasture, fencing, and cultivated fields are visible.

A.S. Morton & Students in Library, 1917: An impressive greying man with a large moustache sits at one end of a highly polished table in a room lined with books. In this clearly staged performance for the camera, three female students wearing academic gowns glance up from the books on the study tables in front of them. It appears that we have interrupted a seminar with A.S. Morton, a prominent historian and university librarian.

Experimental plots of grain, ca. 1920: A large field is carved into a grid pattern of

ANONYMOUS, *First Graduating Class, May, 1912.* Courtesy University of Saskatchewan Archives: A-3638.

IMAGE AND INSCRIPTION

experimental grain plots. A massive stone barn is visible in the background. It is late July or early August judging by the state of the crops (wheat and barley for the most part). Two unidentified men stand at each side of the plots: it is tempting to read class and institutional status into their differing poses and dress.

Chemistry and Physics Buildings, ca. 1927: Students and faculty dressed in overcoats and hats, carrying armfuls of books, hurry between massive greystone buildings. It is a cold day and everyone is muffled up. The buildings with their arched windows, pointed gables, and spires closely resemble the ancient colleges of Oxford and Cambridge.

In this visual archive, the University of Saskatchewan emerges as one of the province's most prominent symbols of colonial settlement. The early twentieth century in Saskatchewan was a period of province building — a time when settler colonialism fashioned a white space of towns, farms, businesses, vegetable gardens, and picket fences on Indigenous land. In this colonial process of cartographic transformation, photographs along with paintings, prints, built forms, film, and postcards worked to constitute the provincial imaginary of Saskatchewan, along with its foundational myths of terra nullius, peaceful beginnings, settlement, progress, and development. This photographic archive of the earliest years of the university clearly marks "the worlding of a world," to borrow the cultural critic Gayatri Spivak's description of the multitude of ways in which imperial space is mapped over Indigenous life-place.[3]

The University of Saskatchewan was founded at the height of British imperialism: a time when the Collegiate Gothic architectural style (along with faculty, books, syllabi, and programs) was being exported from the metropolitan centre to the new universities of the settler colonies of the British Empire.[4] The desire to model the University of Saskatchewan on the colleges of Oxford and Cambridge was made explicit by Sir Wilfrid Laurier at the ceremony to lay the cornerstone of the College Building in 1910: "Education," Laurier states, "is the true patriotism, for it is the best heritage which a people can have given them." "Let a university arise here," he continues, "which may be a worthy disciple of Oxford, Cambridge, and other universities which have done so much."[5] In his speech,

3 This is Gayatri Spivak's term. Gayatri Spivak, "The Rani of Simur," in *Europe and Its Others,* eds. Francis Barker et al., vol. 1. Proceedings of the Essex Conference on the Sociology of Literature (Colchester: University of Essex, 1985), 128.

4 Linda Tuhiwai Smith, *Decolonizing Methodologies: Research and Indigenous Peoples* (London and New York: Zed Books, 1999), 58-77.

5 Sir Wilfrid Laurier's speech as quoted on the University of Saskatchewan Archives Web pages. www.scaa.usask.ca/gallery/uofs_events/articles/1909.php

6 As Dipesh Chakrabarty reminds us, "Europe" as a "figure of imagination" works as a silent referent in so many western histories of modernity. Dipesh Chakrabarty, *Provincializing Europe: Postcolonial Thought and Historical Difference* (Princeton: Princeton University Press. 2000), 26.

7 Gerald McMaster, "Colonial Alchemy: Reading the Boarding School Experience," in *Partial Recall: Photographs of Native North Americans,* ed. Lucy Lippard (New York: The New Press, 1992), 76.

Laurier (like most subsequent historians of the university) constructs a vision of education and culture which looks to Europe and European America as the centre of all knowledge and civilization.[6] In looking at the university's earliest photographic narrative, this Eurocentric curriculum is hidden in plain view in the Gothic-style buildings, picturesque grounds filled with imported trees, shrubs, and flowers, and the academic ceremonies and rituals also imported from Europe. The photographs depict a white settler university built for the children of the pioneers: a world in which Latin mottos, stone gargoyles and quiet courtyards exist alongside a university farm with barns, sheep, poultry, and experimental field plots. It is a story of white privilege, mostly Anglo Canadian but also European and American. But looking back can mean resistance as well as nostalgia, depending on who is doing the looking. Every visual archive has internal and external others, and can be interrogated to reveal things "forgotten" by the makers and disseminators of the images it attempts to contain.

Looking from the Other Side of the Photograph

It is 1992, the year of the Columbus Quincentenary, the Cree artist and curator Gerald McMaster has just published a brilliant essay titled, "Colonial Alchemy: Reading the Boarding School Experience," in Lucy Lippard's edited collection of essays entitled *Partial Recall: Photographs of Native North Americans*.[7] In his essay, McMaster focuses our attention on a photograph entitled, *Battleford Industrial School Football Team,* taken in 1897, just a few years prior to Saskatchewan's centennial frame and a few miles north of the main campus of the University of Saskatchewan (p. 156). This image of education depicts eleven young men, members of the Industrial School football team, posing for a group portrait, wearing medals and sports shirts inscribed with the logo "IS." Stumbling across this photograph in the archives of the Glenbow Museum in Alberta, McMaster writes that he was surprised to find that the "IS" on the boys' shirts stood for the Indian Industrial School in Battleford, the small Saskatchewan town where he grew up. He was further surprised, he says, to discover that the boys' names (listed on the catalogue card) were familiar to him, as many

8 As Doug Cuthand notes: "The treaties promised that a school would be built on reserves, and Indians would become 'educated like a white man.' In Saskatchewan, only a few reserves actually received 'day schools.' The vast majority only had access to education from a boarding school. This was a serious breech of treaty and was disastrous for all concerned." Doug Cuthand, *Tapwe: Selected Columns of Doug Cuthand* (Saskatoon: Theytus Books Ltd., 2005), 57-58.

9 Tagg, *Grounds of Dispute*, 102.

10 A great deal of critical writing has been devoted to the use of the camera as an instrument of imperialism and the differing photographic genres and modes of representing otherness. See, for example, Anne Maxwell, *Colonial Photographs and Exhibitions: Representations of the "Native"* and the *Making of European Identities* (London: Leicester University Press, 1999); and Eleanor M. Hight and Gary D. Sampson, *Colonialist Photography: Imag(in)ing Race and Place*, (Routledge: 2002).

of their descendants still live on the reserves in the Battleford area, including his own grandmother Marie Isabella (Bella) Schmidt, who attended the Industrial School from the age of six to sixteen (1904-1914).

Gerald MᶜMaster's interventionist reading of this cultural document reassembles and makes public the history of the Battleford Industrial School that ran from 1883 to 1916 as well as the names and histories of the eleven young men it depicts. In his reading, MᶜMaster emphasizes the oppressively assimilative education Indigenous children received at a boarding school whose curriculum focused on a mix of athletic and artisanal activities designed "to erase their savage influences, and to expose them to the benefits of Western 'civilization.'" It was an education that broke the treaty promises to provide schools on reserves where "Indians would become 'educated like a white man.'"[8]

This image clearly belongs to a vast instrumental colonial archive of photographic records in which, as John Tagg puts it, "the production of normative typologies is joined to the tasks of surveillance, record, and control."[9] In his reading, MᶜMaster pays attention to the power relations and forms of domination at work in the colonial photographic encounter, noting the ways in which the boys are transformed from subjects into objects by the colonial

gaze. M^cMaster's reading looks from the other side of the photograph in order to return the white settler gaze.[10] Searching for evidence of the boys' defiance, M^cMaster writes: "I was intrigued by their apparent ambivalence about being photographed, indicated by the clenched fists or folded arms... Even in the enforced, dehumanizing atmosphere of the Industrial School, these boys stand firm...."[11]

The steady gaze of the boys reminds the viewer that it was the Indigenous peoples in their own setting who first gazed on the white settlers. This fact was not taught in the schooling I received in England as a child and young adult. And as my students at the University of Saskatchewan tell me, this image of a colonial education system is rarely encountered in mainstream education in the province today. But M^cMaster's reading draws on an impressive tradition of Indigenous activism that is working to transform the colonial and neo-colonial pedagogies of mainstream education in Saskatchewan while, at the same time, creating a series of First Nations educational institutions, including modern schools built on reserves.[12] As Doug Cuthand writes in *Tapwe*, Native leaders in Saskatchewan made education a priority thirty years ago and the effects of this priority can be seen "in the development of a series of educational institutions, including the First Nations University of Canada, the Saskatchewan Indian Institute of Technologies, and the Saskatchewan Indian Cultural Centre."[13] These First Nations' institutions, as Cuthand notes, are now a major force in First Nations education in Saskatchewan and across the country.

Counterpoint

It is 2005 and I am scrolling down the Web pages constructed by the University of Saskatchewan Archives to celebrate the institution's upcoming centenary in 2007. I am reading a photo-narrative titled "Events in the History of the University of Saskatchewan" that stitches together archival photographs with snippets of text (taken from official histories of the university)[14] to produce a linear, stagist history of development. In looking at this photo-narrative of the university's earliest years, it is clear that it belongs to the larger discourse of white settler history in Saskatchewan: a utopian narrative of new "beginnings,"

ANONYMOUS, *Battleford Industrial School Football Team, Saskatchewan,* **1897. Courtesy of Glenbow Museum, Calgary, Alberta.**

157

IMAGE AND INSCRIPTION

11 M^cMaster, "Colonial Alchemy," 76.

12 In 1972, the Federation of Saskatchewan Indians released a report as a result of a two-year task force on Indian education in the province entitled *Indian Control of Indian Education.* Doug Cuthand, *Tapwe,* 49.

13 Ibid., 50.

14 www.scaa.usask.ca/gallery/uofs_events/articles/1909.php

15 In the 2005 centenary, one of the most visible sites of white settler history is a series of weekly articles entitled *100 Years, 100 Towns* in the local Saskatoon paper, *The Star Phoenix*. See Lynne Bell, "Centennial Notes," in *Marking Time* (Saskatoon: Mendel Art Gallery, 2005).

16 Sherene H. Razack, ed., *Race, Space and the Law: Unmapping a White Settler Society* (Toronto: Between the Lines, 2002), 2.

17 Michael Taussig, "The Beach (A Fantasy)," in *Landscape and Power*, ed. W.J.T. Mitchell (Chicago: The University of Chicago Press, 2002), 338.

18 Report on the Royal Commission of Aboriginal Peoples (RCAP). (Ottawa: Supply and Services Canada, 1996).

19 Bill Ashcroft et al. eds., *The Post-Colonial Studies Reader* (London and New York: Routledge, 1995), 425.

20 Marie Battiste, Lynne Bell, and L.M. Findlay, "Decolonizing Education in Canadian Universities: An Interdisciplinary, International, Indigenous Research Project," in Canadian Journal of Native Education, vol. 26, no. 2. (2002): 82-95; L.M. Findlay, "Always Indigenize! The Radical Humanities in the Postcolonial Canadian University" (Ariel, 31): 307-326.

progress, development, and bright futures. In its intense focus on the past one hundred years, Saskatchewan's settlement discourse sweeps the landscape clean of meaning prior to the arrival of the settlers, erasing (or marginalizing) the histories and cultures of the Indigenous peoples of the territory.[15] The central fantasy at the heart of such narratives is that Canada was peacefully settled and not colonized.[16] In this centenary year of 2005, white settler histories are being recycled in many sites including the media, tourism, and the Saskatchewan Western Development Museum. An Aladdin's cave of pioneer treasures, this museum's centenary exhibition extravaganza entitled "Winning the Prairie Gamble," suggests that life on the prairies is a story of competition, of winners and losers, of winners taking all, and of winners writing history. In a similar manner, the University of Saskatchewan Archives has constructed a centennial narrative on its Web pages that is all about "winning the prairie gamble": at once nostalgic and forward-thrusting, this centennial narrative curtains itself off from the politics, histories, and legacies of colonialism.

In recycling archival photographs of the early years of the University of Saskatchewan to establish a nostalgic and triumphalist centenary narrative, the University of Saskatchewan Archives effectively "re-whitens" the imaginary of this institutional place. But if one counterpoints the two group portraits — the *First Graduating Class, May, 1912* and the *Battleford Industrial School Football Team* — a more unsettling articulation of place and education in Saskatchewan asserts itself. It produces a new mapping of difference, revealing the mutually imbricated histories of colonialism and their contemporary legacies. If we use montage as a tool of cultural analysis for these photographs, we encounter a representation of educational place as profoundly organized by racial, class, and gender boundaries. It is an educational system constituted by the social and spatial apartheid so deeply etched into the culture of the British Empire. As many critics have noted, white settler colonialism created proliferating social divisions between peoples. But this fact remains a public secret in Saskatchewan's celebrated centenary year. As Michael Taussig notes, a public secret involves a practice "of knowing what not to know," an ongoing performance of repression and expression, that is at the very basis of being social.[17] In 2005,

the public secret on the Web pages compiled by the University of Saskatchewan Archives is that this white settler university has, for most of its history, flourished at the expense of the Indigenous peoples of this territory. As the final report of the Royal Commission on Aboriginal People's (RCAP) noted in 1996, Canada's universities are still a key agent of colonialism, producing, and reproducing a selected Western knowledge.[18] In the twenty-first century, the West, of course, means the United States more than Europe, and the University of Saskatchewan struggles with the vestiges of British colonial education while it is, like other Canadian institutions, being swamped with American versions of neo-liberalism and globalized forms of cultural capitalism. In this setting McMaster's critical artistic practice reveals how the ambiguity, plurality, and hybridity of visual culture can be used as a decolonizing tool for unpacking not only older systems of colonialism but also the multiple ways in which these systems are now "passing, sometimes imperceptibly, into neo-colonial configurations."[19] His practice also reveals the interventionist power of the Indigenous humanities in the university, and other educational sites.[20]

Sitting Bull and the Moose Jaw Sioux

It is 2004, the year of Moose Jaw's centennial, and I am looking at an immense video installation of moving images and sound entitled *Sitting Bull and the Moose Jaw Sioux* at the Moose Jaw Art Museum. The scale of this four-channel video installation is breathtaking. A massive screen split into three channels runs the entire length of the gallery. A smaller screen hangs on the opposite wall. As I watch this multi-channel video projection in the thick darkness, it begins to work the same magic as the cinema screen, leaving me with a highly charged connection with its flickering images.

The three-channel screen carries a fast-flowing river of moving images, text, sound, music, and voice. Restlessly piling up bits and pieces of evidence, it explores the history of Sitting Bull and the Sioux in Moose Jaw, Saskatchewan, following their 1876 defeat of Lieutenant Colonel George Custer's forces in the Battle of the Little Big Horn, Montana. Here are a few moments in this videoscape:

On the centre screen, a black-and-white photograph of Sitting Bull is juxtaposed with late-nineteenth- and early-twentieth-century newspaper clippings from the Moose Jaw Times: As the camera sifts through piles of yellowed newspapers in the side channels, I catch glimpses of banner headlines proclaiming "Custer massacre refugees given aid by Moose Jaw" and "Kingsway Park once site of Hundreds of Wigwams." The grainy news photos depict Lakota men, women, and children. In a voice-over conversation, two Sioux storytellers recall family stories, accounts, and legends of Sitting Bull and the Moose Jaw Sioux. An English translation runs across the bottom of the screens.

As the camera pans over a photograph of Sitting Bull on the centre screen, images of the Black Hills of Dakota flash past on the side screens: The voice-over states: "They owned that land of the Black Hills....They called that the heart of the earth. That was their homeland.... But gold was discovered...and they broke the treaties."

In the centre panel, video footage of the Sioux campsite is juxtaposed with images of buffalo, moose, and "Indian heads" decorating Fourth Avenue bridge in Moose Jaw: The voice-over states: "They went and saw Father Bernard in Lebret. He gave them food. The RCMP went

there and told them not to give them food. Sitting Bull's tribe came back to Moose Jaw... Father Bernard brought some food to them. The RCMP went there and said, " You're not going to give this tribe anything...."

As snow falls, a close-up view of a contemporary street sign announcing "Sioux Crescent" appears in the side panels. In the centre panel, images of antelope and Saskatchewan landscape : The voice-over tells of the Lakota people's migration south in the summer to hunt antelope in the hills and of the close and peaceful relations existing between the Sioux and the early settlers in Moose Jaw.

In the centre screen, a night sky studded with bright stars is juxtaposed with pure blue skies in the side channels before dissolving into archival photographs of Sioux women and children: When the skyscapes return, a ghostly image of an elk wanders across their vast expanse. The voice-over says: "My grandpa...one morning he woke up and he heard the women crying. He looked out...there is an elk standing there...that's what they were crying about. They miss the old days when they hunt[ed] elk and buffalo...."

In the middle channel, the Lakota storyteller Johnnie La Caine, relates an oral account of the Battle of Little Big Horn that has been handed down through the generations: As he talks, a mix of archival photographs, Sitting Bull's ledger drawings, and image fragments from western paintings and sculptures tell the story of the battle in the side channels. Jostling for attention, these images pulse to the insistent beat of the soundtrack, creating an explosive "Sitting Bull Rave," as Claxton puts it.

In the centre screen, archival photographs of the Sioux—including the famous group portrait of John Okute's family in traditional dress taken in a Moose Jaw studio in 1902: These images are juxtaposed with the names of the inhabitants of the camp (and their descendants), as they scroll past on the vivid green background of the side channels.

In this video installation, Dana Claxton, an artist of Hunkpapa Lakota descent, makes public the history of the Lakota Sioux in Moose Jaw. "This installation," she notes, "is about acknowledging the existence of the Lakota Sioux in this region; to honour it and situate it in this area."[21] As a child, Claxton lived for eleven years in Moose Jaw. Growing up,

DANA CLAXTON, *Sitting Bull and the Moose Jaw Sioux,* **video installation, Moose Jaw Art Gallery, 2004. Courtesy Don Hall.**

DANA CLAXTON, *Sitting Bull and the Moose Jaw Sioux,* **video installation, Moose Jaw Art Gallery, 2004. Courtesy Don Hall.**

21 Mandy Higgins, "Using Media to bring back Sitting Bull," in *Moose Jaw Times Herald* (Friday, September 10, 2004).

22 When Sitting Bull returned to the United States in 1881, some of the Lakota Sioux, including Claxton's great-grandmother, stayed in Saskatchewan, eventually obtaining reserve land in Wood Mountain. Claxton's grandmother and mother were born at this reserve.

23 As the RCAP notes, "The Aboriginal tradition in the recording of history is neither linear not steeped in the same notions of social progress and evolution [as in the non-Aboriginal tradition]." It is an oral tradition, "involving legends, stories, and accounts handed down through the generations in oral form. RCAP, vol. 1, 33.

24 Toni Morrison, "The Site of Memory," in *Out There: Marginalization and Contemporary Cultures,* eds. R. Ferguson et al (New York: The New Museum of Contemporary Art, 1992), 302.

25 Higgins, "Using Media to bring back Sitting Bull."

she heard stories about her maternal great-grandmother and other relatives who travelled to Saskatchewan with Sitting Bull after the Battle of the Little Big Horn.[22]

Working in a space in between poetic form and documentary, Claxton has created an immensely beautiful video installation that is at once a memorial, a living history, and a pedagogical site of critical remembrance. Recognizing the power and necessity of historical memory, Claxton rummaged through books, public archives, parliamentary records, museums, the Internet, and the urban landscape of downtown Moose Jaw, searching for traces of Sitting Bull and the Sioux in Saskatchewan. She also interviewed on film three local men whose grandparents had lived at the Moose Jaw Sioux camp. In gathering together this multitude of remains, Claxton creates a "visual archaeology" that brings light, texture, shading, and complexity to the history of the Sioux in Moose Jaw. Structured on a thirty-minute loop, there is no linear ordering of time and space in this history.[23] Claxton's approach to memory work draws on Aboriginal traditions of recording history. It also reminds me of Toni Morrison's imaginative re-membering of history in her novel *Beloved,* in which she mediates the loss and destruction of an African American past in the United States through the careful construction of a "literary archaeology." "On the basis of some information and a little bit of guess work," Morrison writes, "you journey to a site to see what remains were left behind and to reconstruct the world that these remains imply."[24]

One of the key sites that Claxton turned to in her search for "remains" with which to re-construct and re-imagine the world of the Sioux in Saskatchewan is an archive of late-nineteenth- and early-twentieth-century photojournalism from the *Moose Jaw Times.* This media archive clearly reveals the epistemic violence at the heart of the colonial encounter. In the *Moose Jaw Times* archive, we see how the captioned photograph was used at the turn of the last century to give tangible form to a proliferating set of stereotypes that marked the Sioux as the racialized "other" of the white settler community in Moose Jaw. This media archive also provides clear evidence that photographers and journalists just as much as politicians and government officials (among others) were the authors of Saskatchewan's

racialized regimes of representation in the late-nineteenth and early-twentieth centuries.

How does Dana Claxton liberate the Sioux from the prison-house of the colonial photographic archive? In her video storytelling, Claxton brings the photographs of Sitting Bull and the Moose Jaw Sioux to life with constant camera movement, flickering light effects, shifts in focus, and the pulsating rhythms of the soundtrack. With the assurance of an accomplished and practiced artist, she also invites three Lakota storytellers to animate the photographs of their ancestors with stories, accounts, and legends. In addition, she braids historic photographs of the Sioux with contemporary video footage of the sites of their winter and summer camps in Moose Jaw and the surrounding countryside. As I watch the landscape footage on the single-channel screen that stands alone in the gallery, I have to slow down my viewing pace. The camera-work invites the viewer to experience the heat of the luminous summer day, the wind as it brushes the tips of the long grasses, and the constantly expanding space as the camera angle (and the viewer's position) shifts and moves. "After people see the exhibition," states Claxton, "I hope they take away images of the beauty of Lakota culture, the physical beauty of the Moose Jaw camp, and have a new acknowledgement that part of the Sioux story happened here."[25]

In this multi-channel video installation, Claxton does not shy away from difficult knowledge. In the video, the Lakota storytellers bear witness to the violence of the colonial era in Canada. By 1878, buffalo were scarce in Saskatchewan and the Canadian government gave the Sioux ammunition for hunting, but no food, in order to force them to surrender and return to the United States.[26] This government-sanctioned policy of starvation, enforced by the RCMP, is an officiated silence in the Canadian national imaginary which, as the critics Eva Mackey and Daniel Francis argue, is built on such myths as the peaceful settlement of the West (as distinct from the Wild West of the US) and the revered icon of the fair and just Mountie. According to this main stream version of history, "the most important thing the Mounties brought to the West was their impartiality, one of the basic elements of British law."[27] But as Francis notes, these myths allow Canadians to nurture "a sense of themselves as a just people, unlike the Americans south of the border who were waging a war of extermination against their Indian population." "Canadians believed," Francis notes, "that they treated their Natives justly. They negotiated treaties before they occupied the land. They fed the Indians when they were starving and shared with them the great principles of British justice."[28] This story of the Mounted police, as Francis and Mackey point out, has had a powerful influence on the way Canadians define themselves as "distinct from, and morally superior to," the United States.[29] But Claxton's memory work generates multiple understandings of history in this centennial moment. In generating a counter-memory of an Indigenous life-scape that is hidden (or marginalized) in the province's nostalgic and settler-centred centennial discourses, Claxton creates an Indigenous-centred history that tells of interconnected and interdependent relationships between the Sioux and the white settler society of southern Saskatchewan at the turn of the last century.

26 Beth LaDow, *The Medicine Line: Nations and Identity on the Montana-Saskatchewan Frontier, 1877-1920* (UMI Dissertation Services, 1995), 160.

27 Eva Mackey, *The House of Difference: Cultural Politics and the National Imaginary in Canada* (Toronto: UTP Press, 2002), 35.

28 Daniel Francis, *The Imaginary Indian: The Image of the Indian in Canadian Culture* (Vancouver: Arsenal Pulp Press, 1992), 69. Quoted in Mackey, *The House of Difference*, 35.

29 Mackey, ibid.

30 Ross Gibson, *South of the West: Postcolonialism and the Narrative Construction of Australia* (Bloomington and Indianapolis: Indiana University Press, 1992), 112.

31 Barnor Hesse, "Forgotten Like a Bad Dream: Atlantic Slavery and the Ethics of Postcolonial Memory," in *Relocating Postcolonialism*, eds. David T. Goldberg et al. (London: Blackwell Publishers Ltd., 2002), 165.

Primed to Grow

Claxton's and MᶜMaster's engagement with the historical photograph clearly belongs to a growing body of anti-colonial work that is re-engaging with the storytelling potential of the medium of photography. As the cultural critic Ross Gibson points out, a photograph cannot be understood "without a yarn being spun about it":

When the shutter scythes back and forth, history is in the making, a set of data is scooped out of temporal experience and stored for use after the moment of the spasm. This is the instant of the "triple convergence," the barely perceptible event …when something is "trapped, possessed, fertilized." These three factors define… the historic nature of a photo: a momentary action is arrested and stored, but, crucially, *it is also primed to grow*.[30] (author's emphasis)

In recent years, Indigenous artists and writers such as Jeffrey Thomas, Jimmie Durham, Dana Claxton, Leslie Marmon Silko, Jane Ash Poitras, and Carl Beam, to mention only a few, have used post/colonial reading strategies to re-vision historical photos of North American Indigenous peoples trapped in a range of colonial archives. Appropriating these found images, they interrogate, subvert, and transform their cultural literacies in order to put meaning on the move.

In this centennial year, Claxton's and MᶜMaster's projects offer powerful models for a decolonizing pedagogy of remembrance. In opening up centennial discourses to their historical pasts, they open up the contemporary representation of place and education in Saskatchewan to its often exclusionary white privilege and its systemic racism. This mode of post/colonial memory-work, as Barnor Hesse notes, concerns itself "less with the historical 'wrongs' of the colonial question than with the interrupted and incomplete forms of decolonization and their relation to contemporary social constructions of injustice/justice."[31] It is memory-work that focuses attention on issues of social justice in the present.

* * * * *

I would like to thank Dana Claxton, Len Findlay, Robert Bean, Lori Blondeau, Keith Bell, Katy MᶜCormick, and my anonymous reader for their helpful comments and editorial suggestions. I am indebted to Edward Said and his methodology of counterpoint.

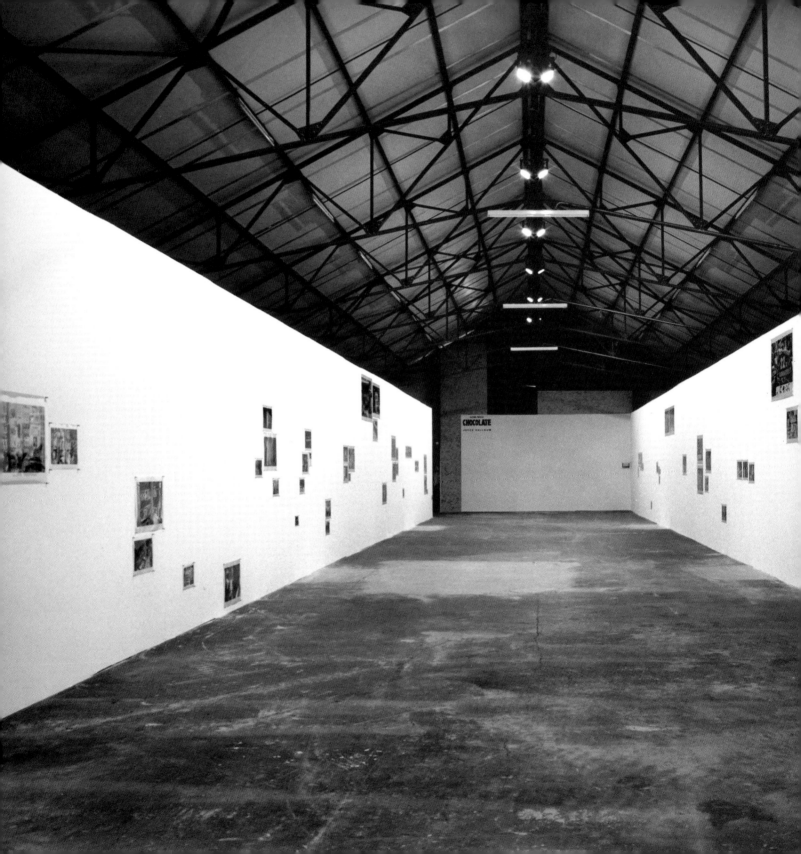

Jayce Salloum: Archive of the Street Jim Drobnick and Jennifer Fisher

FOR MODERN AND POSTMODERN artists alike, the street has served as muse, stimulus, and stage for aesthetic production. From Baudelarian *flânerie* to Situationist *dérives* to activist demonstrations, the street figures prominently as the site for chance encounters and political revolution. It is, in one sense, a heterotopic site, where all actions are seemingly permitted (or at least attempted), and simultaneously dystopic, where social injustices are exposed and raw. Jayce Salloum continues this tradition of exploring the terrain of the metropolis with a photo-installation bearing multiple titles — *NEUTRAL/ BRAKES/STEERING, 22OZ. THUNDERBOLT,* and so on[1] — phrases drawn from the signs, posters, and product packaging appearing in storefront displays. As much as the photographs here form an archive of the street, arise from the street, and are about the street, they constitute a subjective, almost autobiographical, record of the vernacular of the street — an optical diary of numerous journeys and urban ambiences.

City of (Broken) Glass

With the preponderance of storefronts, display cases, transparent façades, and show windows in Salloum's photographs, one could say that glass, as an affective aspect of the built environment, is a consistent *punctum* of Salloum's peregrinations with a camera. The installation thus might be characterized as an investigation into the ideology of glass. The ubiquity of glass in the urban landscape earns it an overlooked status.[2] In the realm of merchandising, glass is the material that revolutionized the display of commodities and goods, yet it is often considered merely a means to display; its function, after all, is to be seen through. What is little considered is the agency of glass, what Margaret Morse calls "vitreous transformation," i.e., its ability to alter, fetishize, and animate whatever lies beyond it.[3] And in regard to window displays, "the plate glass of the storefront," writes Stuart Culver, "invests commodities with a certain supplemental value that ... can't be purchased or consumed."[4] Salloum's photographs, in effect, catalogue the psychic effects of glass, offering a compelling inventory of how objects can be scenified, orchestrated to evoke desire, summoned to infiltrate our interior lives.

JAYCE SALLOUM, HOME MADE CHOCOLATE, installation view, Argos, Brussels, 1999, dimensions variable.

167

IMAGE AND INSCRIPTION

1 For its installation at the Agnes Etherington Art Centre, the title was the former; for the version at the Contemporary Art Gallery, it was the latter. The titles are taken from language found in the installation's photographs, and change with each exhibition venue.

2 Only when glass is smoked, darkened, or mirrored, for example in limousines or business offices, does attention accrue to it as a signal of the opposite – exclusivity.

3 Margaret Morse, "An Ontology of Everyday Distraction," in *Logics of Television: Essays in Cultural Criticism*, ed. Patricia Mellencamp (Bloomington and Indianapolis: Indiana University Press, 1990), 202-3; see also Celeste Olalquiaga on the animation of the dead in *Megalopolis: Contemporary Cultural Sensibilities* (Minneapolis and Oxford: University of Minnesota Press, 1992), ch. 4.

4 Stuart Culver, "What Manikins Want: The Wonderful Wizard of Oz and The Art of Decorating Dry Goods Windows," in *Representations* 21 (Winter 1988): 107.

As much as glass performs psychically, transforming objects and mediating viewers' imaginations, glass is a physical entity. It reveals, yet it also restrains, protects, quarantines. Extolled during the era of arcades and early modern architecture, glass served as the exemplar material of a burgeoning urban aesthetic; its transparency would, many felt, usher in an age of openness and democracy. Architectural visions of entire "cities of glass," crystalline, gleaming and featuring thoroughly unobstructed views, exemplify the most extreme fantasies in the belief in the liberatory potential of glass. Salloum's dissertations on glass, however, allude to dystopic politics and economic uncertainty. Glass that is cracked, taped, gridded, steamed up, or blocked by signs, articulate a reverse mythology: that the materiality of glass, and the promises for both security and enfranchisement which it stands for, are leaky, vulnerable, unstable.

Paul Virilio, in "The Overexposed City," writes of a postmodern city of glass, this one differing from the modernist version by the evolution of the physical city into a simulated one — dominated by the glass of the computer screen and surveillance monitor, a city of pure surface.[5] Salloum's glass city approaches this scenario, especially since the glass of the shop windows imply the glass (or Plexi) framing the photographs on the wall, and from there even allude to the lens of the camera shooting the image. The multiplication and variegation of glass planes, which might lead to the kind of disorientation, dislocation into a non-place, or psychaesthenia — where the boundaries between image and self are obscured — are here counteracted by the artist's three-dimensional installation. Engaging the body negates a purely optical understanding of Salloum's imagery, for the layout brings into play the viewer's corporeality to balance out the de-realizing effects of glass.

Storefront Dreamworlds

In North America, department stores and mall complexes are programmed as "festival" marketplaces, spaces of inclusion where consumers engage in celebratory rituals of acquisition. To enter into these public places is to experience an overdetermined thematic temporality where Christmas, Halloween, or Valentine's Day merchandise and displays

5 Paul Virilio, "The Overexposed City," in *Zone* 1/2, (1986): 15-31.

6 Simon Doonan, employed at Barneys, is a window designer who has gained notoriety. See Guy Trebay, "The Display's the Thing," in *New York Times Magazine*, (November 8, 1998): 61; and in general see Barry James Wood, *Show Windows: 75 Years of the Art of Display* (New York: Congdon & Weed, 1982).

7 Neil Smith, *Uneven Development: Nature, Capital and the Production of Space* (Oxford: Basil Blackwell, 1990).

JAYCE SALLOUM, 22 OZ.
THUNDERBOLT, installation view,
variable dimensions, Contemporary
Art Gallery, Vancouver, March 1999.

JAYCE SALLOUM, untitled (Minnie
Mouse, Mickey Mouse, Barney and
friends, christening wedding birthday
shop, Clinton St., Lower East Side,
NYC), 1994, 50.8 x 61 cm.

parallel the managed seasonal "occasions" marketed by Hallmark cards. In contrast to these hypnotic contexts of consuming pleasure, what Walter Benjamin called "dreamworlds," Salloum's installation returns us to the streets, shaking us awake with images of public space that reveal the dispiriting realist backside of capitalism. Rather than idealized displays, here we see evidence of how individuals "make do" given the brutal truths of commerce.

Often compared to miniature theatres, show windows in urban centres wield a bravura and mystique that earn them the designation of minor spectacles, a popular form of entertainment that has evolved its own lineage of auteurs and devotees.[6] Salloum's vitrine tableaux, however, are far from the glamorous New York creations appearing at Saks, Bloomingdale's, Barneys, or Macy's not only in terms of location but also of sensibility — they are decidedly unspectacular, haphazard, neglected, even abject. His anonymous, quotidian window displays, found mostly in New York City's East Village, document less the drama of leisurely or luxurious consumption than economic distress or what Neil Smith terms "uneven development," i.e., the strategic disinvestment from and subsequent decline of certain areas of a city as other, more politically influential sections grow and become enriched.[7] The number of photographs featuring signs about clearance sales, close-outs, price reductions, and bankruptcy point away from the shop window as an eternal, pristine arena of commodity pleasure to a scenario of financial turbulence and shattering shifts in fortune. While the promises and dreams of capitalism continue undeterred in uptown, upscale department stores and boutiques, the streaked and dusty windows recorded by Salloum invoke narratives of coupon-clipping subsistence. Rather than confirming what

JAYCE SALLOUM, *untitled (textile store display, lower Broadway near Broome St., NYC)*, 1997, 50.8 x 61 cm.

JAYCE SALLOUM, *untitled (cleaning supplies, hardware store/bodega, Avenue B (near 3rd St.), East Village, NYC)*, 1996, 50.8 x 61 cm.

JAYCE SALLOUM, *untitled (bodega, Avenue B and 12th St., East Village, NYC)*, 1994, 50.8 x 60.96 cm.

8 Henri Lefebvre, *Everyday Life in the Modern World*, trans. Sacha Rabinovitch (New Brunswick and London: Transaction Publishers, 1990), 105-6.

9 Michel de Certeau, *The Practice of Everyday Life*, trans. Steven Rendall (Berkeley: University of California Press, 1984), 96.

10 As Susan Buck-Morss has pointed out, however, the "blissful state of the *flâneur* is denial of the other hellish side of the urban phantasmagoria, the shattering of experience due to the neurologically catastrophic, persistent repetition of shock." "The City as Dreamworld and Catastrophe," in *October* 73 (Summer 1995): 8.

11 Jayce Salloum, interview with the authors.

12 de Certeau, 93-99.

Henri Lefebvre calls "the Display Myth,"[8] in which the exhibition of commodities becomes an end in itself, these images reveal the contradictions in the desire for commodities, the breaks in the seamless spectacle of display, the tragedy, banality, and darkness of the consumption ethic.

Lest this interpretation seems to pigeonhole Salloum's photographs as an earnest exposé of urban spatial politics or a fixation with poverty, there is, amidst the surplus of goods and the excess of signage, a vitality to the scenes that nevertheless emerges. It is an energy sparked by cultural complexity, heterogeneous configurations of the local and the global, a syncretic flux of topography and sensibility. The lure of a good deal, a fast buck, a singular find permeates many of the commodity displays from Canal Street, Broadway, Avenue A, or 14th Street. Shelves burgeoning with kitschy knick-knacks, household cleaners, coffee cups, or fake designer paraphernalia attest to an entrepreneurial spirit that despite the best efforts of corporate strategizing cannot be suppressed. This enthu-siasm may be partly due to the colour photography, often shot on sunny days; yet the sense of celebration springs from the diversity of styles and the creative chaos that characterizes the vibrancy of the city.

The storefronts in Salloum's photographs are defined by immediate use or family directives rather than a developer's vision. They fascinate as ruins, places of local and unformalized mythologies lying below the spreading cloud of franchised capitalism. Each shop window arrangement escapes the panoptic standardization of ubiquitous stores like the Gap. They move outside the hegemonic discourse of consumerism by operating beyond the control of the conglomerations' marketplace. The windows of the small businesses lining the streets of the East Village evidence what Michel de Certeau calls "microbe-like, singular and plural practices" which skirt both regulation and collapse to reinforce themselves with "proliferating illegitimacy."[9]

Commodities colonize one's attention in Salloum's images, for actual people are nearly absent. While the photographer may be amongst the crowd, human beings are visible only in a reflection or two. Rather, it is transitional space which is recorded and fixed by the

camera. Whether a public sculpture (which is walked by), a car wash (which is driven through), or a bakery (which is stopped in), what is marked are ambiguous zones of liminality and transience. So unlike Starbucks or Barnes & Noble — those corporately inscribed perches of the contemporary flâneur — none of Salloum's places is one where people would linger.[10] The absence of people, however, is more than compensated by a surplus population of figurines, anthropomorphic toys and media images. These surrogate bodies inhabit a parallel city, one on the other side of the glass, seemingly bearing the potential to reverse the relations of display.

The Phatic Shutter

Salloum's practice of taking photographs works as a kind of visual diary of the act of "passing by." Countering touristic "first-glance" snapshots, he is committed to knowing a place well before photographing it. Daily walks through his neighbourhood in the East Village, where he lived for a decade, dominate

this show. He works intuitively, catching an image at a particular time, often at a moment when he is en route. His process is one of stopping, turning on his heels, snapping the shot, and then moving on without missing a beat.[11] This is so casual that, on occasion, friends accompanying him are surprised to find that he has just taken a photograph. This instantiates what de Certeau has called a "phatic" aspect to walking: moments when walking is interrupted by clearing one's throat, looking at one's watch, saying "hello," or — in Salloum's case — snapping the camera shutter. Despite the inherent visuality of Salloum's practice, his perambulations in the city escape the optical imperative that lies at the heart of photography: "the imaginary totalizations produced by the eye."[12] Contrary to simply viewing surfaces, Salloum explores a spatial practice that fixes moments yet fosters mobility.

JAYCE SALLOUM, untitled (paper products, party items, lottery tickets store, 14th St. (Ave. B/Ave. A) East Village, NYC), 1995, 28 x 36 cm.

JAYCE SALLOUM, untitled (entrance to old tailor shop, now a mixed business selling firewood, coal, AmeriVox long distance, size 9 1/2 x 10 ski boots, 2nd Avenue near 4th St., East Village, NYC), 1996, 12.7 x 17.8 cm.

JAYCE SALLOUM, untitled (discarded phone books and magazines, Mercer St., by NYU, NYC), 1994, 40.6 x 50.8 cm.

13 Jayce Salloum, "Introduction," in *Untitled: Jayce Salloum* (Kingston: Agnes Etherington Art Centre; Vancouver: Contemporary Art Gallery, 1999), 29, emphasis in original.

14 Jayce Salloum, "Untitled: 1988-98," in *Untitled: Jayce Salloum* (Kingston: Agnes Etherington Art Centre; Vancouver: Contemporary Art Gallery, 1999), 41.

15 Edward Said, "Figures, Configurations, Transfigurations," in *Race and Class* 32(1), (1990): 16.

16 de Certeau, 101.

Salloum's position paradoxically draws from and counters the documentary tradition of street photography embodied in the works of Eugène Atget, Walker Evans, Robert Frank, and Gary Winogrand. Saturated with colour, yet anti-formalist, Salloum "make[s] evident the machinery, apparatus and history of documentary, the aggression that documentary partakes in, and the violence that is wrought in its name."[13] Foregrounding the affect of economic disenfranchisement, yet avoiding the romanticization of urban ruins, he seeks "to go beyond a symbolically stated street photography that relies upon the fetish of the moment(ary) (simultaneity, coincidence, serendipity, etc.), into a more conceptual and theoretical arena in the investigation of visual culture, one that maintains direct ties to the actual social referent."[14] The documentary style Salloum practices is a self-conscious and reflexive one in which pleasure, deconstruction, affect, and politics are dialectically interrelated.

The Street as Gallery

Salloum's photographs record the material evidence of presentational gestures: how commodities, objects, and signage have been arranged. In turn, the photographs themselves are clustered and hung on the gallery wall in unusual configurations — in what Edward Said might call "atonal ensembles,"[15] groupings which assert an indefatigable sense of hybridity and heterogeneity. There is an intriguing reversal to the dimensions of display: on the one hand, the street becomes a gallery for the photographer; on the other, the gallery becomes a virtual street for the beholder.

Here the street is Salloum's primary context. While the majority of the photographs record storefronts, businesses, or public spaces, the few that present domestic interiors are significant in that they depict an "inside" counterpoint to street-life's "outside." Their calm, cozy ambience is the bustling street's other, a retreat from the inevitable shocks accompanying a walk in the city. An artist's studio, a friend's kitchen, these are the places away from the street where refuge and regeneration take place.

Many of the storefront displays disclose traces of human presence via the placement

of objects and signage. Whether at the hands of the proprietor of the bodega, the shop cashier, the bakery counter clerk, each store window instances a logic of array, a three-dimensional sign in the rhetorics of the street. De Certeau has described the synecdochal capacity of fragmentary objects to, in effect, expand in space when he remarked that "a piece of furniture in a store window stands in for a whole neighbourhood."[16]

Salloum's photographs do not simply record the surfaces of storefronts, they document the dimensional practices of "outsider" curators — a kind of folk art. Whether in the windows of pharmacies, bakeries, driving schools, or doorways (one has a particularly poignant handwritten sign urging a runaway to call home), we find elements "put together" notwithstanding their untrained, amateur, or vernacular design. These photographs are an implicit examination of display practices — stacking, arranging, or marking — in the

context of ordinary culture. Order and disorder are fluid notions as happenstance and chance rule. Relics and signs collide, revealing an unconscious at work, even if appearing unaesthetic in conventional terms. Hand lettering and misspelling ostensibly tell us something about the person who made them, and to whom they are addressed, be they a potential customer, a runaway, or good Samaritan. Whether such displays are organized haphazardly or carefully, each manifests — however idiosyncratically — particular logics, hierarchies, and sentiments of presentation. It is ironic that despite their transience, Salloum's shop windows exude an ambience of museum period rooms.

The Gallery as Street

In contrast to the instantaneity of the images, captured in a split-second, the process of installation is laborious. Photographs of different sizes — from 5" x 7" to 30" x 40" — have been grouped and meticulously hung in a salon-style arrangement. Whether singly, in pairs, trios, quartets, or in oblong or transverse relationships, they counter the aura and authority of the singular image.

Salloum records the empirical domain — things found, handled, moved, arranged — while at the same time he takes the conceptual role of curator-collector in developing the groupings of images. Photographs have been amassed from different cities, but when displayed in the gallery the thematic of the street appears continuous. One aspect of coherence is evident in the photographs themselves — the point of view of the pedestrian-photographer who traces a path of meaning and affect by his choice of images and trajectories.

Salloum's compositions of photographs recall another trope featured in de Certeau's analysis of walking in the city: that of "asyndeton." In written discourse, asyndeton

17 de Certeau, 101.

18 Trinh T. Minh-ha, "The Totalizing Quest of Meaning," in *When the Moon Waxes Red: Representation, Gender and Cultural Politics* (New York and London: Routledge, 1991), 30.

describes the suppression of linking words such as conjunctions and adverbs. As a figure of pedestrian rhetoric, de Certeau points out, asyndeton "selects and fragments" the spaces traversed.[17] So in addition to the spatiality of synecdoche — where a notable object expands to signify the whole neighbourhood — Salloum's gallery installation disconnects the storefront from the continuous expanse of the street. The hanging of the photographs places elements in spatial relationships which open up lapses and gaps. In the gallery, the photographs act as reliquaries of street affect; records of specific atmospheres, experiences, and moments are configured together, oriented in relation to beholders as if pedestrians themselves.

As viewers engage with Salloum's installation, they adopt a perspective of seemingly perpetual locomotion. The irregular placement of the images on the gallery walls — forcing one to bend down and stretch up to view in detail — makes visitors conscious of their own manner of perambulation. The negative spaces indicate that viewers are not just optical points; for the time of the show, we reside within and negotiate the images and voids on the walls with the entirety of our bodies. The noticeable gaps instantiate what is normally glossed over in more seamless representations — the empty space is room to project, imagine, fill up; viewers are responsible for negotiating these spaces just as much as the images. Like Trinh T. Minh-ha's notion of the interval — "a break without which meaning would be fixed and truth congealed"[18] — these voids destabilize the autonomy and self-sufficiency of the individual images, compelling visitors to consider the possibilities of meaning against, across, beyond the boundaries of the frame.

And what can be discerned from these constellations of photographs? Any reading will necessarily be partial, for the images contain a surfeit of formal, symbolic, social, and iconographic clues. They evoke a range of resonances, from humour to poignancy. A pairing of cigarettes and collectible figurines, for example, appear to make as much of a statement about the addictive aspects of consumption as its pleasures. Issues of control are insinuated when chicken cages and a bank's hand-railed ATM queue are juxtaposed. When photographs of bride-and-groom figurines atop a wedding cake, a baseball team

JAYCE SALLOUM, *untitled (car wash, 24th St., Chelsea, NYC), 1995, 66.2 x 101.6 cm.*

JAYCE SALLOUM, *untitled (icon and print shop, 14th St., East Village, NYC), 1994, 60.9 x 66.2 cm.*

perched on a field of frosting, and an advertisement for guns and beer are clustered, the concept of "togetherness" doesn't seem so natural, peaceful, or beneficial to society. A column of photographs picturing housewares, a plea for wayward son to return, and cheap firewood, strike an uncanny note whereby the home can be just as easily an ominous as inviting place. The profusion of celebrity images — of sports heroes, fashion models, movie icons — at once call to mind the hope (and futility) of star worship, and the irony that the uniqueness of the idol depends upon mass production and popular identification. Yet these thoughts are only a few of the numerous possible linkages one could articulate. The circuits of meaning at play here are manifold, and each viewer will walk away with his or her own network of interpretations.

Imperfect Mirrors

It is not easy as it first seems to situate ourselves in such a virtual street. While the grids underlying the installation imply a certain logic of connections between images at once striking and evanescent, they are not without a certain type of anxiety, manifesting what the artist has termed "productive frustration."[19] Resisting any form of singularity, for either himself as photographer or for us as viewers, these photographs demand the adoption of a motile subjectivity. Their diversity, occupying all positions on the spectrum of aesthetic possibility — alternatively seductive/repulsive, intriguing/banal, formally sophisticated/snapshot raw, empathetic/voyeuristic, surreal/documentary — replicates not the identifiable, trademark vision that is so often demanded of an artist, but the fractured, fluid experience of living and being in a contemporary metropolis.

Since the glass of the show windows (and the glass of the photographs) both reflect and allow the viewer to peer through, it performs as an imperfect mirror, forcing viewers into a kind of protean mirror stage. Unlike the psychoanalytic version, in which the child amalgamates inchoate, disjunctive bodily sensations into a coherent image of the self, Salloum's reflective surfaces yield a multiplicity of subject positions and sensibilities — images of the self splintered by commodities, signs, architectural forms. Coherence of the

JAYCE SALLOUM, untitled (reward poster, motorized toys and sales items, Love discount drugstore, 14th St. and 1st Ave., East Village, NYC), 1996, 50.8 x 28 cm.

JAYCE SALLOUM, untitled (Love discount store, 14th St. and 1st Ave., East Village, NYC), 1993, 28 x 36 cm.

JAYCE SALLOUM, untitled (NY Yankees, Audrey Hepburn, Marky Mark, Bruce Lee, Betty Page, Mike Tyson, Micky Mantle, Al Pacino (Scarface), and friends, framing shop, Broadway and 17th/Union Square, NYC), 1993, 40.6 x 50.8 cm.

19 Jayce Salloum, interview with the authors.

JAYCE SALLOUM, *untitled (home made chocolate, Lafayette St., NYC)*, 1994, 50.8 x 60.9 cm.

20 For a discussion of the "stranger/*flâneur*" complementarity, see Rob Shields, "Fancy Footwork: Walter Benjamin's Notes on *Flânerie*," in *The Flâneur*, ed. Keith Tester (New York and London: Routledge, 1994), 68.

21 Fredric Jameson, *Postmodernism, or, the Cultural Logic of Late Capitalism* (Durham, NC: Duke University Press, 1991), 38-54.

22 Salloum, "Untitled: 1988-98," 41.

23 Elizabeth Grosz, "Bodies-Cities," in *The Sexuality of Space*, ed. Beatriz Colomina (Princeton: Princeton University School of Architecture, 1992), 248.

24 Rosalyn Deutsche, "Art and Public Space: Questions of Democracy," in *Social Text #33* (1992): 49.

self is not an end, the stability of identity not a goal.

Through the photographs, one can read a variety of gazes: the first is that of resident, in which the photographs reveal an intimacy with a neighbourhood, where ordinary sights acquire a patina of significance by virtue of their familiarity. The newsstand, bank, or coffee shop are instrumental reference points necessary to the day-to-day negotiation of the city. The second is that of the tourist, prowling for bits of local flavour to visually consume, seeking souvenirs of the streetscape to savour at home. We can also see the documentary gaze of the sociologist, ethnographer, or journalist present here. The details of the everyday framed against each other could conceivably be used to compose a collective portrait of how members of a particular community live, work, desire, and survive — if we only had an elucidating textual component. Some photographs seem to embody the detective gaze, whereby objects act like mute clues, environments like crime scenes seething with narrative potential. A political edge manifests many of the images, and it is the eyes of an urban activist that are invoked as the photographs portray the injustice of the city's social and economic policies. There is also something of the flâneur's appreciation of the ironic and oneiric in these metropolitan tableaux; looking at them one identifies with the visual connoisseur who relishes odd juxtapositions, uncanny ambiences, or arresting contradictions. Finally, the images here evoke the sensibility of a stranger.[20] As much as any particular scene is familiar, there is a peculiar overlay of liminality, otherness, and alienation, a dislocation, that prevents us from knowing exactly which side of the outsider/insider divide we inhabit.

During the time Salloum photographed the streets of New York and other cities for this installation, a phrase (re-)entered critical discussion of the politics of space and urban geography — "cognitive mapping."[21] The revival of the term was in response to the search for a tool by which a comprehensive understanding could be made of the pluralities, ambiguities, and discontinuities of postmodern space and society. Several assumptions are implicit in the notion of cognitive mapping: that a unitary, totalizing representation of the city is necessary to urban living; that space is a static, passive backdrop to human

will and desire; that mastery and resolution of difference is the primary goal of residing in a complex environment. The grid-like schema underlying Salloum's installation may give the impression that his cartography of the cityscape aligns with the objectifying principles of cognitive mapping, yet the effect of the photographs is, if anything, subjective and contestatory. Salloum's mapping methodology identifies places where divergent histories and cultures intersect, and "specific acts and struggles of representation are played out."[22] The themes, interpretations, and connections one makes between the photographs are multiple and equally plausible. The fact that the artist changes the exhibition title with every venue, and periodically adds to the collection, underscores that this representation of the city is resistant to the singularity of cognitive mapping and is, instead, protean, partial, and dynamic.

For Salloum, the ambiguities of the postmodern metropolis are not something to be controlled or eradicated but sought out and heightened. The space of the cityscape is not experienced as prima materia but in an ongoing relationship with the self. Bodies and the built environment are, as Elizabeth Grosz asserts, "mutually defining."[23] In turn, the aesthetic experience may act upon us just as Salloum's titles suggest: contexts may wash over us (like the car being cleaned in *NEUTRAL/BRAKES/STEERING*) or we may be hit out of the blue (by the lightning seen in *22OZ. THUNDERBOLT*). The fragmentation foregrounded by Salloum need not be immediately assumed to be problematic. For Rosalyn Deutsche, fragmentation is a positive, restorative process because it "allows the perception of conflicts, heterogeneity, and indeterminacy in the social, a precondition of the search for new kinds of common ground."[24] Salloum's installation continues in the photographic tradition of imaging the street — but avoids the urge to make the city comprehensible, legible, stabilized. It is precisely the embrace of the urban streetscape's irreducible complexities and polyvalency that demonstrate the intertwining influences of space and identity.

JAYCE SALLOUM, *untitled (kids clothing store, Broadway, downtown Los Angeles)*, 1997, 50.8 x 60.9 cm.

IMAGE AND INSCRIPTION

* * * * *

This essay is a slightly revised version of the original appearing in *Untitled: Jayce Salloum*, Kingston: Agnes Etherington Art Centre; Vancouver: Contemporary Art Gallery, 1999, 19-26. Reprinted by permission.

ENTRE LA VIE ET LA MORT

Menton June 2003

Because of Burning and Ashes:
A Few Works by Robert Frank and Lani Maestro

Stephen Horne

So, he said, what's the point of art? Her answer: it's life of course.
But then, what if the point of art is art? Wouldn't that be the same?
No, she said, that would be different, the difference of death.
The work of life lives its death while the work of art lives its life.[1]

ROBERT FRANK, *Entre La Vie et La Mort*, 2003, digital ink-jet print with hand-applied text, 33 x 24.1 cm. Copyright Robert Frank. Courtesy of Pace/MacGill Gallery, New York.

Robert Frank: Turning the Sky Dark

What then is this phrase of yours, "entre la vie et la mort;"[1] what could possibly be "between" life and death? But, if there is nothing "between" the two, can they be different? What is between pairs of frames facing each other from within other frames? The frames are from the work titled *Entre La Vie et La Mort* (2003) in the series *Memory For The Children*. The work, four Polaroids patched together in two pairs, presents images of a framed screen, in each case a large and imposing frame against which has been placed, in each separate Polaroid, a smaller frame containing even smaller frames. The work is given an occasion with a handwritten text placing the work: "telephone conversation with Martine Barrat from Paris 2003." The work is further identified by the place, date, and signature of the artist: Mabou, June 2003, R. Frank, which appears in the lower frame of the upper right image. Frame and images of frames make a consistent appearance through the series of Polaroid works and so we are sent in search of the photographic "there" and "now," perhaps leaving home, coming home. This search for place though, as artists have so often pointed out, compels us to pursue the bond of place to love and to death. As Maurice Blanchot wrote, "Death suspends the relation to place...the place is missing,"[2] or, the place is the place of that abandonment photographer Roni Horn says, "casts us into an abrasive and exquisite consciousness."[3]

1 Robert Frank, in his work titled *Halifax Infirmary*, 1978.

2 Maurice Blanchot, *The Space of Literature*, trans. Ann Smock (Nebraska: University of Nebraska Press, 1982), 256.

3 Roni Horn, *Roni Horn* (London: Phaidon Press Ltd., 2000), 121.

BECAUSE OF BURNING AND ASHES | STEPHEN HORNE

ROBERT FRANK, *I Want to Escape,* **1993, two gelatin silver prints, sheet: 50.3 x 80.1 cm. Robert Frank Collection, Gift of Robert Frank. Copyright Board of Trustees, National Gallery of Art, Washington, DC. Copyright Robert Frank. Courtesy of Pace/MacGill Gallery, New York.**

4 Robert Frank, *Polaroids,* 1971–2000.

5 Jacques Derrida, *Writing and Difference,* trans. Alan Bass (Chicago: The University of Chicago Press, 1978), 66. Derrida talks about estrangement or exposure to otherness, a site of in-betweeness that is a source, synonym for homecoming and self-discovery in his observations on the Judaic paradox of "site" found in the work of Edmund Jabès. In this case, homecoming does not refer to any sort of fixed abode but to a place of transit located between self and other and between nearness and distance. Homecoming as found here means that transit through otherness that is fundamental for any ethics. The "now" as the "there," the site, the place. Jean-Francois Lyotard, *The Inhuman,* trans. Geoffrey Bennington and Rachel Bowlby (Stanford: Stanford University Press, 1991), 89.

6 See the work *I Want to Escape,* 1993. Image/ text *The Past, Silence — the sky turns Dark — no one lives here anymore. I want to escape.* In Robert Frank, *Moving Out* (New York: Scalo, 1994), 293.

7 Robert Frank, in his work titled *Halifax Infirmary,* 1978.

8 Heraclites, *Heraclites and Diogenes,* trans. Guy Davenport (San Francisco: Grey Fox Press, 1976), 11.

9 Robert Frank, in his work titled *Memphis,* 1955–1990.

10 Luce Irigaray, *An Ethics of Sexual Difference,* trans. Carolyn Burke and Gillian C. Gill (Ithaca and London: Cornell University Press, 1993), 11.

In these Polaroids,[4] that intimacy of experience — your daughter's death, your son's death, so many goodbyes — you draw us with you through life-pain toward the Outside, a homecoming toward the source, toward the site. This exodus, a transit through otherness, this uncanniness that derives from estrangement, may be the "fire" of which you speak.

You have had to think drastic thoughts. The thought of oblivion, the thought of each day and of finding the right road in the night. Of the where of home and its life. Of it never being where you believed, constantly elsewhere, always gone, outside, in the forgetfulness that is forgotten. For this site, this land, calling to us from beyond memory, is always elsewhere.[5]

Photographer, you turn the sky dark. When night comes, you participate in that darkness.[6] "Sick of goodbyes," you say, end the dream. Isn't this how we finally get to think oblivion, that space of love and of death? Thinking of her everyday, getting at home with pain, with the body, You said, "the wind will blow the fire of pain across everyone in time"[7] —"fire catches up with everything, in time."[8] You said, "watch out for hope," and you said, "no one lives here anymore, I want to escape."[9] What moves you toward me is her death. The *thought* of her death, a thinking which comes from Outside. Thinking of you not being there beside me each day.

But those houses, those words, envelopes with which to surround ourselves, that nostalgia for a first and last home, you would burn them to free yourself into meeting and living with the other. Is home "…a nostalgia that blocks the threshold of the ethical world?"[10]

The Polaroids. Scratching, writing into these Polaroids, you disrupt yourself. You crash my regard down in this destruction of a photograph toward its own death. Andrea's death becomes the death of the image, destruction of representation, a disfigurement of illusion this opening toward the psychically real. Welcoming and moving toward the oblivion of a pure materiality, the corpse, bringing the photograph toward earth.

These Polaroids let you destroy that image, that perfect image. A destruction opening a void where matter can be matter, wanting nothing, as words want nothing, undoing any

capacity for thought. It is the *there*, the void you call the soul, but which "far from being mystical, …it is, …material,"[11] in the sense of "matter in the arts, i.e., presence."[12] "Now" could be the point of these acts of destruction. Materiality, itself another point, and the site, a place where materiality and the "now" coincide.

The sculptor Robert Smithson often called attention to the materiality of language, linking words and rocks that "contain a language that follows a syntax of splits and ruptures. Look at any *word* long enough and you will see it open up into a series of faults, into a terrain of particles each containing its own void."[13] Words drying in the wind in a bleak sky over a bleak ocean, rocky coastline, Mabou, 1977. This is wo/words,[14] painted black on white, words in the cold sky landscape. Words framed in paint, stark severe warning of stormy weather and worse to come. Things get worse not better, they turn into wo/words, ruined, made into an abyss. Perhaps "…words themselves, in the most secret place of thought, are its matter, …what it cannot manage to think… Words want nothing. They are the 'un-will,' the non-sense of thought, its mass… They are always older than thought…. But like timbres and nuances, they are always being born."[15]

11 Lyotard, *The Inhuman*, 150.

12 Ibid., 138.

13 Robert Smithson, *The Writings of Robert Smithson* (New York: New York University Press, 1979), 87.

14 References the image titled *Mabou*, 1997.

15 Lyotard, *The Inhuman*, 142.

Desolate, damaging landscape. A desert, a paradox, that the sublime in this instance is impossible. Representation of the sublime destroyed by the here and now of this photograph. Trying to get to nothing, you scratch and draw your way of disruption across those Polaroids, away from essence, flooding/freeing filmically what has been held either inside or outside. You create an epitaph, one that works against memory, destroying itself toward the "now" of materiality itself. An epitaph that kills memory, eats it to feed imagination, exchanging present for past, and imagination for memory. Marguerite Duras, novelist/filmmaker once wrote, "Then when you wept it was just over yourself and not because of the marvelous impossibility of reaching her through the difference that separates you."[16] In this case, the difference is death, ultimate subtraction of being, radical scattering. And what of love, that other self-dispersal, the losing that is a way of being more? In this space, made by death and by love we are drawn into beauty, by blindness. As you drew over your images, by blind — love — faith.[17]

Lani Maestro: The Invisible Colour of Air

Living death coming to my other. Alterity beside me. Holding hands. Embracing death. Coming to identity that knows its belly.[18]

Framing a house, a text, or a picture is a foundational step in the building process. With this framing begins a structure with which to secure a certain permanence. What could not be framed in this way? Perhaps an ocean, that sea of forgetting, of crossing to the other side. "Thick" is a sound, a book thick of ocean. What is "thick" is materiality, an image is what is thin. An awkward phrase, "a book thick of ocean." The title for a book, a thick

16 Marguerite Duras, *Malady of Death*, trans. Barbara Bray (New York: Grove Press, 1986), 54.

17 Text from Robert Frank, *Blind, Love, Faith*, 1981.

18 Lani Maestro, *Death in The Family* (Vancouver: Presentation House Gallery, 1997), 13.

book, a book almost too heavy to lift, a thing full with its weight, the weight of ocean and of paper. A thing dense with your own voyage through mortality, into the body of life-pain. This materiality, flesh thick with its blood which is movement, time. This ocean, outward, an *into* which is more of a *toward*. Toward the outside, dispersal into disappearance, into what is elemental but perhaps more accurately into that silence, night, forgetting, suffering, death, and nothingness that are sometimes called the sublime.

An ocean that is wide enough, deep enough to be lost in, an ocean to voyage, leaving home, coming home. Going outside, to the other, returning to the source. And, in another water, one sees oneself, or the doubled surface of one's self, an other, like a photograph. Photographic water, water of forgetting. Water disperses, the virtue of its dis/appearance emptying itself and going toward a you. A gift. Like the fire of the first metamorphosis, fire into sea, sea into earth, a homecoming, a return to sources. And yet, fire will not burn without air, rapid oxidization. (Fire catches up with everything, in time.) Can there be earth before air? Can there be appearance before dis/appearance? You try to conserve disappearance, another venture in paradox. Page after identical page, how many, perhaps five hundred? You turn my pages, you burn my fingers with your images of ocean, this melancholy of love and death.

Video is in my imagination an electro-magnetic medium. It sucks things up, like a water tap in reverse. Video imagery is spewed out in a rectangular format, a frame with temporal continuity that is mere duration, like turning a water tap on in any city, it just runs and runs. We place two monitors side by side and this feeling becomes evident. Even better, you present two images of eternity on the two monitors, ocean surf rolling onto a beach. Two images the same so far as we can say. The waves roll in, frontally filmed to emphasize the rectangularity of the monitors and their plinth, and the structured space of the room. The doubled image of surf rolling in contradicts itself, this icon of nature's originality and uniqueness. The conundrum posed by having two waves the same is at the source of the framing; permanence, imposed closure which fragments the event from the flux of time, from disappearance. Where disappearance is itself "disappeared," and made permanent.

IMAGE AND INSCRIPTION

a book thick of ocean

19 Marguerite Duras, *Malady of Death*, trans. Barbara Bray (New York: Grove Press, 1986), 32.

20 Lyotard, *The Inhuman*, 142.

21 Ibid., 150.

22 Sam Mallin, unpublished letter to the artist.

23 Lyotard, *The Inhuman*, 98. "The failure of expression gives rise to a pain, a kind of cleavage within the subject between what can be conceived and what can be imagined or presented. But this pain in turn engenders a pleasure, in fact a double pleasure: the impotence of the imagination attests a *contrario* to an imagination striving to figure even that which cannot be figured, and that imagination thus aims to harmonize its object with that of reason — and that furthermore the inadequacy of the images is a negative sign of the immense power."

Sifting. You stop looking. Stop looking at anything. You shut your eyes so as to get back into your difference, your death.[19] You have covered your face with your hands, a protection in the face of photographic visibility, of being rendered as an interior, a self. A protection that allows you to regain the space of desire, difference, the unsayable, emptiness, solitude, or death. Sending me into the reciprocity of our becomings.

Two white frames on a floor near a wall. One frame "full," one frame "empty." The empty frame introduces the architectural relation. The "empty" frame "gathers"; the Outside passes through, this is the fullness of the two frames but it is also what is blocked by the frame with the image. Your face blocked, empty, and full are interlaced. Emptiness is fullness as in breathing. This void we think of as a pregnancy, as readiness. What is a frame that is made of a powder like flour? How can such a frame hold against the dispersing waters of wind, rodents, or time? What is a frame but the death of difference or the love of appearance?

These frames of flour, a material between the body and the earth. Where the frame renders conceptual the void of difference. This "flesh" as Lyotard described it, "...does not question the mind, it has no need of it, it exists, or rather *insists*, it sists 'before' questioning and answer, 'outside' them. It is presence as unpresentable to the mind, always withdrawn

from its grasp. It does not offer itself to dialogue and dialectic."[20] He pursues this commentary on material, linking experience of music and "...colour, in its being-there..., appears to challenge any deduction. Like the timbre in music, it appears to challenge, and in fact undoes it. It is this undoing of the capacity for plot that I should like to call soul. Far from being mystical, it is, rather, material. It gives rise to an aesthetic 'before' forms. An aesthetic of material presence which is imponderable." [21]

In a *book thick of ocean*, we are confronted with this sense of the imponderable, a contact with the unsayable. Hundreds of identical pages, a voyage into the erasure of repetition, of destruction, a paradoxical nothingness, that can equally bring us toward death, or love, or the two. Each a "...rending bond that makes us feel all the tenuousness and dangerous mortality of life and history...the pain of exile and alienation everywhere, pain of dislocation and loss."[22] Pain can be further thought of as difference, here as that difference between experience and symbolizing.[23]

LANI MAESTRO, *a book thick of ocean*, 1993, installation with hardbound book 60.9 x 48.2 x 3.8 cm, approximately 500 pages, offset printing, silver stamping on linen cover, and oak table. Collection of The Canada Council Art Bank, Ottawa. PHOTOS Lincoln Mulcahy.

Caught Up In Disappearing

Intimacy, private memory, spontaneity, immediacy, self-reflexivity, are not stylistic goals but procedures by which to undermine authoritative discourse. Insistence on bringing

LANI MAESTRO, *Sifting,* **1991, white flour, colour photograph, 27.9 x 35.5 cm. PHOTOS Pierra Palucci.**

private experience into the present and into art institutional discourse, "life-pain" into public space and so into narrative where each is disrupted and reworked, is a process of destruction and of unworking the frame. Robert Frank draws himself back into experiencing by way of his images and of his subsequent defacement of those images in the process. "Keeping in touch" with one's experiencing requires practices of resistance and destruction in the face of whatever confuses us, distances us from our own experiencing. What happens when art experience hits the windshield of the art institution? Symbolization needs feeling, colonizes it for its own ends, but is inevitably altered, destabilized in this process.

That death is the fundamental subject of art and photographs is often remarked. The unrepresentable reality or "hereness" of death is a proposal undermining the false (full, present) and representable reality of life in favour of flux and difference. Say the same for love, these two subtractions that grind up the wholeness, the unity, and the identity of the individual. But, in life, self-dispersal, the lessness that scatters identity, is also accretion, a way of being more. If one must love in order to destroy, one must also, before destroying, have freed oneself from everything — from oneself, from loving possibilities, and from

LANI MAESTRO, *dream of the other (rêve de l'autre)*, 1998, two slide projectors, slide dissolve unit, audio recording, dimensions variable Installation view, La Central Gallery, Montréal. PHOTOS Paul Litherland.

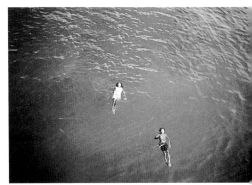

things dead and moribund — by way of death itself. This formulation of Blanchot's could be a description for an ethics of compassion.

This undermining of false fullness is the movement toward Outside. From the perspective of being-in-the-world, in existing one is always already outside, in the world through one's projects but delimited by one's own mortality, which, ontologically, is always prior. What is privileged is not an interiority but this "exile," a "homelessness" that is closer than home. A condition that makes our existing radically relational, deeply "with others." This is difference enacted through the materiality of the work of art, which arises in the alterity of the earth, its exteriority, its irreducibility to the world's concepts and categories.

Strange, this rendezvous between experience and death in art. But not so, if by experience we understand that flow of feeling that one can detect inwardly at any moment: the real is the experienced. And if by love or by death we can understand that release of ego and identity boundaries that initiates us into difference, that outside to oppositions, finding our way to the multiple contacts of a purely relational being. The immanence of this self-extensibility is perhaps what we call beauty. It makes appearances shine, pregnant with all the space beyond themselves, with all the hospitable otherness in which they are perhaps about to replicate and dissolve. The various modes of this human extensibility into the world underlie the critical ethic intuited through these works, speaking on the other side of a certain joyousness we may take pleasure in if we allow ourselves to be blinded by the radiance of art's bodies.

Pursuing counter-authoritative approaches to photographic work, these artists have found sources of resistance to "abstract" formation in the events of their own daily lives, making space by withdrawing, creating void as an alternative to occupying or dominating space. Robert Frank and Lani Maestro begin with, and return to, experience as the space where the boundaries of private and public, inside and outside, will be sent into perpetual displacement, each by the other. Both love and death point us in the direction of mystery, the uncanny and not-knowing. There, incorporated, they undermine our alienation by reminding us of our own finitude, making place in the "there" and the "now."

Questions of Obsolescence

Robert Bean

There is always something uncanny about a photograph; in the freezing of the moment the real is lost through its doubling. The unique identity of a time and a place is rendered obsolete. This is undoubtedly why photographic reproduction is culturally coded and regulated by associating it closely with the construction of a family history, a stockpile of memories, forcing it to buttress that very notion of history that it threatens to annihilate along with the idea of the origin.[1]

—— MARY ANNE DOANNE

CHERYL SOURKES, *Cam Cities: Virtual London* (detail), 2001, vinyl banner print, 121.9 x 182.8 cm.

191

IMAGE AND INSCRIPTION

PHOTOGRAPHY IS COMMONLY UNDERSTOOD as a surrogate for memory. Conversely, the temporal and phenomenological associations of photography reside in the domain of loss, oblivion, and forgetting. Typically, the photograph coincides with memory in the context of narrative, lived experience, and history. The optical description of the referent that occurs in a photograph has a fundamental difference to the selective and irrational process of human memory and the ideology associated with public archives and collections.

Although the indexical foundation of the photograph continues to be decisive for the reception and interpretation of images in contemporary culture, the movement from photographic objects to digital media has instigated critical questions concerning the phenomenology of the image, embodied experience, and systems of memory. Within a contemporary framework, the deliberations on memory and forgetting in the discourse of photography are also receptive to considerations of *paramnesia*, otherwise known as déjà vu. As an affect of human experience and temporality, déjà vu is a distortion of memory. Neither remembrance nor forgetting, the effect of déjà vu has a significant relation to modern technology and media. As Peter Krapp has observed:

Early ideas about déjà vu were contemporary with the invention of media technologies such as photography, telegraphy, and phonography. Granting access to and control over repetition in an unprecedented way, these and later technologies instigate the debates around déjà vu, learn to harness the déjà vu effect, and in

1 Mary Ann Doanne, "Tecnophilia: Technology, Representation, and The Feminine," in *The Gendered Cyborg: A Reader*, eds. Gill Kirkup, Linda Janes, Kathryn Woodward, and Fiona Hoevendon (London and New York: Routledge, 2000), 120.

CHERYL SOURKES, *Interior: Lloyds of London,* **UK, 2003, light-jet print, dimensions variable.**

QUESTIONS OF OBSOLESCENCE | ROBERT BEAN

2 Peter Krapp, *Déjà Vu: Aberrations of Cultural Memory* (Minneapolis and London: University of Minnesota Press, 2004), x.

3 Marshall McLuhan, *Understanding Media: The Extensions of Man* (Cambridge and London: The MIT Press, 1994), 22-73.

4 Paul Virilio, *Open Sky,* trans. Julie Rose (London and New York: Verso Press, 1997), 9.

5 Walter Benjamin, "Surrealism: The Last Snapshot of the European Intelligentsia," in *Walter Benjamin: Selected Writings, Volume 2 1927-1934* (Cambridge and London: Harvard University Press, 1999), 210.

6 Sharon Beder, *Is planned obsolescence socially responsible?,* Engineers Australia, (November 1998): 52.

the end transform the experience of déjà vu. Thus media technology accelerates a history of déjà vu that complicates our relation with the familiar.[2]

It is the "relation to the familiar" that has relevance for photography in an era of digital and electronic teletechnology. At this moment in the evolution of digital technology, photography's relation to experience and memory is transformed by the information industries that utilize and consume it. Evident throughout the practice of contemporary art and photography are recurring investigations of identity, history, and the culture of obsolescence. The duration associated with individual memory is frequently superseded by the rapid temporality of machine time and the reified memory of institutions. Contemporary formations of remembrance and forgetfulness, however, may not be readily condensed to the mechanisms of storage, accumulation, and data retrieval that are inherent to digital media. The acceleration of experience induced by modern technology has a fundamental relation to obsolescence. Marshall McLuhan anticipated the transition from anxiety to boredom in the cultural evolution of electronic media and information technology. Observing the transformation of content to pattern as well as the non-linear destructuring of reception that occurs with electronic technologies, McLuhan perceived an anaesthetic or numbing influence on human sensorial perception. For McLuhan, electronic media was the extension and reconfiguration of the human aesthetic experience.[3] For Paul Virilio, duration itself could be eradicated by the acceleration of time and the dislocation of space through telepresent technologies.[4] Not surprisingly, both authors recognize that art has a significant contribution to make in relation to these effects. Consequently, we may ask, how will art that engages these technologies affect the potential outcome of material and temporal obsolescence?

The Question Concerning Obsolescence

It was the residue of obsolescence that gave Walter Benjamin a motive for his investigation of the Paris arcades. Benjamin identified the expired aura of the artwork at the end of the nineteenth century as a source for his theorization of photography, film, and mechanical

reproduction. A hypothesis that was open to a redemptive future transformed by "revolutionary nihilism." He commended the Surrealists for their insightful use of outmoded culture in their literature and art:

[Breton] was the first to perceive the revolutionary energies in the "outmoded" — in the first iron constructions, the first factory buildings, the earliest photos, objects that have begun to be extinct, grand pianos, the dresses of five years ago…. No one before these visionaries and augurs perceived how destitution — not only social but architectonic, the poverty of interiors, enslaved and enslaving objects — can be suddenly transformed into revolutionary nihilism.[5]

With every consideration of the passé, Benjamin revealed how the detritus of capitalist culture continued to unearth the ways that memory and oblivion were encrypted as images. Arcades, the nineteenth century precursors of the shopping mall, were dream worlds of commodities and desires from which the cultural present would awaken. Anticipating the end of the twentieth century, Benjamin's legacy of obsolescence would seem to be more relevant today than ever before. For dreaming and obsolescence characterize our way of life.

The question concerning obsolescence should be self-evident to any consumer living in Western culture. As early as 1934, engineers at General Electric were working to increase the sales of flashlight bulbs by intentionally decreasing the lifespan of the product. With obvious economic benefits, these manufacturing strategies were readily adopted by the automotive industries as well.[6] Now understood as an ethical and environmental dilemma, planned obsolescence (the intentional design of inferior products) and planning for obsolescence (anticipating the rapid exhaustion of styles as well as the fluctuation of software and hardware products in the digital industries) are paradigmatic phenomena of industry and consumer lifestyles. Moreover, the rate of economic affluence is linked to expenditure, which is, in turn, dependant upon obsolescence. This is perhaps best characterized by the flux in digital technologies and the constant updates one must obtain in order to stay current, culminating in the need to buy a new computer in order to support the

7 Walter Benjamin, *Charles Baudelaire: A Lyric Poet in the Era of High Capitalism* (London and New York: Verso, 1969), 146.

8 Clement Greenberg, "The Camera's Glass Eye: Review of an Exhibition of Edward Weston," in *Clement Greenberg, Collected Essays and Criticism*, vol. 2, ed. John O'Brian (Chicago: University of Chicago Press, 1986), 60-61.

9 From the rhyme "Gelatine" by Marc Oute in *British Journal of Photography Almanac* (1881): 213. Quoted in Beaumont Newhall, *The History of Photography* (New York: The Museum of Modern Art, 1964), 88.

10 Michel Foucault, *The Archaeology of Knowledge*, trans. A. M. Sheridan Smith (London: Tavistock, 1972), 7.

11 A comprehensive reference to the Stieglitz image of *Fountain* within the context of the history of photography may be found in Sarah Greenough, Joel Snyder, David Travis, and Colin Westerbeck, *On the Art of Fixing a Shadow: One Hundred and Fifty Years of Photography* (Washington, DC: National Gallery of Art; Chicago: Art Institute of Chicago, 1989), 227-233. In the art historical context of Marcel Duchamp, see Thierry de Duve, *Kant After Duchamp* (Cambridge: The MIT Press, 1996) and William A. Camfield, *Marcel Duchamp Fountain* (Houston: Houston Fine Art Press, 1989).

latest software. The volume of garbage that we produce is a measure of our prosperity.

The transformation of déjà vu and the vicissitudes of technological transition and obsolescence are contemporaneous with the historical epoch that generated photography. Lacking an identifiable tradition, photography's transparent function as a document was privileged over its status as an autonomous art form. Immediately seized upon for its instrumental applications in the discourses of science and economics, its slow acceptance as an art form is evident in Baudelaire's statements regarding the "startling and cruel"[7] effects of the mechanistic reproduction that would deplete the artwork of its "aura." Eighty years later, the formalist critic Clement Greenberg[8] would make an insightful yet disparaging declaration that photography's indexical limitations would obstruct the transcendent properties that are required of an autonomous artwork.

The transition in photographic technology from the nineteenth-century gelatin silver processes to digital media has lately prompted copious observations on the obsolescence of photography itself. Often misunderstood as disappearance rather then transformation, this discourse has been encouraged by doctrinaire nostalgia. It is worth noting that the transition from collodian to gelatin emulsion in the late-nineteenth century was also received with a similar misunderstanding and longing. Marc Oute's rhyme pokes fun at the dread that was generated by the changing photographic process:

Onward still, and onward still it runs its sticky way,

And Gelatine you're bound to use if you mean to make things pay.

Collodian — slow old fogey! — your palmy days have been,

You must give place in future to the plates of Gelatine.[9]

Déjà Vu

[I]n our time, history is that which transforms documents into monuments.[10]

— MICHEL FOUCAULT

The envisioned threat of obsolescence attributed to the emergence of new imaging technologies has actually emphasized the critical relevance of photo-based art. Photography

© Copyright Gruppe Deutsche Börse

CHERYL SOURKES, *Interior: Dax, Germany,* 2003, light-jet print, dimensions variable.

and photo-based art of the last thirty years have been significantly informed by the ingenuity of avant-garde art during the twentieth century and the defining role that photography has had in both Pop Art and Conceptual Art. A significant feature of this development has been its correlation of image and language, a central concept shared with poststructuralist theory. It fulfills, to some degree, what László Moholy-Nagy and Walter Benjamin agreed would be the literacy of the future — the ability to read and caption photographs. If conventional photographic practice has failed to realize this opportunity, it may be that the strategic use of these tools in Conceptual Art has been more edifying. The dialectic between the practice of art and the photographic document can no longer be reduced to an ahistorical dichotomy of real and fiction, authentic and inauthentic, and so on. Rather, the diverse and situated practice that has emerged in photography during this period has critically redefined the social, cultural, and indexical authority of the documentary photograph and continues to have a significant influence on the discourses of postphotography.

Photographers have always been attracted to fountains. In 1917, Alfred Stieglitz made a photograph of Marcel Duchamp's *Fountain* that, in all estimation, has retained patent consequences for the history of twentieth-century art. Paradoxically, this photograph has received marginal acknowledgement from within the accredited histories of photography.[11]

Duchamp submitted *Fountain* to the Society of Independent Artists at the Grand Central Palace under the pseudonym of Richard Mutt in April 1917. *Fountain*, an inverted urinal displaying the crude signature of R. Mutt, was subsequently rejected from the exhibition that had guaranteed participation to any artist that paid a six-dollar entry fee. Duchamp, one of the organizers of the exhibition, used his undisclosed identity to generate a series of events and documents around the scandal of the excluded object. Understood today as an art historical anecdote, the concept of the readymade would receive validation and the terms and conditions of what is named "art" would be radically redefined.

To protest the exclusion of *Fountain*, Duchamp resigned from the Society of Independent Artists without revealing his complicity in the R. Mutt case. At the same moment, he asked

Alfred Stieglitz to photograph *Fountain* for a commentary in the magazine, *The Blind Man*, apropos the censorship of the urinal. Stieglitz consented to the request, relocated the urinal to Gallery 291, and photographed it using a Marsden Hartley painting, *The Warriors* (1913), as an oblique backdrop. Not only did Stieglitz provide the urinal with a temporary exhibition space at Gallery 291, he also established an axiomatic relation between painting, photography, and the readymade with his photographic document. The formal qualities of the Stieglitz photograph and the lighting, vantage point, and the relationship of the urinal's shape to the graphic composition in the Hartley painting are often cited as an influence

12 Camfield, *Marcel Duchamp Fountain*, 33-38.

13 de Duve, *Kant After Duchamp*, 412.

on the history and reception of *Fountain*. The toilet quickly acquired the anthropomorphic attributes of both a Buddha and a Madonna and eventually appeared in *The Blind Man* with the caption "Buddha of the Bathroom."[12]

A testament to both photography and obsolescence, all that remains of the original *Fountain* is the photograph by Alfred Stieglitz. Although Duchamp authorized a set of replicas in 1964, Stieglitz's photograph is the presence of absence.

Stieglitz exhibited *The Steerage* (1907) and *The Hand of Man* (1902) in the same exhibition that Duchamp's *Fountain* was expelled from. His decision to photograph the urinal was based in ethics. Stieglitz was morally opposed to any bigotry implied in the censorship of *Fountain*. He seemed unaware of the other motivations that Duchamp was exploring with this readymade. Although Duchamp's stunt continues to be deliberated in art history, it is the survival of the Stieglitz photograph that poses a fundamental consideration for the status of photography in Conceptual Art and neoconceptual photography.

Caught in Duchamp's strategy of "delay," Stieglitz would eventually comprehend the displacement of tradition with intent. Duchampian associations with the concept of delay include the physics of light. *Large Glass* was subtitled "A Delay in Glass," in part referring to the refraction and slowing of light as it passes through glass. It also acknowledged Duchamp's refusal to work with materials that reconstitute the figure/ground conventions of painting. Delay can be referenced to the latent image of a photograph as well as the gradual process of revealing, that the readymades and *Large Glass* would have to undergo to be validated as art. In this instance, the delay has an anarchistic principle of denying the artistic conventions of painting and deferring the further appropriation, or domestication of the avant-garde by institutional authority. Recalling Foucault, Thierry de Duve notes that this validation of the readymade is an example of *statement* and *enunciation* that cannot be reduced to an essence.[13] It was Duchamp's use of appropriation (redeploying a mass-produced urinal into an art exhibition) and his declaration that this constitutes a work of art that has sustained critical and institutional authorization. The statement, "this is art," enunciated by R. Mutt and validated by the photography of Alfred Stieglitz,

achieves the intent of this readymade. The disappearance of *Fountain* and its replacement by the photograph ensures the legitimacy of his statement.

The Stieglitz photograph continues to be consigned to "… the *allegorical appearance* of the urinal and the proof that the title *Fountain* once had a referent."[14] The image was made at a time when the Photo-Secessionist Group associated with Gallery 291 was struggling, through quaint aesthetic convention, to have photography recognized as an autonomous art form. Although Stieglitz and his entourage would abandon Pictorialist techniques, developing a preference for so-called straight photography, the metaphysical subtext that informed their work, that photography could claim the transcendental qualities of traditional art forms, would continue to be a lingering contradiction and ideal. The Stieglitz photograph of Duchamp's urinal remains a tautological document of artistic intent and, due to its delayed effect, was not advantageous to the photographers and historians of that time. It is emblematic of the contradictory assumptions of subjectivity and objectivity that have formed a paradigmatic division in the modernist interpretations of photography. The effects of art and déjà vu that complicate our "relationship with the familiar" that was enacted with Duchamp's *Fountain* and Stieglitz's photograph was handed down to other photographers such as Edward Weston who, by 1925, was photographing his own toilet, proclaiming the aesthetic beauty of modern porcelain plumbing. As a young photographer struggling with Oedipal resentment, Weston was both captivated by and disillusioned with the historical presence of Stieglitz. On the other hand, photographs such as *Excusado* (1925), *Washstand* (1925), and *Bed Pan* (1930), all divulge the genealogy that Weston acquired from the Stieglitz photograph of Duchamp's *Fountain*.

It is compelling to consider the influence that Duchamp's readymade may have had on Stieglitz's series entitled *Equivalents* (1923-1931). Like the readymades, these abstract photographs of clouds were accompanied by the use of statement and enunciation, the very attributes that de Duve attributes to the importance of *Fountain*. In fact, the linguistic terminology of "equivalent" and "readymade" would seem to be absurdly related. For Rosalind Krauss, the readymades and the *Equivalents* are related through their

14 Ibid., 96.

15 Rosalind Krauss, "Stieglitz/Equivalents," in *October 11* (Winter 1979): 134.

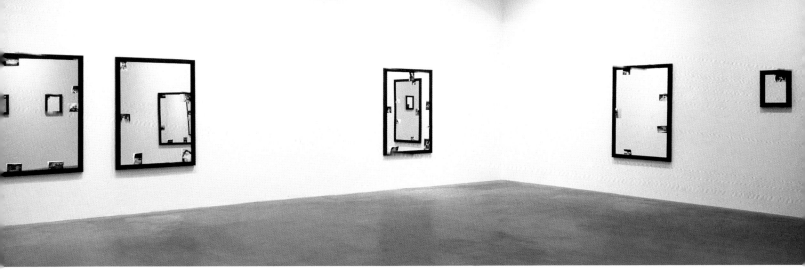

KEN LUM, Installation view, Andrea Rosen Gallery, NY, January 31–March 8, 1997. © Ken Lum. Images courtesy of Andrea Rosen Gallery, NY.

"... resistance to internal arrangement, a positing of the irrelevance of composition."[15] She cites how the *Equivalents* are cut from the sky, a subject that is also not composed, and that this effect of displacement produced by the *Equivalents* is achieved through the formal gesture of cropping. The spiritual and metaphysical intent of the Stieglitz project, however, made it clear that the anaesthetic detachment of Duchamp's readymade would be discarded in favour of an intuitive and transcendental authenticity. What Stieglitz perhaps failed to comprehend was that the same mechanism of signature and context that validated *Fountain* was also a condition for the desired reception of the *Equivalents*.

The scrutiny of an artistic statement (the apparition of Duchampian delay) was still being unveiled with the use of photography in Conceptual Art. Bruce Nauman's performative parody of Duchamp's *Fountain* entitled *Self-Portrait as a Fountain* (1966) is a colour photograph of the artist spitting an arc of water from his mouth toward the camera. Both images are documents of events that cannot be reclaimed as material incarnation.

Duchamp's *Fountain* and the photograph by Alfred Stieglitz that validates it reveal a central paradox of photography and art. Beyond the procedural differences implied by selection and synthesis, we might be enticed to ask why the indexical artifact that appears so matter-of-fact is also the source of radical uncertainty? This is manifest in the historical difference between *Fountain*, understood as the transformation of context and the *Equivalents*, traditionally historicized as transcendental pronouncement. The indexical mythologies of the photograph as well as the photographer's compromised desire to be validated as an artist in the gallery context may finally have reached a finale in the era of postphotography.

In response to these historical observations, I will consider the work of Ken Lum and Cheryl Sourkes, two contemporary Canadian artists that are critically and creatively defining photographic practice in the era of its obsolescence.

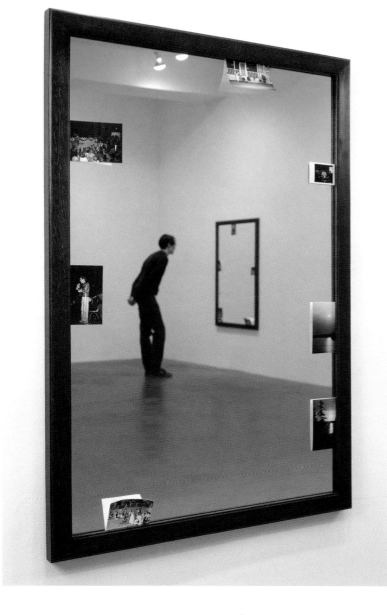

KEN LUM, *Photo-Mirror - sunset*, 1997, maple wood, mirror, photographs, 137 x 99 cm. © Ken Lum. Images courtesy of Andrea Rosen Gallery, NY.

The Mirror with a Memory

The question concerning photography, conceptual art, and obsolescence exceeds the material loss or change in the technological apparatus. Rather, the question must consider how the photograph and its use as an "image" continue to be inscribed by photographers and artists. In this respect, the over-determination of technological essentialism is succeeded by a subjective and cultural contextualization that acknowledges the depth that photographs have in relation to memory, déjà vu, and human experience.

In the work *Photo-Mirrors* (1997) by Ken Lum, a distinctive yet ordinary encounter with the snapshot invites the viewer to reconsider the trace of these everyday objects. Originally installed at the Andrea Rosen Gallery in New York City, the work is constituted by a series of mirrors of varying sizes installed in an intermittent linear sequence on the walls of the gallery. Immediately familiar and strangely out of place, the mirrors inhabit a space where we might expect to see a more conventional representational art form. Inserted into the stained maple frames of the mirrors are anonymous snapshots that the artist found, often curling away from the polished surface and reflecting the white underside of the photographs. The number of snapshots on each mirror is variable — ranging from clusters to singular images. As the spectator moves through the exhibition, they encounter their reflection in the mirrors as well as the reflected presence of others in the gallery. Moving into the frame of the mirror, the viewer becomes a portrait bound in a labyrinth of sightlines created by the mirrors proximity to one another.

Connoting a house of mirrors, this disconcerting experience of concurrent images

and distorted space is punctuated by the unidentified snapshots tucked into the margins of the mirror frames. Overwhelmed by the scale and illusory space of the mirrors, the snapshots depict the everyday experiences and ceremonies traditionally reserved for familial documentation: weddings, birthdays, and vacations, as well as portraits of supposed friends and lovers. In each case, the generic activity or description of the subject in the snapshot provides the prosaic title for each of the *Photo-Mirror* works: "sunset," "rhubarb," "Japanese lovers," "boy in blue vest," and so on. In an extraordinary way, the snapshots function as the captions to the reflections of the passing viewers in the *Photo-Mirror* series. They provide a shared cultural inscription to our reflected presence and accentuate the public and private space that *Photo-Mirrors* assembles.

The vernacular content of *Photo-Mirrors* has an unexpected ability to disrupt the viewer's subjectivity. Who wants to see themselves in the art gallery or be self-conscious of the fact that others may be watching their reflection? Recalling the encounter between Duchamp and Stieglitz and the use of the photographic document to validate the readymade urinal, this photoconceptual work also combines vernacular objects, the snapshot and the mirror, in an installation that appropriates the personal artifacts of domestic space. On the other hand, unlike Duchamp's *Fountain*, neither the snapshot nor the mirror requires supplementary validation to be accepted as an object of art. This work is not limited to the question of naming "art" and, as a consequence, suggests an affinity with the photo album and the living room rather than an institutional archive.

Photo-Mirrors recalls a depth of psychoanalytic reference that provides valuable

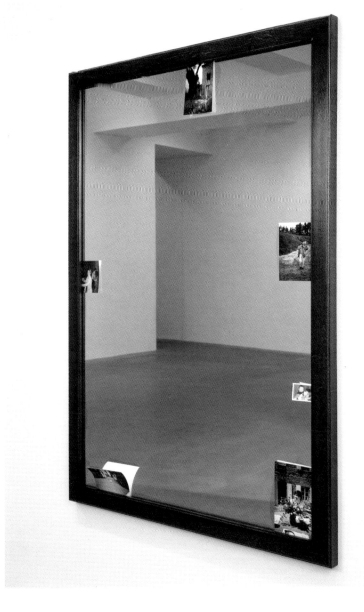

KEN LUM, *Photo-Mirror - rhubarb*, 1997, **maple wood, mirror, photographs, 137 x 99 cm.** © **Ken Lum. Images courtesy of Andrea Rosen Gallery, NY.**

CHERYL SOURKES, *Interference: 5th Ave*, New York, 2003, Lambda print.

CHERYL SOURKES, *Interference: Niagara Falls*, 2003, Lambda print.

CHERYL SOURKES, *Interior: Slaughterhouse*, Germany, 2003, Lambda print.

16 Dylan Evans, *An Introductory Dictionary of Lacanian Psychoanalysis* (London and New York: Routledge, 1996), 116.

17 Michael Payne, *Reading Knowledge: An Introduction to Barthes, Foucault and Althusser* (Oxford: Blackwell Publishers, 1997), 82.

18 In the work of Mary Kelly, Lacan's theories of the subject find an initial feminist interpretation in the history of Conceptual Art. See: Mary Kelly, *Post-partum document* (London and Boston: Routledge, 1983).

19 Jacques Lacan, *Ecrits: A Selection*, trans. Alan Sheridan (New York and London: W. W. Norton and Company, 1977), 312.

20 Geoffrey Batchen, *Each Wild Idea: Writing, Photography, History* (Cambridge and London: The MIT Press, 2001), 111.

21 David Tomas, "From the Photograph to Postphotographic Practice: Toward a Postoptical Ecology of the Eye," in *Electronic Culture: Technology and Visual Representation*, ed. Timothy Druckrey (New York: Aperture Press, 1996), 153.

22 Lev Manovich, *The Language of New Media* (Cambridge and London: The MIT Press, 2001), 165.

historical content to the reading and experience of this work. The most apparent is Jacques Lacan's theory of subject identification and ego formation, articulated in the narcissistic encounters of young children. Known as the "mirror phase," Lacan associates this event with the child's recognition of their specular image, by either seeing their reflection in a mirror or by identifying with the replicated behaviours of others. He uses this phenomenon to explain the process wherein the subject identifies himself or herself as both self and other. For Lacan, "... the mirror stage shows that the ego is the product of misunderstanding (*méconnaissance*) and the site where the subject becomes alienated from himself."[16] This alienation is accompanied by the tragic disappointment of learning that we are not the unified identity situated by the ego, and the imaginary effects of the specular image that initially deceives us also becomes the source of a "... continuous state of longing for an always receding future, a future that will never arrive."[17] Although Lacan's theories have been well articulated in film theory, conceptual art, and postconceptual art of the late-twentieth century,[18] it is rare that an artwork actually imparts an immediate experience of *captivation* and *captation* that Lacan identifies with the specular image. As a metaphor, the etymological allusion of "capture" that accompanies the specular image is also *mirrored* in the photographic portraits that we call snapshots. Our images have been seized and held in the past. As the predictable is made into something foreign, and memory is delayed by déjà vu, the *méconnaissance* of self as other becomes discernible.

If the snapshots along the ledges of the mirrors state the obvious, they also inscribe the work with a relationship to other subjects that recall a more profound social and cultural narrative of self as other. This realization of self as other can serve to displace the public/private dichotomy through the identification that an audience forms with the intimate objects and images of others. As Lacan notes "...desire is the *désir de l'Autre* (the desire of the Other)."[19] It is the wish for recognition that is situated in the desire of someone else.

The Telepresence of Desire

As noted, we need not assume that obsolescence is an end in itself or that this paradigm of industrial culture does not provide a critical axis from which to evaluate and renovate the epistemology of the photographic image. Technological essentialism, whether engaged through naïve enthusiasm or passive longing, merely affirms the obvious and disadvantageous attributes of obsolescence. Alternatively, a more decisive text on photography, art, and digital media has emerged, and not unexpectedly, the question of obsolescence saturates the dialogue:

Turned into an artifact, the photograph has become just one more reference point to an industrial age already rapidly passing us by. Photography has become "photography," eternally framed by the quotation marks of historical distance and a certain awkward self-consciousness (that embarrassment one feels in the presence of the recently deceased). In short, for these artists, photography has taken on a memorial role, not of the subjects it depicts but of its own operation as a system of representation.[20]

The ecological absorption of the photograph and the obsolescence of the photographer precipitate the cultural dissolution of the photographic eye. A postphotographic culture has no need for a witness, a transcendent and discriminating eye, to testify to the significance of events by organizing and fixing them according to a chronological code of before and after. With postphotography there is no longer a point of view, but visual contexts.[21]

It is from the array of "visual contexts" and from a site of virtual reflection, the screen, that Cheryl Sourkes gathers evidence of cultural repetition, surveillance, and subjective displacement through images appropriated from webcam transmissions on the Internet. In many respects, these images have an affinity with found snapshots. More accurately described as "image grabs," these digital snapshots are data and their mutability and evanescence evoke complex relationships between embodied location and an experience of computer-based telepresence ("The ability to see and act at a distance").[22] With a

CHERYL SOURKES, *Interference: Dnipropetrovsk,* Ukraine, 2003, Lambda print.

CHERYL SOURKES, *Interference: Boskovice,* Czech Rebublic, 2003, Lambda print.

CHERYL SOURKES, *Interior: Cityplaza Ice Palace,* Hong Kong, 2003, Lambda print.



CHERYL SOURKES, *Interior: Laki Auto,* **Estonia, 2003, light-jet print, dimensions variable.**

QUESTIONS OF OBSOLESCENCE | ROBERT BEAN

perceptive sense of play, Sourkes accumulates webcam images, archives them into typologies, and disseminates the work on her Web site or as prints for "...life off-screen."[23]

This archive is selective and does not attempt to present an exhaustive catalogue of tangible understanding. It is a personal process of appropriation and invention. With webcams, the frame belongs to remote access cameras, the screen, and the domestic site where these images are pursued, collected, and viewed. With the increased access to computers, digital cameras, home printers, and the World Wide Web, it is apparent that the digital image is a vernacular media analogous to the evolution of the point-and-shoot camera and the ubiquitous reality of television. Unlike television, however, dialogue and interaction with Internet sites is often expected, obscuring the dichotomy of the public and private domain. Cheryl Sourkes' work restructures the reciprocal potential of imaginative interaction with found data, retrieving algorithmic debris from the public domain and subjectively archiving the obsolete information in a postphotographic context.

The images that Sourkes discovers are also reproduced as large-scale prints for exhibition. In a photographic sense, this is a transition from temporal flux to motionless space. The work titled *Cam Cities* (2001) is a set of five prints that presents grids of image grabs taken from webcams located in London, Taipei, Toronto, Vienna, and Warsaw. Each print has been digitally altered to generate a large spherical orb in the centre of the frame. This is a formal intervention in the guise of *trompe l'oeil,* that alludes to the shape of the eye, the webcam, a globe, or perhaps the bloated accumulation of data gathered through digital image capture. Adapting the digital gimmicks utilized in television graphics for news broadcasts, the grid of images appears to wrap around and encapsulate the underlying sphere. This stream of images encircles the ocular sphere and the planet. The protruding orb is a sign that the digital image is no longer bound to the surface effects of perspectival knowledge. Referring to the prints, Sourkes states that the images "...move beyond the distanced instrumentality implicit in their origins and turn into indeterminate hybrids; more substantial and at the same time more ambivalent than at their source."[24]

Cam Cities also alerts us to the more ominous attributes of webcam technology and

23 See www.cherylsourkes.com/

24 Ibid.

25 Ibid.

CHERYL SOURKES, *Interior: Jennicam,* **US, 2003, light-jet print, dimensions variable.**

the extensive network of voyeurism and surveillance that they establish. Along with other forms of video surveillance, webcams add to the electronic Panopticon that has both instrumental and disciplinary functions in the public and private domain. Media mug shots and the last sightings of victims are all retrieved from remote camera sources.

In this respect, Sourkes work traverses and engages an accumulating data bank of Internet and webcam phenomena. The typology entitled *Interiors* (2003) presents a series of nondescript images from cameras located in remote locations. Although some sites are only identified by the date and time, many are already captioned or identified by such names on the Web page as: "Live from Cityplaza Ice Palace, Hong Kong," "Aerobic Room 11/19/03 01:18:48 PM," "Air Academy HS," or "TemporaryResidenceCam." Sourkes notes that, "[a]lthough people in these spaces may be aware there is a camera present, it doesn't alter their behaviour in noticeable ways."[25]

Interiors includes a still photograph of two people lying in a bed, an image culled from *Jennicam,* one of the most documented Web sites of the last ten years. In 1996, Jennifer Ringley, a University student in Pennsylvania, attached a webcam to the computer in her bedroom and began to webcast her daily life in three-minute intervals as image grabs. The transmitted images produced a time-lapse flow of her private life that would irrevocably dismantle the Kodak moment. At the peak of its popularity, *Jennicam* was receiving five million hits per day. Along with the rush to watch Jenni on-line, was her growing celebrity status in popular culture. Articles in *Wired Magazine,* appearances on the *Late Show with David Letterman,* as well as her inclusion in the exhibition *Fame After Photography* (1999) at The Museum of Modern Art in New York City, all suggested that this average, yet motivated student, had successfully anticipated the impact of digital images and Internet media. She had created an environment where narcissism and voyeurism found a technological home that was not contingent on the pornography industries. Although the webcam has also been a staple technology for sex trade workers who may chose to work from home, *Jennicam* was streaming the banality of a young woman's daily life into the public domain. Although the site was recently discontinued, apparently due to the disapproval by her

Internet provider of the intermittent nudity and sex, the legend of *Jennicam* continues to appear in the chronicles of popular culture, media theory, and feminist discourse.

In its most insightful gesture, this site realized the extent to which popular access to affordable imaging technology would influence the use of computer networks for subjective and idiosyncratic reasons. These moments of subjectivity and public intervention often elude the obsolescence that the base technology is founded upon and also have the ability to transform these applications for inclusive cultural use. This does not imply that the effects of media reification and the use of surveillance technologies for the purposes of subjugation and oppression should be underestimated. What it does indicate is how this technology may be adapted to a situated, creative, and reciprocal use of data.

The typologies that Cheryl Sourkes appropriates and modifies represent a considered scope of public and private contexts that reflect shared relationships to media and

26 Krapp, *Déjà Vu: Aberrations of Cultural Memory*, xiv.

photography. The work entitled *Interference* (2003) is a witty accumulation of images from webcams where lighting conditions and aberrant weather often distort the image that the camera is transmitting. The optical and robotic features of the webcam are interrupted and disfigured by the aleatory conditions of its location. A giant spider looms over Niagara Falls and the frost on a window in front of a webcam replays the gratuitous pictorial effects desired by the fine art photographers of the nineteenth century. The formal amusement and visual pleasure of these images is highlighted by the additional historical references to photomontage and surrealism, modernist experiments with photography that were equally responsive to themes of obsolescence and intervention. Recalling the concept of noise in information theory, these image grabs document visual noise as an unanticipated bifurcation in the information that constitutes the resulting photograph.

Both Sourkes and Lum rely on the familiar and the found as subjects for their work. They refer to the transitions and indeterminacy in their work as hybrids of cultural and personal experience. These experiences are relayed in a manner that actively engages the subjectivity of the audience. The hybrid contextualization suggests that these works have an uncertain and transitory relationship to the images, materials, and sources that comprise the artworks and consequently, they inform and withstand the conventional misgivings of obsolescence. In many respects, this has an affinity with the "...contradiction and inversion of distance and proximity"[26] that Peter Krapp identifies with the experience of cultural déjà vu, also a hybrid of memory and forgetting. Both artists have engaged the transformed relationship of photography and memory and have recognized the critical transformation and obsolescence occurring in the saturated culture of teletechnology.

CHERYL SOURKES, *Cam Cities: Virtual Toronto,* **2001, vinyl banner print, 121.9 x 182.8 cm.**

IMAGE AND INSCRIPTION

Cathy Busby WE HAVE A SITUATION: SORRY

KENNETH POLLACK (KP), Middle East expert and former CIA analyst, interviewed by Deborah Solomon (DS): "…Your last one [book], *The Threatening Storm* helped persuade many reluctant Democratic policy makers to support the invasion of Iraq. KP: I made a mistake based on faulty intelligence. Of course, I feel guilty about it. I feel awful. DS: It's nice to hear at least one American say that he's sorry. KP: I'm sorry; I'm sorry!," *New York Times Magazine*, October 24, 2004.

HARRY SCHMIDT, major, "…one of two US National Guard fighter pilots who attacked Canadian troops carrying out a nighttime, live-fire military exercise near Kandahar, Afghanistan, on April 18, 2002… 'I thought we had been ambushed at the time. If you witnessed a hostile act it is an order to defend yourself'…Against the orders of air controllers, he drops the 225-kilogram bomb that injured eight Canadians and killed Pte. Richard Green, Pte. Nathan Smith, Cpl. Ainsworth Dyer, and Sgt. Marc Léger." In an NBC interview about this "friendly fire" incident, Schmidt said: "There is a huge hole in those families. And I want to tell them I understand that. I hope they know that I am truly sorry that the accident happened." www.cbc.ca/news/, June 6, 2005.

RICHARD A. CLARKE, former White House counterterrorism chief, "words of apology were unmistakable…" to victims' families of those who died in the Trade Center Towers on September 11, 2001, "Your government failed you. Those you entrusted with protecting you failed you. And I failed you…We tried hard. But that doesn't matter because we failed. And for that failure, I would ask, once all the facts are out, for your understanding and for your forgiveness." *The New York Times Large Type Weekly*, May 3, 2004.

ANDREW GILLIGAN, former BBC journalist, "I am today resigning from the BBC. I and everyone else involved here have for five months admitted the mistakes we made. We deserved criticism. Some of my story was wrong, as I admitted at the [Hutton] inquiry, and I again apologise for it. My departure is at my own initiative. But the BBC collectively has been the victim of a grave injustice. If Lord Hutton had fairly considered the evidence he heard, he would have concluded that most of my story was right. The government did sex up the dossier, transforming possibilities and probabilities into certainties, removing vital caveats; the 45-minute claim was the 'classic example' of this; and many in the intelligence services, including the leading expert in WMD, were unhappy about it. Thanks to what David Kelly told me and other BBC journalists, in very similar terms, we know now what we did not know before." www.news.bbc.co.uk, January 30, 2004.

BILL GRAHAM, former minister of foreign affairs, Canada, "Everyone was trying their hardest to get Mr. Arar out as quickly as we could. Clearly we would have preferred he'd gotten out earlier and I'm very sorry he was not." *The Toronto Star*, June 3, 2005.

TONY BLAIR, prime minister, UK, "The evidence about Saddam having actual biological and chemical weapons, as opposed to the capability to develop them, has turned out to be wrong. I acknowledge that and accept it. I simply point out, such evidence was agreed by the whole international community, not least because Saddam had used such weapons against his own people and neighbouring countries. And the problem is, I can apologise for the information that turned out to be wrong, but I can't, sincerely at least, apologise for removing Saddam." Speech to Labour Party Conference in Brighton, www.news.bbc.co.uk, September 28, 2004.

DONALD RUMSFELD, secretary of defence, US, "…who bears responsibility for the terrible activities that took place at Abu Ghraib…As secretary of defense, I am accountable for them and I take full responsibility…I feel terrible about what happened to these Iraqi detainees. They are human beings. They were in US custody. Our country had an obligation to treat them right. We didn't, and that was wrong…So to those Iraqis who were mistreated by members of the US armed forces, I offer my deepest apology. It was inconsistent with the values of our nation. It was inconsistent with the teachings of the military, to the men and women of the armed forces. And it was certainly fundamentally un-American." www.washingtonpost.com, May 7, 2004.

* * * * *

The previous series of cropped images from newspaper, magazine, and internet sources were originally accompanied by these statements.

— CATHY BUSBY July 2005

Jeanne Ju Art Stars

Michael Maranda Archival Treatment

Languishing in the Archives nationales françaises are the earliest colour photographs. Predating autochromes by several decades (indeed, predating Maxwell's trichromate process by a decade), these prints were produced with the crucial drawback of not being fixable and thus were sealed in lead boxes to conserve the images for posterity. I seem to remember that the process was developed by Niépce de St-Victor, nephew of Nicéphore.

In the mid-1990s, I invoked these images in a portfolio of twenty documentary photographs. The images produced all relate to an extensive investigation into my familial history. These 20 x 25 cm. fibre-based black-and-white images were printed, developed, and extensively washed, but not fixed. I fabricated copper envelopes in which to store them, safe from ambient light. Once the prints were made, I destroyed both research and production material related to their creation, including the negatives.

In the ten years that have lapsed since this project was initiated, I've carefully stored and transported the images. I've long since forgotten what the photographs depict.

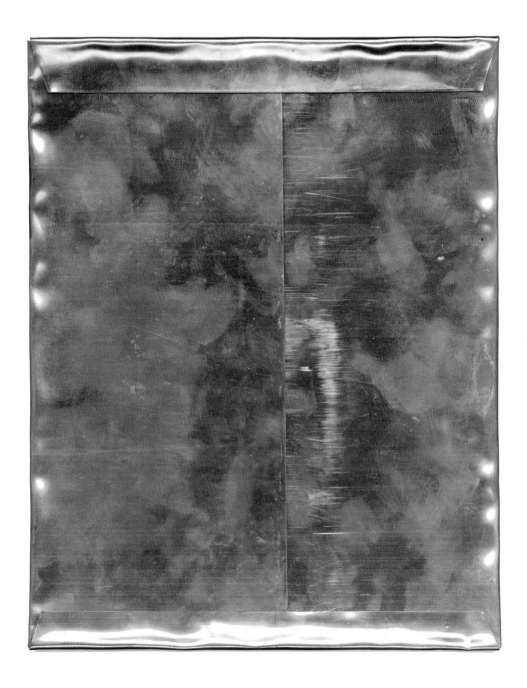

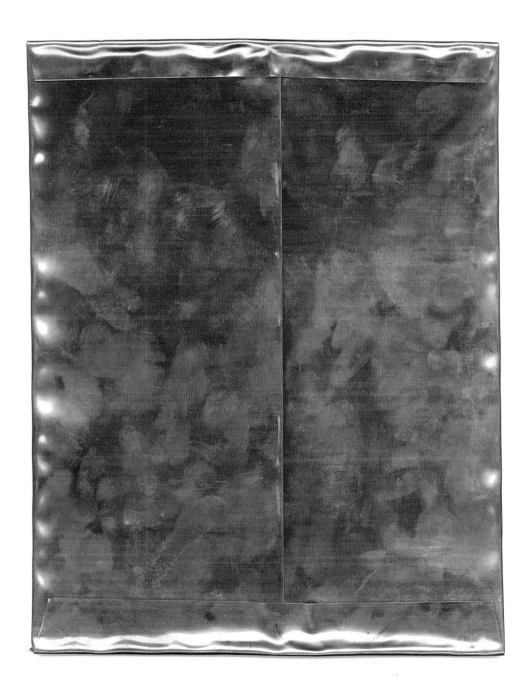

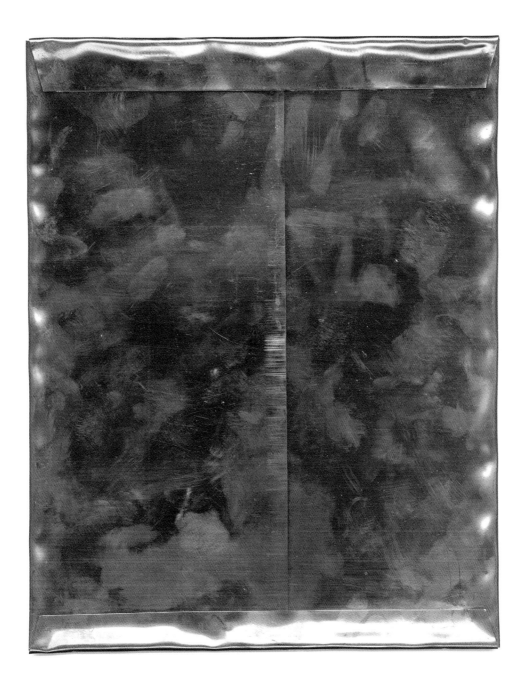

Contributor Biographies

ROBERT BEAN is an artist, writer, and teacher living in Halifax, Nova Scotia. Born in Saskatchewan, Bean has lived in Nova Scotia since 1976, where he is Associate Professor at NSCAD University (formerly known as the Nova Scotia College of Art and Design). Bean served as division chair of media arts at NSCAD University from 1999 to 2003. Bean has exhibited his work in solo and group exhibitions in Canada, Europe, South America, and New Zealand. He has published articles and essays on art, photography, aurality, and popular culture. Robert Bean is the recipient of grants and awards from The Canada Council for the Arts, the Ontario Arts Council, and the Social Sciences and Humanities Research Council of Canada. His work is in public and private collections, including the Nova Scotia Art Bank, The Canada Council Art Bank, the Art Gallery of Nova Scotia, and the Canadian Museum of Contemporary Photography. Bean has received commissions from the Royal Architectural Institute of Canada and Gallery TPW, Toronto.

LYNNE BELL is professor of Visual Culture, Department of Art and Art History, University of Saskatchewan. She has published widely on decolonizing visual culture, and art and activism. Recent publications include such essays as "Artists' Pages: Decolonizing Interventions in Writing Space" (*The Future of the Page*, UTP, 2004); "Restless Images, Scandalous Personas and Difficult Knowledge: The Performance Art of Lori Blondeau" (*Canadian Art*, 2004); and co-authorship of "On the Fightin' Side of Me: A Conversation with Rebecca Belmore" (*FUSE Magazine*, 2005). Since 2001, she has worked on an interdisciplinary, cross-cultural research project entitled "Decolonizing Education in Canadian Universities" with professors Marie Battiste (principal investigator and a Mi'kmaq specialist in education) and Len Findlay (director, Humanities Research Centre).

CATHY BUSBY makes art that responds to the mediation and representation of emotion in consumer culture. She has looked for their patterns and extracted recurring instances of emotional representation in the following: self-help books (*How...*, Gallery 101, Ottawa, 2001), SUV advertising (*Testdrive*, eyelevelgallery, Halifax, 2002; *Totalled*, Carleton University Art Gallery, Ottawa, 2004), public apologies (*Sorry*, Saint Mary's University Art Gallery, Halifax, 2005; and the M^cMaster Museum of Art, Hamilton, 2005), and management language (*24/7 in the Workplace*, eyelevelgallery, 2004; *24/7 at Work*, Mount Saint Vincent University Art Gallery, 2005). She has a BFA from NSCAD University (1984), an MA in Media Studies from Concordia University (1992), and a PhD in Communication from Concordia University (1999). She currently teaches at Mount Saint Vincent University in Halifax.

JIM DROBNICK and **JENNIFER FISHER** are the founding members of DisplayCult, a collaborative framework for interdisciplinary projects in the visual arts. Together they write, curate, organize conferences, and produce art. Their exhibitions include *CounterPoses* (1998), *Vital Signs* (2000), and *Museopathy* (2001), among others. Drobnick has published on performance art, video, dance, and postmedia practices, and is the editor of *Aural Cultures* (2004) and the forthcoming *Smell Culture Reader*. Fisher is assistant professor of Contemporary Art and Curatorial Studies at York University. Her research focuses on exhibition practices, performance, the visual arts, museums, collecting, and non-visual aesthetics. Her writings have appeared in anthologies such as *Foodculture* (2000) and *Naming a Practice* (1996), and she is currently editing a book on the sixth sense.

ROBERT ENRIGHT is a Winnipeg-based writer and critic. He is the senior contributing editor for the cultural magazine, *Border Crossings*, and the university research professor in Art Criticism in the School of Fine Art and Music at the University of Guelph. Enright has contributed over 30 essays, interviews, and introductions to books and catalogues in Canada, the United States, and Europe. He is the host of the "Artists Talk Series" at the Perimeter Institute and a regular contributor to the arts section of *The Globe and Mail*. He has also

published interviews, articles, and reviews to a number of international magazines, including *ArtReview, Modern Painters, Contemporary* and ARTnews. Enright is the author of *Peregrinations: Conversations with Contemporary Artists* and the monograph, *Eric Fischl: 1970-2000* (with Arthur Danto and Steve Martin). In 2005, he was made a Member of The Order of Canada.

ROSALIE FAVELL was born and raised in Winnipeg, Manitoba. Much of her work draws upon both her family history and Métis (Cree/English) heritage that goes back seven generations in the Winnipeg and surrounding areas. She also uses other sources to present a complex self-portrait of her experiences as a contemporary Aboriginal woman. In addition to scouring her family albums for visual material, she finds inspiration in popular culture and has incorporated a number of warrior women from television series and movies into her works. Recent work undertakes a spiritual quest, drawing upon a number of religions and beliefs. In 1998, she earned an MFA from the University of New Mexico, Albuquerque, NM. She is currently enrolled in the PhD program in Cultural Mediations at Carleton University.

BLAKE FITZPATRICK holds the position of dean, Faculty of Art at the Ontario College of Art & Design. He is a photographer with research interests in the area of documentary photography, and he has written on the

work of the Atomic Photographers Guild. Fitzpatrick recently collaborated on a photographic project that traces and documents the displaced fragments of the Berlin Wall in sites throughout North America, which was shown at the Goethe Institute, Toronto in 2004. In May 2005, he curated *Disaster Topographics* at Gallery TPW, Toronto.

STEPHEN HORNE was born in Nairobi in 1948. An artist and writer, he lives part of the year in Halifax, Canada, and lives the rest of the year in Orgeres, France, with his companion, artist Lani Maestro. His writing has been published in catalogues and in periodicals such as *Third Text, Parachute, Art Press, Flash Art, Canadian Art, C Magazine* and FUSE, as well as in anthologies in English, French, and German. He edited *Fiction, or Other Accounts of Photography*, a photography anthology published by Dazibao in Montréal. In Halifax, Horne teaches in Media Arts at NSCAD University.

VID INGELEVICS is a Toronto-based artist, writer, and independent curator. As an associate professor in the Faculty of Art at the Ontario College of Art & Design, Toronto, he teaches in the areas of Photography, Criticism & Curatorial Practice, and Design. His artwork has been exhibited across Canada and Europe. His writing on art has been published in *Alphabet City, Blackflash, Canadian Art, C*

Magazine, CV Photo, Mix Magazine, FUSE, Prefix Photo, Visual Resources, An International Journal of Documentation and the catalogue for Le Mois de la Photo à Montréal. His curatorial projects include *Camera Obscured: Photographic Documentation and the Public Museum*, originally commissioned by the Photographers Gallery, London, England, and, most recently, *The Damage Done: Re-materializing the Photograph*, commissioned by the Prefix Institute of Contemporary Art, Toronto. His Web site can be found at www.web.net/artinfact.

MARIE-JOSÉE JEAN is the artistic director of L'Espace VOX and an independent curator. She was previously the director of Le Mois de la Photo à Montréal's sixth (Le Souci de document, 1999) and seventh (Le Pouvoir de L'image, 2001) editions. She recently curated an exhibition entitled *The Space of Making*, presented at the Neuer Berliner Kunstverein in 2005. She is currently working on a doctorate in art history and communication at McGill University, Montréal.

JEANNE JU was born in Pointe-Claire, Québec, in 1976. She holds a B.Sc. in Biology from Dalhousie University and a BFA (Double Major in Photography and Media Arts) from NSCAD University. She has exhibited her work in Halifax, Toronto, New York, and New Jersey, notably in *Unframed First Look* (2004), a show juried by Cindy Sherman, Adam Fuss, and Jack Pierson, at the Sean Kelly Gallery in

New York. Ju has received numerous awards, including the Nova Scotia Talent Trust and the Charlotte Wilson-Hammond Visual Arts Nova Scotia Award. She will commence MA studies at Chelsea College of Art and Design in 2006.

KATHERINE KNIGHT's metaphoric approach to landscape can be traced to her studies at the Nova Scotia College of Art and Design (now NSCAD University) and formative travels in the Maritimes, Labrador, and the Arctic. Since receiving her MFA at University of Victoria in 1984, she has worked as an artist, administrator, and teacher. She has exhibited extensively in solo and group shows across Canada and her works are held in many public and corporate collections including the Canadian Museum of Contemporary Photography, Museum London, Art Gallery of Nova Scotia, Department of Foreign Affairs, Banff Centre for the Arts, and The Canada Council Art Bank. In 2000, Knight received the Duke and Duchess of York Prize in Photography. In 2005, she participated in L'été de la photographie de Lectoure in France.

ARNAUD MAGGS continues his investigation of colour with *Cercles Chromatiques de M.E. Chevreul, 1861.* Originally published in 1861, *Cercles Chromatiques* serves as a purely theoretical application, containing eleven colour wheels. Arnaud Maggs was born

in Montréal, and practiced as a graphic designer and illustrator before switching to photography. Recent solo exhibitions include *Christo*, at the Art Gallery of Ontario, Toronto, *Orford String Quartet*, at the Agnes Etherington Art Centre, Kingston, and *Joseph Beuys*, Goethe Institut, Toronto. Group exhibitions in 2004 included *Making Faces* at the Hayward Gallery, London, England, *Facing History*, at the Canadian Cultural Centre, Paris, and *Je t'envisage*, at the Musée de l'Elysée, Lausanne, Switzerland. In 2003, he was included in *The Bigger Picture*, Art Gallery of Ontario, Toronto, and *Confluence: Contemporary Canadian Photography*, at the Canadian Museum of Contemporary Photography, Ottawa. In 1999, his retrospective *Arnaud Maggs: Work 1976-1999*, was presented at The Power Plant, Toronto. He lives and works in Toronto.

MICHAEL MARANDA is an artist, arts administrator, and writer who resides in Toronto. He attended the University of Ottawa (Political Science), Concordia University (Photography), and the University of Rochester (Visual and Cultural Studies). He has also been a visiting scholar at the University of Amsterdam, Tisch/NYU, and the Folger Library (Washington DC). He has exhibited across Canada, as well as in France and the US. His visual practice currently consists of the production of artist books that investigate the structural elements of

meaning within found texts. Lately he has also extended his practice to the publishing of books by other artists through Parasitic Ventures Press.

SCOTT MCFARLAND's solo exhibitions in 2005 include *Analysing, Trapping, Inspecting* at the Union Gallery in London, England, and *Gardens* at the Monte Clark Gallery in Toronto and Vancouver. His work was recently part of the *Everything Gone Green* exhibition at the National Museum of Photography, Film and Television in Bradford, UK. He has also had solo exhibitions at the Contemporary Art Gallery in Vancouver, and Union Gallery in London, UK. His work is in the collection of The Museum of Modern Art, New York, The National Gallery of Canada, and was recently included in *The Space of Making*, curated by Marie-Josée Jean at the Neuer Berliner Kunstverien.

ROBIN METCALFE is a writer, critic, and curator based in Halifax. His past exhibitions include *Object Lessons* (Art Gallery of Nova Scotia, 1995), *Queer Looking, Queer Acting: Lesbian and Gay Vernacular* (Mount Saint Vincent University Art Gallery, 1997) and *Dressing Down* (Oakville Galleries, 1998). He served as administrator for HX: *Halifax Exhibition of International Contemporary Art*, a multi-gallery program of exhibitions during the summer of 2000. Metcalfe works with a wide range of media and contemporary

cultural practices, including visual art, architecture, craft and design, and has a special interest in issues of Queer identity, gender, and the body. He served as curator of Contemporary Art at Museum London in Ontario and is now director/curator of the Saint Mary's University Art Gallery, Halifax.

ALAIN PAIEMENT's work has moved from painting to photography and architecture over the course of twenty years, with a sustained interest in mapping. Working with multiple fragments to construct a single image, he represents constructed spaces. Using photography and sculpture, he establishes a dialogue between architectural subjects and their photographic translation. Alain Paiement has exhibited his work nationally and internationally. He lives and works in Montréal.

ARTHUR RENWICK was born in 1965 in Kitamaat, BC, and is a participating member of the Haisla First Nation. His work combines photography with traditional and industrial materials to explore the relationship between cultural identity and colonial development and to address the impact of industry on landscape and culture. He completed his undergraduate studies in Photography at the Emily Carr College of Art & Design and received an MFA from Concordia University. He has worked in a curatorial capacity at The Power Plant in Toronto and the

Canadian Museum of Civilization in Ottawa. Exhibiting nationally and internationally, he is represented in many private and public collections, including the Winnipeg Art Gallery and the National Gallery of Canada. Renwick teaches at the University of Guelph and is represented by Leo Kamen Gallery in Toronto. He lives in Toronto.

ÈVE K. TREMBLAY's photographic projects question the sometimes ambiguous relations between the real and the "strange." Tremblay completed a BFA at Concordia University in 2000. She had a solo show recently at White Space in Zürich, Switzerland. In 2003, she was the recipient of grants from The Canada Council and the Québec Art Council for the IAAB-Christoph-Merian residence in Basel, Switzerland. She is currently attending a residency in Strasbourg (2005-06). Her work has been published in art magazines such as CV Photo, Ciel Variable, Spirale, Etc, Parachute, Esse, Border Crossings, and Mix Magazine. She has upcoming group shows at the McCord Museum of Montréal, curated by Loren Lerner (2006); at Jack Shainman in New York, curated by Penny Cousineau-Levine; and at the Kunstverein Wolfsburg, Germany, curated by Justin Hoffman; as well as solo shows at Vu, Québec City, and Buia Gallery, New York. Tremblay is represented by the Buia Gallery. She lives and works in Montréal.

CAROL WILLIAMS is assistant professor in the Women's Studies Department at the University of Lethbridge, Alberta. From 2001-2003 she was a postdoctoral fellow at the University of Houston. In 2003, her book *Framing the West: Race, Gender, and the Photographic Frontier in the Pacific Northwest* was published by Oxford University Press, New York. In August 2004, her book was awarded the Norris and Carol Hundley Award, an annual book award given by the American Historical Association Pacific Coast Branch.

Other titles from YYZ Books

Other titles from Gallery 44

The Sharpest Point: Animation at the End of Cinema
Edited by Chris Gehman and Steve Reinke

Grammar & Not-Grammar: Selected Scripts and Essays by Gary Kibbins
Edited by Andrew J. Paterson

Mining the Media Archive: Selected Writings on Technology, History and Cultural Resistance
By Dot Tuer

Pro Forma – Visual Art/Language/Text
Edited by Jessica Wyman

Caught in the Act: an Anthology of Performance Art by Canadian Women
Edited by Tanya Mars and Johanna Householder

Peter MacCallum: Material World
Edited by Rebecca Diederichs

Aural Cultures
Edited by Jim Drobnick

Susan Kealey: Ordinary Marvel
Edited by Jennifer Rudder

Why Stoics Box and Other Essays on Art and Society
By Jeanne Randolph, edited by Bruce Grenville

Crime and Ornament: The Arts and Popular Culture in the Shadow of Adolf Loos
Edited by Melony Ward and Bernie Miller

Money Value Art: State Funding, Free Markets, Big Pictures
Edited by Sally McKay and Andrew J. Paterson

LUX: A Decade of Artists' Film and Video
Edited by Steve Reinke and Tom Taylor

Practice Practise Praxis: Serial Repetition, Organizational Behaviour and Strategic Action in Architecture
Edited by Scott Sorli

Foodculture: Tasting Identities and Geographies in Art
Edited by Barbara Fischer

Material Matters: The Art and Culture of Contemporary Textiles
Edited by Ingrid Bachmann and Ruth Scheuing

Plague Years: A Life in Underground Movies
By Mike Hoolboom, edited by Steve Reinke

By the Skin of their Tongues: Artist Video Scripts
Edited by Steve Reinke and Nelson Henricks

Symbolization and its Discontents
By Jeanne Randolph

Mirror Machine: Video and Identity
Edited by Janine Marchessault

Decalog: YYZ 1979-1989
Essay by Barbara Fischer

Struggles With The Image: Essays in Art Criticism
By Philip Monk

Jeff Thomas: A Study of Indian-ness
Introduction by Katy McCormick, essay by Richard W. Hill

Donald Lawrence: The Underwater Pinhole Photography Project
Introduction by Susan Gibson Garvey, essay by Katy McCormick
Co-published with Dalhousie Art Gallery, Gallery ConneXion, and The Richmond Art Gallery

Rare (Ad)diction
Essay by Scott McLeod
Featuring: Julie Arnold, Tonia di Risio, Susan Kealey and Luis Molina-Pantin

Simon Glass: YAHWEH!
Essays by Terry Costantino and Scott McLeod, poetry by Paul Celan

Eric Fong: Corpus Interna
Interview by Sara Angelucci, essay by Yam Lau

Gallery 44 publications are available for purchase by individuals through the gallery, and by institutions through ABC Art Books Canada. Orders can be made from ABC by telephone or via the Web.
Toll free number: 1.877.871.0606
www.abcartbookscanada.com